THE
SWEAT
OF
THEIR
FACE

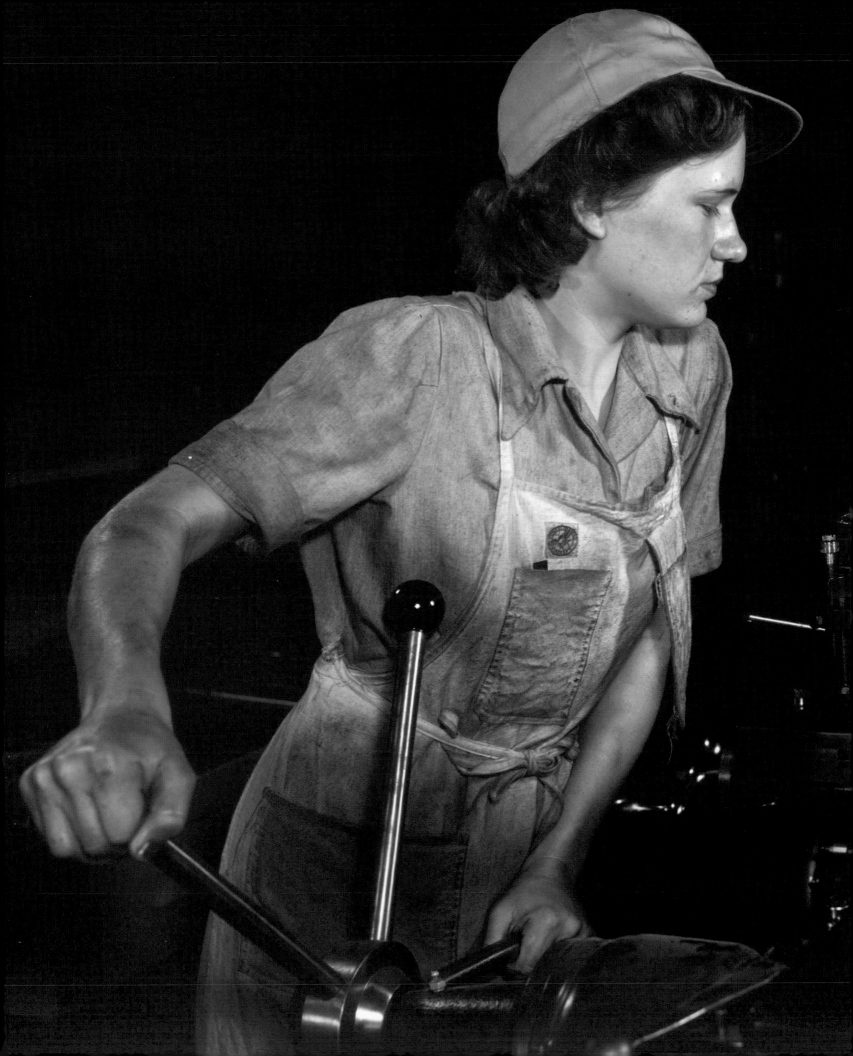

THE SWEAT OF THEIR FACE

PORTRAYING AMERICAN WORKERS

David C. Ward and **Dorothy Moss**

With an essay by **John Fagg**

In association with the National Portrait Gallery

Smithsonian Books
Washington, DC

The Sweat of Their Face: Portraying American Workers
has been made possible through the generous support
of its leadership committee:

Chapman Hanson Foundation

Mr. and Mrs. Hunter S. Allen Jr.
Dr. and Mrs. Paul Carter
Patricia and Walter Moore
Mr. and Mrs. John Daniel Reaves
The Stoneridge Fund of Amy and Marc Meadows

Mark Aron
Ronnyjane Goldsmith

Additional support received from the
American Portrait Gala Endowment and
other generous donors.

It is true of all, that "in the sweat of their face, they shall eat bread."

—Joseph Maskell, "The Curse and the Blessing of Labour: A Sermon,"
Church of England Magazine 42 (January–June 1857): 343

CONTENTS

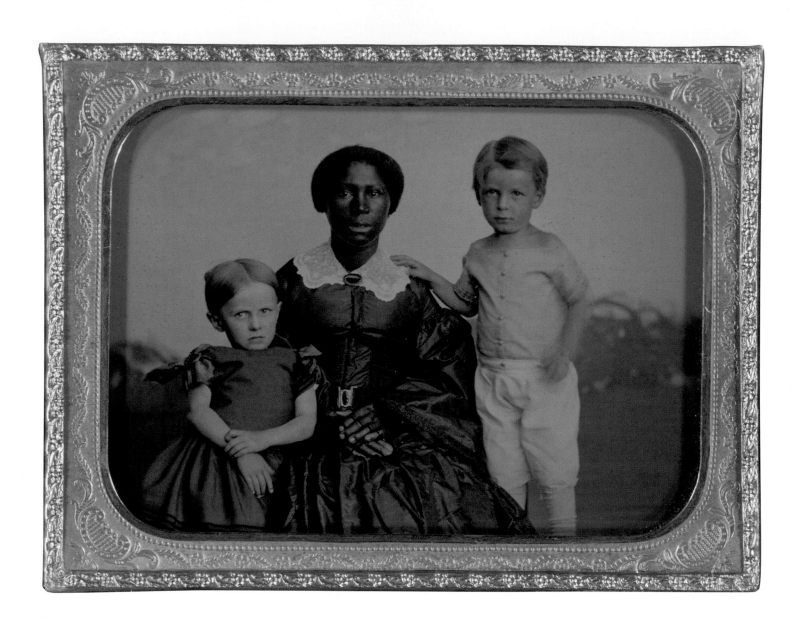

FOREWORD

For there is a perennial nobleness, and even sacredness, in Work. Were he never so benighted, forgetful of his high calling, there is always hope in a man that actually and earnestly works: in Idleness alone is there perpetual despair.
—Thomas Carlyle, 1843

In the great struggle now progressing for the freedom and elevation of our people, we should be found at work with all our might, resolved that no man or set of men shall be more abundant in labors, according to the measure of our ability, than ourselves.
—Frederick Douglass, August 3, 1857

AMERICA HAS ALWAYS defined itself by—and fought over—work. Who works, under what supervision and conditions, and the tangible benefits derived from it have been central concerns since before independence to the present day. In 1774, colonials petitioned King George III to reconsider taxing the fruits of their labor to pay the debts of the British parliament. The subsequent boycott of goods made by British workers was threatened as a way to force the issue. The eventual Declaration of Independence linked self-government and the ability to control global alliances, trade, and commerce with "life, liberty and the pursuit of happiness."

Men who could vote in the colonial period were admired for the public contribution their work provided. Of particular value was the ability to make useful things that served a larger purpose. Pat Lyon and his forge, for example, made tools that supported other industries, while the cooper's barrels made it easier to ship products (see cats. 2 and 4). As much a show of citizenship as an economic necessity, masculine work was in the service of nation-building.

For women, work was primarily in the service of the family or community—playing a supporting role or operating behind the scenes. The adage "A woman's work is never done" confirmed the repetition of the labor; Lilly Martin Spencer's washerwoman will attempt to clean those same clothes again in a few days' time, while Maria Boyd's

African American Woman with Two White Children by an unidentified artist (cat. 9, p. 81)

9

weaving shuttle for a brief moment is held at rest from the endless back and forth that is its function (see cats. 7 and 3).

The work of enslaved people, however, was imposed through a system of legal coercion and violence; their bodies and their portraits were largely relegated to an invisible background of anonymity. It is therefore remarkable to include in this exhibition the photograph of an African American nanny with her charges (p. 8 and cat. 9), since portraits of enslaved workers are almost nonexistent.

As America entered the Industrial Age, the skilled artisan was replaced by someone who could operate a machine, such as "Rosie the Riveter," and the portraits of industrialization show bodies coated in sweat and grease, with darkened faces peering out of darker interiors at the end of a work shift. In particular, children who worked blended into the streets and factories where they delivered, cleaned, and assembled alongside their parents, siblings, and neighbors. Not until adult employment declined during the Great Depression did child worker protection laws gain acceptance, solving an economic problem as much as a social one.

Migrant workers have always been a part of American labor's story, and portraits such as Jean Charlot's *Tortilla Maker* (cat. 38) and photographs from the California fields remind us that alongside immigration has come cultural exchange, innovation, and economic growth.

The protean figure of the worker in a photograph by Lewis Hine or in a painting by Ben Shahn indicates the crucial role of so many millions of anonymous figures in the making of America. Their lives were difficult, chancy, and frequently tragic. They worked hard—and endured much—not just because they had to, but because of their commitment to their families and to the possibility of a better life for their children. In the early years of the twenty-first century, crucial questions persist over issues of jobs and workers' rights, as well as larger issues of economic equality and social mobility. As we grapple with these questions, we might reflect on the labor of the workers from past epochs who have been brought out of anonymity and given the fullness of their humanity by some of America's great fine artists.

To that point, there are a number of people I wish to thank on behalf of the National Portrait Gallery who have labored hard to bring this exhibition to fruition. First, the curators, Senior Historian David C. Ward and Curator of Painting and Sculpture Dorothy Moss, who tracked down the artworks and made this idea a reality. Second, the lenders, both private and institutional, who agreed to let their works go on view. And finally I thank the *Sweat of Their Face: Portraying American Workers* leadership group, who gave their financial support to the exhibition and book, including the Chapman Hanson Foundation, Mr. and Mrs. Hunter S. Allen Jr., Dr. and Mrs. Paul Carter, Patricia and Walter Moore, Mr. and Mrs. John Daniel Reaves, the Stoneridge Fund of Amy and Marc Meadows, Mark Aron, and Ronnyjane Goldsmith, with additional support from the American Portrait Gala Endowment and others.

Kim Sajet
Director, National Portrait Gallery

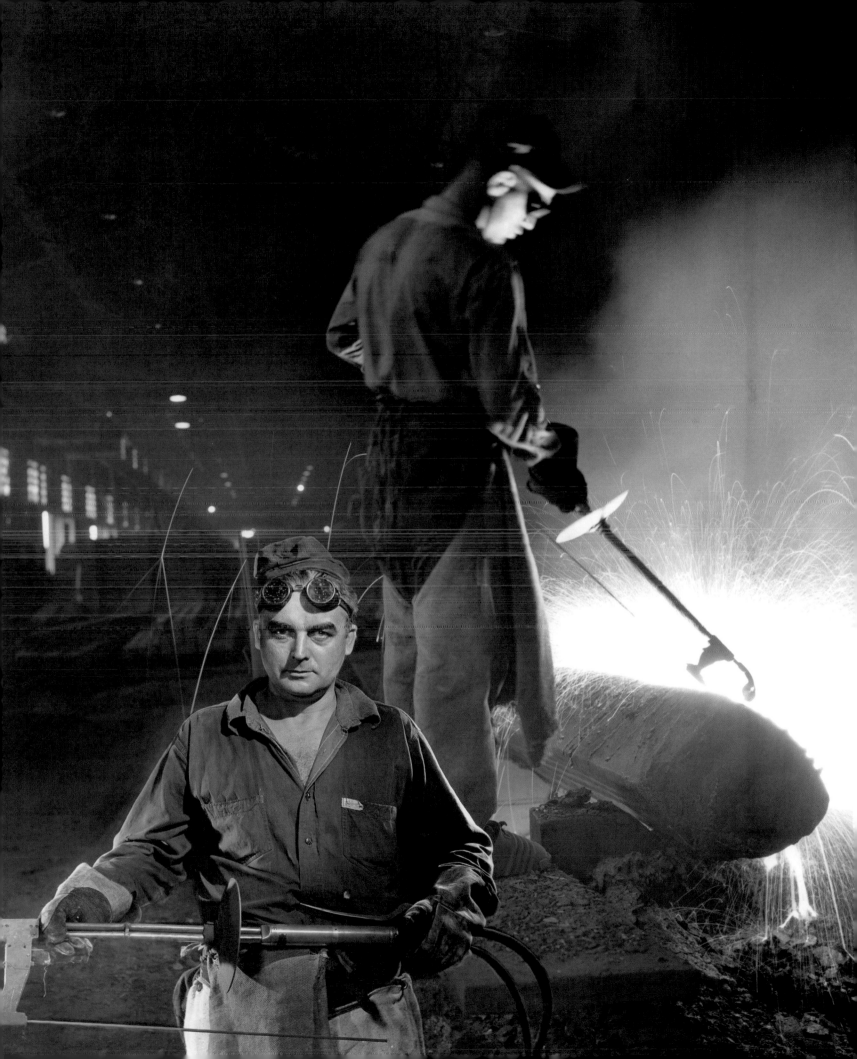

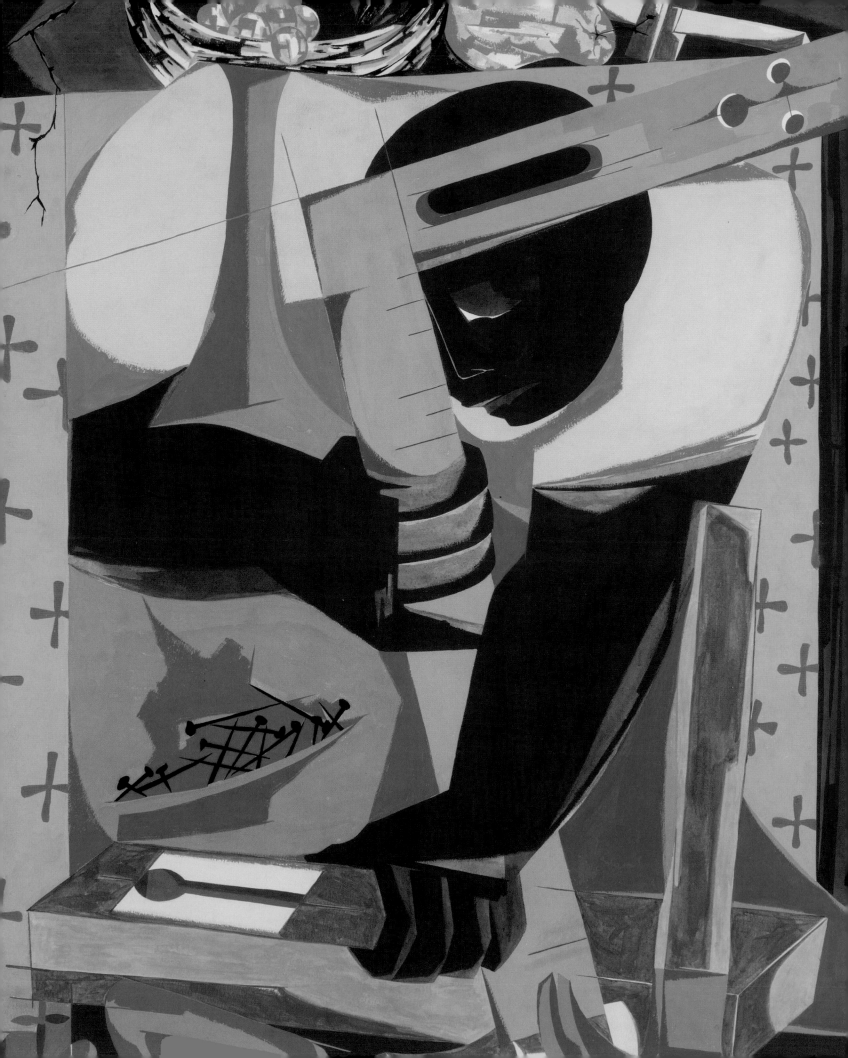

INTRODUCTION

David C. Ward

WE TAKE OUR TITLE from the biblical judgment that expelled Adam and Eve from paradise and enjoined them to work, that "in the sweat of their face, they shall eat bread."[1] The Fall acknowledges a fundamental tenet of thought, both religious and secular, in the West: that men and women are agents of their own destiny and that salvation is dependent on their labor, through which they are subject to all the pain and triumph that such self-definition entails.

Work has always been a central construct in Western civilization, and it has been especially so in America. In the eighteenth and nineteenth centuries, work was valued as the key element in an ideology of self-improvement and social mobility that underlay the American value system. In a society imbued with a strong commitment to the Protestant ethic—early Americans took the lesson of the expulsion from the Garden of Eden very seriously—labor provided an avenue to redeem individuals born into sin. It quickly became seen as redemptive, disciplining the body and the mind to perform the skills that work required. Work was central to the moral project of America—or, as Benjamin Franklin noted, "It is the working man that is the happy man." Crucial to the self-definition of Americans (and America), work not only has been a necessity but also has determined how Americans measure their lives and assess their contribution to the wider society.

That Paul Revere was first a silversmith was essential to his activism as a revolutionary; the republican ideology of American radicalism was rooted in the skills and craft of artisans. Conversely, as the economy accelerated, as the factory replaced the artisan, and as labor was organized on a large scale, the plight of the industrialized worker—especially the child laborers documented by Lewis Hine and others (see cats. 19, 24, and 27)—stirred the public conscience over the toll exacted by unregulated industry; periods of hardship, such as the Great Depression, occasioned similar concern. The awareness of work's toll, as the skill of the artisan atrophied under industrialization, is etched into the faces of the people depicted in this book and exhibition. Indeed, the future of labor is very much in question in the early twenty-first century, with the deindustrialization of the economy effectively devaluing labor itself.

Cabinet Maker by Jacob Lawrence (detail of cat. 59, p. 181)

13

The historical and narrative arc of *The Sweat of Their Face* traces the changing status of labor through the production of fine artists. It makes a telling contribution to the history of portraiture and, by doing so, to the histories of working Americans as depicted in those portraits.

Portraits of workers have been a significant theme in the output of major American artists from John Singleton Copley (fig. 1.1) to Winslow Homer (cats. 10–12 and 15–16) and Elizabeth Catlett (cat. 57) down to contemporary artists such as John Ahearn (cat. 65) and Dawoud Bey (cats. 62–63). The subject of the laboring body has engaged their attention and spurred them to produce iconic and socially significant images, and both the developing economy and the evolution of work can be traced in American portraiture. The empowered artisan (as seen in Copley's *Paul Revere*; fig. 1.1) and the Heroic Worker (as seen in John Neagle's *Pat Lyon at the Forge*; cat. 2) give way to the mill girls who toiled in New England's factories. Gender issues, as well as concern over the growth of an American working class, led artists such as Homer to depict these girls as inhabiting bucolic homes or schools, a pretense that would not last long. As industrialization took off, workers became more anonymous and immiserated. Labor under the factory system was becoming a social problem, and the culture reflected this via portraiture. Slave labor, meanwhile, was largely invisible except in anthropological or scientific portrayals (as in the photographs of Renty and Delia; figs. 1.4–1.5), but portrayals of the gang labor system of the South do appear in paintings by Homer. The subject of coercive labor appeared even after the demise of the slave system; Catlett portrayed an African American sharecropper (see cat. 57), and more recently photographer Danny Lyon has taken for his subject the work gangs of prisoners hired out to the state or private contractors (see cat. 61). The ebb and flow of migratory labor populations is also in evidence in American portraiture, from the Asian immigrants who built the railroads of the nineteenth century to farm workers in the agricultural sector.

An implicit strand of social consciousness can be seen in many of these artworks as the devolution of labor proceeded from the nineteenth to the twentieth century. After the valorous figure of Pat Lyon, there is a century-long transition to Hine's intrepid high-flying steelworker (cat. 32), who seems an extension of the building itself. Episodic crises of labor alternated with periods of celebration, especially during wartime, as the worker was again historicized as heroic and essential to the nation's backbone; the many iterations of Rosie the Riveter are a case in point. But as America evolved from a society organized by production to one oriented toward consumption, the status of labor was hard, if not impossible, to sustain. Questions of automation, "runaway" factories, and the Rust Belt continued the dissolution of work as a core value of American identity, both individual and societal. Organized labor, which waged a long struggle to affirm and sustain its presence, has now become an attenuated presence in the American landscape, replaced by offshore outsourcing or contract and casual labor. The rise of the so-called gig economy is reminiscent of the early history of the modern economy, when the certainty of steady employment was replaced by the uncertain labor of piecework.

The Sweat of Their Face is not a history of labor or a history of the organized labor movement or its leaders. Rather, it seeks to illuminate the intersection of the history of fine-art portraiture in America with the subject of the laboring body. That portraits of working people exist indicates the issue was an important one for visual artists. As John Fagg delineates in his essay in this book, such portrayals usually occur in genre painting and illustration—"slices of contemporary life" that chart the manners and mores of American culture against the backdrop of the expansion of both the economy and democracy. In my own essay, I deal with a paradox: I argue that because portraiture valorizes images of people who were publicly or privately successful, not anonymous workers, it is impossible to paint a true portrait of a working person, for reasons of class, money, and ideology. Nonetheless, I also show that, for complicated reasons that changed over time, workers *were* portrayed by fine artists, frequently to make a political or sociological point; the worker as subject became possible as America became more democratic and as the labor movement arose. Finally, Dorothy Moss shows how the labor of art became a metaphor for the act of work itself: the expansion of the parameters of portraiture reflected how artists became identified with their subjects in a manner that broadened the genre in ways that were surprising both formalistically and in the wider culture. The interlocking combination of these essays, in association with the artwork selected by the curators, provides an entry point for the exploration of new themes in both American art and American labor history.

Notes

1 Joseph Maskell, "The Curse and the Blessing of Labour: A Sermon," *Church of England Magazine* 42 (January–June 1857): 343.

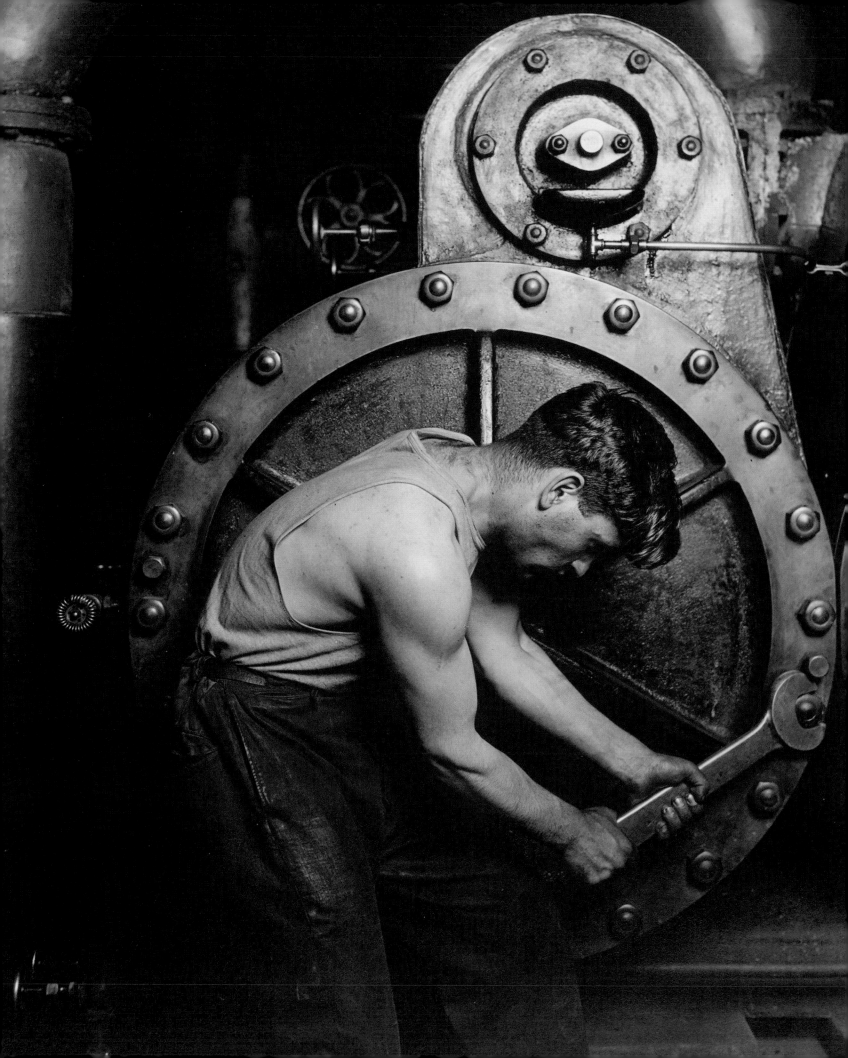

THE FACE OF LABOR

PORTRAYING THE AMERICAN WORKER

David C. Ward

GIVEN PORTRAIT PAINTING'S TRADITION of representing political and economic elites, it is impossible to create an authentic portrait of a member of the working or laboring class. Impossible, first of all, because the very condition of *being* a worker, in every historical epoch's incarnation from Roman slave to postmodern fast-food cook, means a denial of one's individual selfhood; one does not control one's labor, and hence one does not control one's likeness, which disappears, becoming absorbed into an undifferentiated social category. In terms of the practice of portrait painting, it is impossible because a portrait of a member of the working or laboring class violates the historic conditions that have defined the making of such likenesses since the Renaissance.

Portraiture was designed and intended to create an exemplary image of an exemplary life—usually a public life. Although the definition of *exemplary* has changed with historical circumstances, at the apex of portraiture's hierarchy was a society's political rulers, followed by a descending scale of public figures who directly served the state and then, below them, private individuals who fulfilled the normative values of society. Crucially, portraiture became *the* art form for the bourgeois society that began to develop in the West during the sixteenth century. As capitalism (abetted by the rise of Protestantism and allied with democratizing political systems) privileged individual initiative, so portraiture—frequently commissioned by the successful themselves as a form of self-advertisement—became a way to visually and artistically celebrate both the achievements of the individual and the system that had allowed him to succeed. Even more so than the novel, portraiture was the archetypical art form for the bourgeoisie because it revealed no uncertainty or anxiety about success or worldly attainment; the novel, in contrast, was too insightful, too destabilizing about what went on behind the mask of appearance.[1]

Furthermore, until the advent of the camera—and even thereafter—portraiture was largely denied to nonelites because of the expense and exclusivity of its means of production. Portrait artists were rare, and portrait paintings consequently scarce. Portraits were (and remain) costly. Moreover, both the price and the cultural value of

Power House Mechanic by Lewis Hine (detail of cat. 29, p. 121)

portraiture were enhanced by portraits' fetishization by societies that enveloped their production in the social ritual of commissioning, sitting, and paying. If the door to acquiring a portrait was closed economically to most people, it was a door that was also locked and bolted by the complexity of negotiating with an artist for the creation of a likeness. In America, portrait painting became popular only in the mid-eighteenth century, when the colonial economy had grown enough that household surpluses could be devoted to small and then larger improvements in the utilitarian items of daily life. Silver replaced pewter or tin or wood in tableware, for instance. Interior walls were papered instead of painted. International patterns of furniture such as Chippendale replaced locally made items and were rendered in gradations of increasingly finer woods. It was the start of a luxury market where things would be produced and purchased because they were aesthetically pleasing and not simply functional. An influential interpretation of the transitional phase in the colonial economy has dubbed portraits "wall furniture," linking the appearance of portraiture to other improvements and embellishments in the material culture. This is accurate as regards the state of the economy, if not quite right about the rich symbolic vocabulary created by portraiture; portraits speak back to those who look at them in a way that utilitarian items, however fine, do not. But that interpretation is a useful reminder of the conditions that generated the first wave of American portrait painting.[2]

The public's association of portrait painting with material culture incubated the first American portrait artists to depict the world of preindustrial artisans and skilled craftsmen. The case of Charles Willson Peale, who became not the best early American portraitist but the most emblematic in his picturing of the new nation, is instructive. He was able to become an artist precisely because there was no preexisting American tradition or institution of the arts that could prevent him from doing so on his own initiative. Peale came out of the artisanal class and started painting portraits because he had no preconception that it was anything other than a handicraft. He saw some paintings and thought he could do better. As he tried painting, he received instruction from other artists, including John Hesselius, but he made his own way, largely without academic instruction (hence the stylistic and formal limits that dog his likenesses). Peale was also fortunate in his birth and in the absence of competition: when the grandees of Maryland's planter class wanted to memorialize themselves, he had the necessary genealogical ties and the visibility to be brought into their web of patronage and sent to England to study with Benjamin West. In London, Peale recognized his limitations as an artist but was shrewd enough to also recognize that his homely talents, combined with his natural energy and ambition, could suit the self-fashioning of the rising American middle class in the revolutionary and early national periods. Peale moved from Maryland to Philadelphia in 1776 and found a market for his portraits of the leaders of the era.[3]

The rhetoric of the Revolution was heavily fueled by attacks on European luxury and corruption, including suspicion of the fine arts. Later, America's artistic development would be retarded by the continual reiteration of the argument that art was an indulgence, inessential, and even a sign of decadence. Portraiture escaped this stigma because it was about the subject and not the artwork; it depicted exemplary

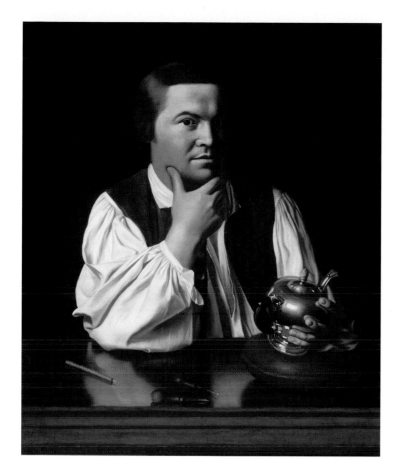

lives. And in the formative eighteenth century, when the economy was still fluid and based on the workshop, this could include, for a brief window in historical time, working people in their fullness. An emblematic portrait of the era is John Singleton Copley's *Paul Revere* as a silversmith (fig. 1.1). Popularly known for his dramatic ride to raise the alarm that "the British are coming," Revere, as one of Boston's Sons of Liberty, embodied a revolutionary activism that derived from the social and cultural world of the skilled artisan. Character traits of the ideal artisan included his completeness and self-sufficiency, the harmony among head, hands, and heart that was expressed by his dexterity in wielding the tools of his trade. Dependent on his own skill, the artisan was self-reliant. His labor was indicative of his honesty: his character was written in the objects he made, and those objects redounded to create the open countenance with which he greeted the world. You can see all of this in Copley's painting: the unity of Revere's character is evoked in the relationship among his broad forehead, his thoughtful gaze and pose, and the globe of the silver teapot. Unseen by the viewer is Revere's own reflection in the teapot, which is tilted up toward his face. No mere product, the teapot embodies Revere himself. As the American colonists mounted an ideological critique of British rule, they pointed to the corruption of that rule and its departure from principles of fairness, equity, and transparency. British administration was not simply exploitative or unfair; it was morally dishonest because it treated Americans as imperial subjects and as objects or things. The American Revolution was a conservative revolution, seeking to restore for Americans a prelapsarian state of equity and equipoise to a relationship that had been allowed to become unequal and unbalanced; it was no longer "workable." Hence the importance of Copley's picturing of Revere as a self-sufficient artisan whose livelihood depended on his individual skill and character—on his independence.[4]

Economically, the artisanal "moment" in American history was relatively brief, but politically it has persisted as a strong animating force both for individuals and working-class movements ranging from the founding of the Democratic Party to the Populist movement of the 1890s as well as aspects of the modern labor movement. But early in the nineteenth century, the unity of Copley's picture of the working man was about to fracture, both socially and in art. This rupture underlies what is an otherwise powerful image of the worker as a protean, seemingly invincible figure: John Neagle's *Pat Lyon at the Forge* (cat. 2). The piece is theatrical and loud, not just because the viewer can "hear" the din of the blacksmith's shop, from the roar of the fire to the beating of metal being forged, but also because the ideological point is overdetermined—hammered home, as it were. The metaphor of forging stretches from Lyon's own self-fashioning to making the body politic, with wider references to the

FIG 1.1
Paul Revere by John Singleton Copley (1738–1815), oil on canvas, 1768. Museum of Fine Arts, Boston; gift of Joseph W. Revere, William B. Revere, and Edward H. R. Revere (30.781). Photograph © Museum of Fine Arts, Boston

construction of a nation in the formal, official-looking building seen from the window at upper left—a building that can easily be read as Independence Hall.[5]

Except it isn't the hall, but a jail. Lyon's status as a worker was tenuous at best. He actually was a very successful and wealthy Philadelphian whose career and psychology were marked by a false accusation of theft and imprisonment as a young man. Rebounding from that setback and public scandal, Lyon specified that when it came time to paint his portrait, he should be depicted not as a businessman but as an "honest" working man. Businessmen were speculators, not producers; they were tricky, subtle, and possibly corrupt, and they earned their money not through honest toil but by manipulating the market and exploiting the gullible or the weak. Against the false front put forward by the businessman/confidence man, Lyon has himself portrayed as an honest toiler, a man of the people. He wears the open-necked shirt that Walt Whitman would later adopt and laud as a signifier of the plain, democratic American. It is the same sort of shirt that Revere wears in his portrait. (Appearing in shirtsleeves—and ostentatiously rolling up those sleeves—as a sign of one's democratic and populist character is a set piece in every male politician's arsenal.) The ideological charge and moral impact of Copley's *Paul Revere* persisted even as its reality had disappeared. But Lyon insisted that the jail, too, appear in his portrait, both as a marker of a psychological scar and a sign of what he had overcome. The portrait thus becomes a morality play of his redemption and social mobility, albeit with a twist. Lyon doesn't show his final triumph as a businessman but instead cloaks himself in the moral guise of the honest worker.[6]

If Copley's *Paul Revere* marked the brief moment of the empowered artisan, his rural equivalent, the yeoman farmer, had a longer run. Both figures expressed the social and political aspirations of the independent producing classes. America, after the turn of the nineteenth century, was transitioning to large-scale production that would eradicate the skilled craftsperson and the smallholder, yet success retained its definition as independence; it was the "pursuit of happiness" written into the Declaration of Independence. As artisans and craftspeople lost control of their skill and livelihoods and became hired labor, the portrayal of workers and the depiction of labor became more difficult. Artists responded by eliding or displacing the reality of work in a way that reflected society's unease with the consequences of industrialization. For instance, the urban artisan—the "workie" celebrated by Walt Whitman in *Leaves of Grass*—was turned into a popular theatrical type by the worker, fireman, and performer Francis Chanfrau (cat. 6). As Mose, the archetypical Bowery "B'hoy," he was greeted raucously by urban audiences delighted to flex their cultural (and political) muscles in the burgeoning cities of the East Coast.[7]

More conflicted and displaced images of labor appeared around the advent of America's first industrial complex, the mills that were erected north of Boston in Lowell, Lynn, and Lawrence (fig. 1.2). The labor force in these factories was entirely young and female. This raised huge ideological problems, not because women didn't work but because they hadn't worked outside of small units, doing piecework or domestic labor. Now single women were being imported from their homes and communities to toil with hundreds of other women, running the spinning and cloth-making machinery of the

American industrial revolution. This violated all previous norms of the political economy as well as striking at the carefully maintained protected status of women (an ideal that was frequently violated in practice, of course). The consequence in both the initial operations of these businesses and depictions of these women was to efface industrial work by placing the factory in a pastoral setting in which the actuality of mechanical wage labor could be ignored. Factory owners, uneasily justifying their practices, minimized the details of machine work and life by arguing that the mills were really just extended families and a complement to schools, claiming that their mission was not profit but the development of character and proper deportment. At least initially, an elaborate social welfare network, including classes and a literary review produced by the workers, was put into place at the mills to dampen industrialism's impact on the girls and, perhaps more important, on the wider society. Americans were very uneasy about introducing the factory system and supplanting the reality and the still-powerful ideology of the independent producer. The camouflaging of the factories, historian John Kasson writes, extended even to adding rustic decorative items, such as flowers or cornstalks, to the casting of metal machinery. Spinning equipment was adorned with corncob capitals, just like the columns designed for the U.S. Capitol. The machine would be reconciled with the garden through these decorative touches, although they did nothing to minimize the reality of factory labor and soon disappeared. The key visual text for this displacement and elision of the factory's true purposes and functioning was Winslow Homer's *Old Mill (The Morning Bell)* (cat. 15), which recreates the factory by hiding it amid the landscape. The painting was misread for many years as depicting a public school. Only much later was the building revealed to be a mill and the women not teachers but industrial workers.[8]

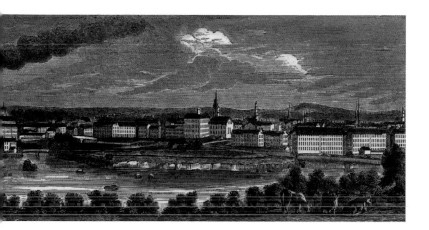

FIG. 1.2
East View of Lowell, Mass., drawn by J. W. Barber and engraved by E. L. Barber, wood engraving, 1839. Lowell National Historical Park, Lowell, Massachusetts

Artists depicting agricultural labor and laborers had an easier time pursuing visual themes that romanticized the working of the land. Images of the family farm predominated, with hand labor persisting even as mechanical reapers and large-scale cultivation were spurring the American agricultural revolution. That transformation was slower to get underway than the revolution in manufacturing, and corporate agriculture—or "agribusiness," as it is now known—would not arrive until the twentieth century. So images of farm labor, such as Homer's *Haymaking* and *Girl with Pitchfork* (cats. 10–11), idealized the actuality of farm work, cloaking it in a pastoral haze, but nonetheless depicted it accurately enough. Homer's agenda in making these paintings was to capture a lost world of innocence that had been destroyed by the Civil War—a general artistic theme that confronted the conflict through its indirect effects. As the war was a turning point in American economic development, marking the replacement of handwork by large-scale mechanization, Homer was evoking a simpler time in his images of the young woman and the man standing in the sunny uplands of an imagined past.[9]

Thus for the farm in the rural North. The South, however, was an exception, not just because it relied on slave labor but also because of how that labor was deployed

THE FACE OF LABOR

on the large plantations that were the sine qua non of Southern political economy and culture. Most slaves worked on small farms—the average number of slaves per farm was fewer than six—but the model was the plantation with dozens, if not hundreds, of slaves working in a routine that organized and regimented the twenty-four hours of the day. One of the manifold ironies in the slave system is that it seemed to replicate the most advanced features of capitalist enterprise as it produced staple products (especially cotton but also sugar and indigo dyestuffs) for an international market. And yet the plantation was founded on the purchase not of labor power but of the laborers themselves, body and soul. That these toiling bodies had to be cared for 24/7—there was no factory whistle to dismiss them for a few hours of private respite and recovery—meant that slave owners had to create a system to feed, clothe, and house them. To rationalize this servitude, elaborate racist justifications were developed that argued that the plantation was actually a school or extended family in which a beneficent master cared for "his people." The slaves themselves, of course, were rarely heard from except after they had escaped from the "peculiar institution." In the South, they were invisible except when they could be used to justify the system that exploited them.

Charles Willson Peale created an inadvertent picture of the distance between master and slave in his portrait of Maryland's Gittings family (fig. 1.3). The family is pictured in the foreground; to celebrate their status, the artist painted behind them a view looking down from their great house over their land; there the slaves are visible, but only as anonymous dots in a sea of wheat. Bound labor also appeared in genre paintings of the "moonlight and magnolias" variety that romanticized Dixie and frequently made light of the labor itself. That life on the plantation was different than the myth is attested to by the scarred and lacerated back of a slave runaway known only as Peter (formerly identified as Gordon), whose wounds were discovered when he was given a physical examination upon his enlistment in the Union army in 1863. Peter became "visible" to Americans—a photograph of his wounds was reproduced in etchings and print—as he became a symbol of abolition.[10]

FIG. 1.3
Mr. and Mrs. James Gittings and Granddaughter by Charles Willson Peale (1741–1827), oil on canvas, 1791. Baltimore City Life Museum Collection, Museum Department (MA8754), courtesy of the Maryland Historical Society, Baltimore

The picture of Peter is important beyond its political uses. It also marks the emergence of photography in American portrait making. As has been often pointed out, the camera made portraiture easier, more accessible, and more democratic, in the sense that it permitted the portrayal of ordinary Americans. Oil painting retained its hieratic function, especially in the political realm, but photography allowed a flexibility in tune with the populist aspects of American culture. Photography expanded

THE SWEAT OF THEIR FACE

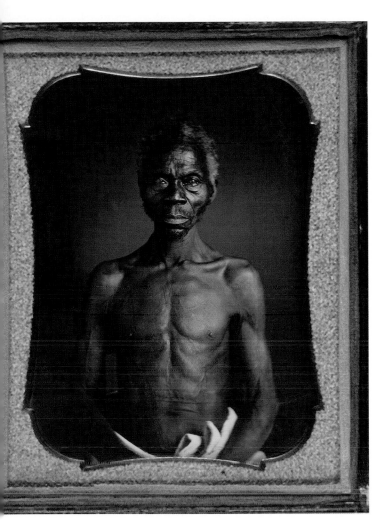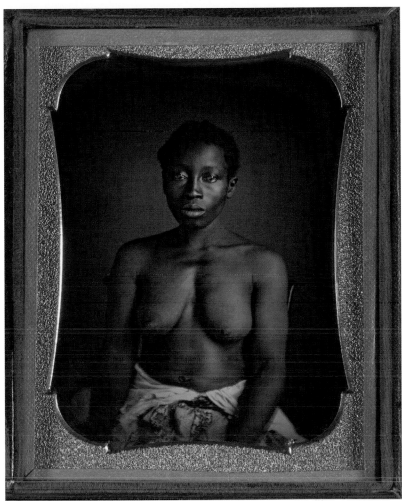

FIG. 1.4
Renty by Joseph T. Zealy (1812–1893), daguerreotype, 1850. Peabody Museum of Archaeology and Ethnology, Harvard University, Cambridge, Massachusetts (PM #35-5-10/53037; digital file #99320117)

FIG. 1.5
Delia by Joseph T. Zealy (1812–1893), daguerreotype, 1850. Peabody Museum of Archaeology and Ethnology, Harvard University, Cambridge, Massachusetts (PM #35-5-10/53040; digital file #101250004)

the scope of public culture's visual field, making representation less hierarchical and less structured by the arcane economic process of commissioning a portrait of an exemplary individual.[11]

This is not to say that the camera—especially in the formative years of photography—was automatically an expression of popular democracy; that development, including the recent "selfie" phenomenon, would be years in the making. What the camera permitted was the objectification of working people and other nonelites as they became the subjects of photographic practice. Photography became a method of mapping the demographic and sociological terrain in ways that included surveillance and the categorization of racial, ethnic, and social "types." For working-class, poor, and subject peoples, this mapping could amount to an invasion of space and a further indication of their lack of autonomy and control of their own bodies. A series of extraordinary daguerreotypes of slaves—including the images of Renty and Delia seen in figs. 1.4 and 1.5—were taken in order, presumably, to categorize their features and ethnographic background in Africa, but their effect is dehumanizing, not least because the subjects are shown half-naked and thus completely open to scrutiny. This nakedness reinforces their status as chattel, as "things" that could be manipulated and displayed in ways that would never be countenanced by or for the middle classes.[12]

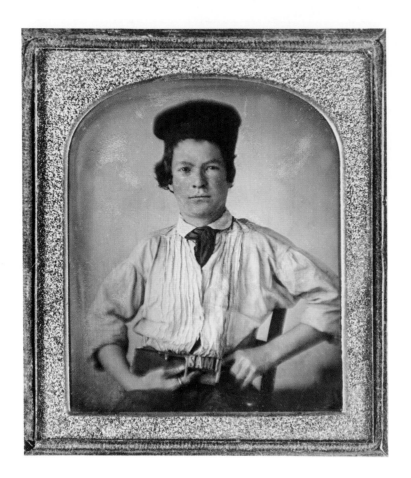

More benignly, photography allowed for a survey of occupational and demographic types that included likenesses of working people. Against the anonymity of the sitter in most such images, the camera could turn up surprising results. Such was the case in the portrait taken in 1850 of a young printer's apprentice who spells out his name in type: one Samuel Clemens (fig. 1.6). He worked as a typesetter for his hometown newspaper in Hannibal, Missouri, and would later find employment as a printer in cities on the East Coast (he was a member of one of the first labor unions in America, the International Typographical Union) before winning fame as the author Mark Twain. The virtue of the camera in a populist democracy is that it can capture people throughout their careers, before they become wealthy or noteworthy and might have an oil painting done of them. The camera allowed the process of an autobiography to be recorded, providing serendipitous discoveries of people who would become "somebodies," as was the case with young Sam. As Mark Twain, world-famous author and humorist, he would of course be the subject of many portrayals, including oil paintings, in his trademark white suit and luxurious mustache.

But images of exemplary figures amid their working-class background were extremely rare, if not unique to this case. For instance, Abraham Lincoln had a hard-scrabble youth, but no images exist of him as a rail splitter; nor are there portraits of the capitalist Cornelius Vanderbilt as a young ferryman on the East River. While social mobility was indeed possible in the United States, the rags-to-riches myth was very rarely played out; instead, upward mobility tended to occur in incremental steps across generations. (My own family, the Wards, emigrated from Ireland in the late nineteenth century, became cement workers in upstate New York, and four generations later became white-collar professionals in Boston.) Alongside the possibility of rising was the possibility of failure—an outcome that the dominant ideology of upward mobility tended to suppress or ignore. Considering the biography of someone such as Lincoln, for instance, makes it evident just how fine the margins were between success and disaster in everything from mortality to obtaining a steady income in any job, let alone one you desired. Social life in America was a constant struggle against invisibility and disappearance.[13]

The camera promised a new objectivity, and it (along with the photographic process) replicated the mechanization of society. As the economy grew and hardened along class lines, there was no automatic visual response to picture the results of industrialization in realist terms. Sentimentality was still the dominant tone in the portrayal of working people, but a concern for the afflicted and helpless among the dispossessed also began to emerge. In particular, social and political worries about

FIG. 1.6
Sam: Portrait of Samuel Clemens as a Youth Holding a Printer's Composing Stick with Letters SAM by G. H. Jones (fl. 1850), daguerreotype, 1850. Courtesy of the Mark Twain Project, The Bancroft Library, University of California, Berkeley (MTP9.07a[001])

urbanization were bifurcated: "respectable" opinion feared adult male workers (especially in organized groups such as volunteer fire departments and "gangs," a term that could connote both nascent trade organizations and criminality) but shed tears over the plight of the young. Newsboys made their appearance in American art as one such object of pathos (see cats. 5 and 23), a status they maintained well into the twentieth century and the era of film. In other words, their image persisted as long as papers were hawked on the street and in saloons in a highly competitive contest for readers and sales.[14]

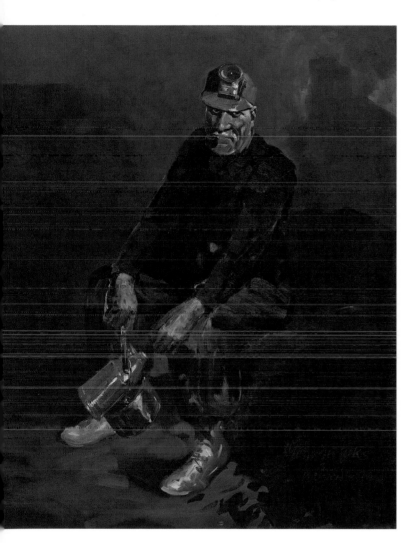

If American society was generally callous about the impact of industrialism on adults—who were conceived of as being free agents—there was a dawning recognition of the toll that it took on children. The idealization of the mill girls of Lowell, working in harmony and sorority among other girls, earning money and getting an education, soon took on a darker hue as manufacturers jettisoned any attempts to run factories as social-welfare institutions. Paintings of industrialism's strays and waifs tended to sentimentalize, but the camera, which played a major role in the campaign against child labor, was more merciless, depicting barely clothed and vulnerable adolescents against a background of machinery that figuratively and literally threatened to swallow them up. Lewis Hine's poignant photographs, for example, helped to galvanize opposition to child labor even as they contributed to the realist revolution in American literature and art (see cats. 24 and 27). His photographs were the complement to Stephen Crane's *Maggie. A Girl of the Streets* (1893). Paintings such as George Luks's *The Miner* (fig. 1.7) and portrayals of workers by the artists of the Ashcan School marked the appearance of the working class as a legitimate focus of the fine arts. The subjects of those works, however, were still bound to the gaze of the artist, incapable of acting autonomously in their own self-presentation. However estimable in their good intentions and moving in their formal aesthetic properties, Hine's photographs of mill children were still an invasion of privacy—there is a stunned expression on their faces as the shutter is tripped and they are caught by the camera, just as they are caught in the industrial processes of the factory regimen.[15]

Conversely, Hine also heroicized the worker, creating the image of a protean "superman" who mastered the material world, and indeed created it, rather than the other way around. Hine's striking image of a steelworker on the Empire State Building launched, arrowlike, into space, was the key document in this visual reversal (cat. 32). Instead of being inured within industry, like Luks's beaten-down miner, Hine's worker has the verve and élan of a circus performer. (In Hine's *Power House Mechanic* [cat. 29], the circularity of the composition and the relationship between the worker's body and the machinery turns the man into a machine: a much more realistic explication.) The worker on the skyscraper is connected to the actual building site by only the thinnest

of connections, both actual and metaphorical: the wire around which he braids himself acrobatically. The picture is a genuine celebration of the skill and courage of steelworkers. (Note the absence of any safety gear and that the worker is wearing ordinary clothes.) More symbolically, though, the picture makes the specificity of the site and the myriad complex details and interlocking organizational parts that went into erecting the building disappear and replaces them with an act of magic. The worker transcends his work, and in an increasingly corporate, anonymous world, the power of the individual is reasserted. For a society that was experiencing a bewildering succession of social changes, the aerial worker on the Empire State Building acted as reassurance that man was still on top of things.

During the first third of the twentieth century, the organized labor movement was well established in the United States, although it faced continued opposition from business groups and others. The American Federation of Labor (AFL) was founded in 1905 by Samuel Gompers and largely represented the craft unions. In 1912, the Socialist Party, drawing broadly on labor support, polled an impressive 6 percent in the presidential election and had considerable success in state and local elections. The party was also strong in ethnic immigrant communities, particularly German and Jewish ones, whose members had brought with them a tradition of European radicalism. (The party's foothold in electoral politics would be destroyed by a nationalistic backlash during World War I, which was abetted by governmental repression that included the jailing of Eugene V. Debs, the greatest figure in the early U.S. labor movement.) The movement's internal history, marked by the schism of the breakaway industrial unions led by John L. Lewis with the founding of the Congress of Industrial Organizations (CIO), was one of organizational problems and factionalism but was also indicative of labor's responsiveness to changing economic conditions, as small shops and handwork gave way to corporatism on a massive scale. Summarizing, the AFL was generally more conservative and looked back to the defense of traditional craft practices modeled on the empowered artisan of the early republic. The CIO, more radical or progressive, accepted that the corporate and bureaucratic organization of work required the organization of labor by industry and not by craft specialty. For our purposes, the appearance of organized labor as a political force meant the appearance of images of the leaders of the labor movement: Gompers and Lewis were subjects of pen-and-ink sketches on the cover of *Time* magazine in 1923, its

FIG. 1.8
The Migration Series, Panel No. 57: The Female Workers Were the Last to Arrive North by Jacob Lawrence (1917–2000), casein tempera on hardboard, 1940–41. The Phillips Collection, Washington, D.C.

founding year. This was journalistic or "news" portraiture, to be sure, but their sharing cover status with politicians and other luminaries was indicative of labor's increased national presence—and political power.[16]

By this time, labor, including the portrayal of individualized workers, had also become the subject of visual documentary projects on the American people. The documentary impulse stretched back to eighteenth-century categorizations of social and "personal" types, including studies of the emotions as well as the cataloguing of the "lower orders" as part of their policing; the daguerreian images of slaves mentioned above were part of this trend. By the end of the nineteenth century, European and American social realism in the arts had brought living conditions and the working class into focus broadly, and occasionally specifically, as in Crane's *Maggie: A Girl of the Streets*. With the labor movement, including its association with radical political groups such as remnants of the Socialist movement and the Communist Party, documentary work took on a political edge and purpose, particularly during the Great Depression. The employment of artists in government works programs is one of the best-known aspects of the New Deal. Public art addressed labor and work directly; the most notable example may be the work of Mexican muralist Diego Rivera, especially his murals about the automobile industry in Detroit. (Infamously, the mural he did on commission for Rockefeller Center in New York was effaced because of its explicitly radical messaging, which included portraits of Lenin as well as socialist realist–style depictions of heroic workers.)[17]

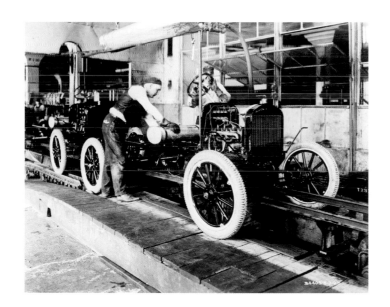

The Works Progress Administration and the Farm Service Administration provided artists with public employment to alleviate the effects of the Depression, and the artworks that resulted document the social and economic effects of the economic collapse. James Agee and Walker Evans's *Let Us Now Praise Famous Men* uses documentary inquiry and depiction for literary as well as political effect. The title, taken from a Jewish text, *The Wisdom of Sirach*, was intended to be ironic in the sense that the ordinary, downtrodden Americans portrayed by Evans's photographs were clearly not "famous" in any obvious way, and yet the title also valorizes the lives of ordinary working Americans. The next phrase in the source text, "and our fathers that begat us," establishes the genealogical presence of working people, a presence commensurate in its dignity—if not in its social, economic, or political status—with the "famous men" of public history. More than just a repetition of the fatalistic idea "that the poor are always with us," this was a genuine attempt to reveal the reality of the dispossessed and, in so doing, to elevate their humanity. The biblical or liturgical reference, as in Agee and Evans's title, was irresistible, not least because of the connotation of suffering or even martyrdom.

The most famous image from the Depression is by Dorothea Lange, and it is not known as *Mrs. Florence Owens Thompson* but as "Migrant Mother" (cat. 34). It is the absence of documentary specificity (the work is not called "Migrant Worker and Mother") that turns Thompson into a universal symbol. The photograph evokes

FIG. 1.9
Assembly Line at the Ford Motor Company's Highland Park Plant by an unidentified photographer, reproduced from original glass-plate negative, Detroit Publishing Company, ca. 1923. Prints and Photographs Division, Library of Congress, Washington, D.C.

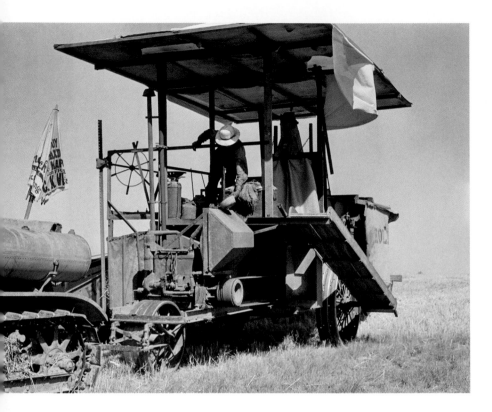

biblical resonances with suffering, exile, wanderings in the wilderness, and finally Mary herself, the mother of Jesus (and wife to a carpenter and laborer). The Depression was thus generalized—and sacralized—into the Calvary of the American people.[18]

An important story within the overarching narrative of the 1930s was the emergence of a solid number of African American artists who engaged themes related to black history and contemporary life. Printmaker Elizabeth Catlett invested her portrayal of a woman sharecropper with the pathos and sorrow of a life lived with endurance and dignity (see cat. 57), giving a face to the anonymity of sweated labor under the systems of coercion that had replaced slavery in the South and lasted well into the twentieth century. Contrastingly, the Depression accelerated the movement, starting right after emancipation, of African Americans from the rural South to the urban North. The Great Migration was documented in a multipart print series of the same name by Harlem-based artist Romare Bearden, who was originally from North Carolina. Jacob Lawrence's family also journeyed from the South to the North, where he became an artist (see cat. 59). His depiction of the social and cultural consequences of that exodus was his monumental sixty-painting series originally called *Migration of the Negro* (now known as the *Migration Series*; fig. 1.8).[19]

The geographical mobility of Americans—"Go West, young man!"—accelerated dramatically in the twentieth century, not least because of the expansion of the transport industries: first automobiles (fig. 1.9) and then airplanes. The country's center of gravity shifted west, with people following jobs and vice versa in an ongoing wave of development. Since the Gold Rush, California had had a special status in the American imagination as a land of opportunity, a place where you could start over, and a space that could be occupied by cutting-edge industries from films to aeronautics. Charles Lindbergh's epoch-making solo flight from New York to Paris actually began in San Diego (the city's airport is named after the flyer), where he picked up the *Spirit of St. Louis* and flew east with only one stop; he crossed the Atlantic to Paris ten days later. Lindbergh, "the Lone Eagle," was a salient case in the accommodation of traditional American individualism to advanced technology and manufacturing. If Lindbergh was one of the great public celebrities of the first part of the twentieth century, Hollywood created the film industry, which produced celebrities on an assembly line, like engines and airplanes. The myth of American success had gone from the boy heroes of the Horatio Alger story, who basically traveled from outcasts to the respectable middle class, to a latter-day Gold Rush in which eager aspirants would be "discovered" (usually accidentally in the mythology) and made into stars. Cloaked in glamour, the industry relied on thousands of technicians and

FIG. 1.10
Combine Harvester in California. Wheat Field. San Joaquin Valley by Dorothea Lange (1895–1965), reproduced from original nitrate negative, 1938. Prints and Photographs Division, Library of Congress, Washington, D.C.

THE SWEAT OF THEIR FACE

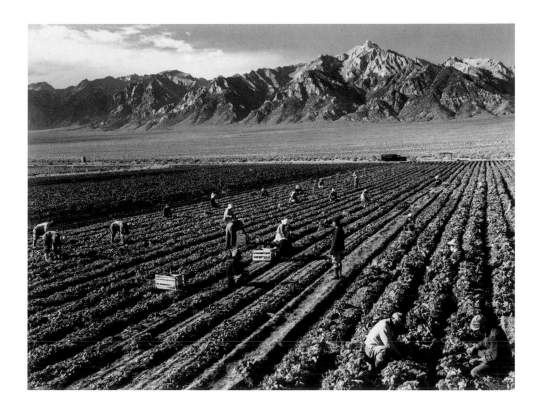

FIG. 1.11
Farm, Farm Workers, Mt. Williamson in Background, Manzanar Relocation Center, California by Ansel Adams (1902–1984), gelatin silver print, 1943. Prints and Photographs Division, Library of Congress, Washington, D.C.

ordinary workers to make it successful. And its success presaged future changes in the economy: the creation of culture as an American industry in its own right.[20]

More prosaically, the West rested on agricultural labor (as well as large-scale government development projects that dammed rivers to make land arable and built highways to truck farm produce to market) and the exploitation of subsistence labor drawn from other nationalities, especially Mexicans and Asians. Unlike the Midwestern grain farms, Western agriculture was labor intensive, especially in the harvest season, and it resisted mechanization not least because there was a ready supply of workers, including children. The seasonal and migratory aspects of this work only increased the social, cultural, and legal vulnerability of the agricultural working class (figs. 1.10–1.11). Agribusiness relied on almost premodern labor relations, albeit with the difference that the workers, unlike in previous forms of tenant farming or sharecropping, had no connection with the land at all. These labor markets were easily controlled by industry and government, especially because of the widespread animosity and racism with which migrant labor was treated, despite its being essential for the economy; the way that Asian immigration was controlled through both local and national ordinances was a textbook case of labor market regulation abetted by racism. Labor unions made little headway in organizing the farm workers, even into the twenty-first century, although the radical International Workers of the World at least made the attempt and had some success. The issue of illegal immigration remains a flashpoint in contemporary politics in large part because agricultural jobs are drying up and there is an overabundance of available casual labor. The irony of Lange's "Migrant Mother" photograph, and one of the reasons for its aesthetic power, is that it gave a face to the dispossession and despair of white labor; African American, Asian, or Mexican labor had always been naturalized as part of the landscape.[21]

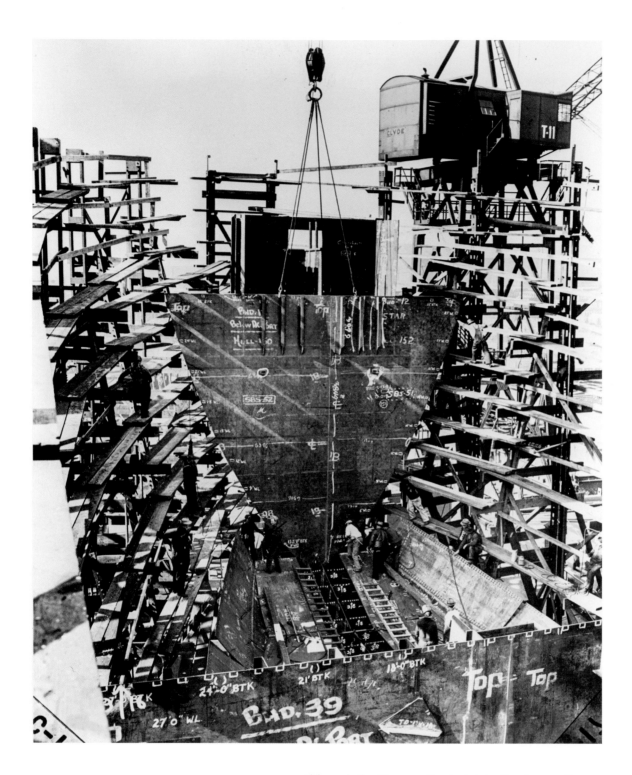

Although the Roosevelt administration began the process of creating the social welfare system, those efforts were only partially instituted, and controversy remains about their short-term impact in alleviating the effects of the Great Depression. It was World War II, even before America's entry into the conflict in 1941, that pulled the economy out of the doldrums. The war, and the tremendous boost provided by government spending and contracting, confirmed the advent of the activist state, involved in issues ranging from public welfare to the production and allocation of essential goods. Wartime output fueled a tremendous economic boom that would last, with occasional fluctuations, well into the late 1960s. It was the period of big industrial production, as

factories ramped up to make what the armed forces required; emblematic of the frenzied pace of industry was the show-stopping construction and launch of a "Liberty Ship" (a cargo vessel built on a standardized design) in four and a half days (fig. 1.12). As the United States became the "Arsenal of Democracy," and especially after Pearl Harbor, the impetus for laborers to work hard for the national purpose was driven by genuine patriotic feeling backed by publicity campaigns at all levels of government and society. In compensation for being security conscious ("Loose Lips Sink Ships") and frugal ("Is This Trip Necessary?"), workers were heroicized as essential to the war effort.[22]

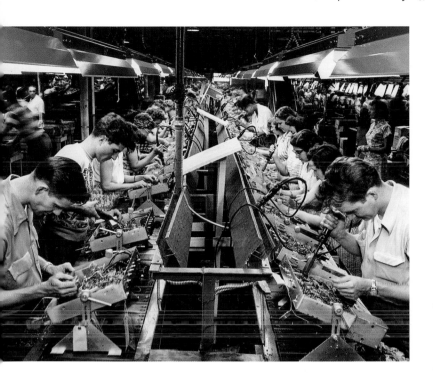

This was especially true of the women who entered the industrial workforce, either replacing men who had joined the military or to meet the strain of expanded production on the labor market. The result of this influx was a revolution in mores and gender roles. Pictorially, women were given equal status to men as powerful individuals. Indeed, traditional models of femininity were jettisoned due to the practical and ideological demands of the workplace. If women wore trousers or jumpsuits in the factories, they also were now shown flexing their muscles, as in the iconic figure of "Rosie the Riveter." Norman Rockwell's 1943 *Saturday Evening Post* cover on this theme mildly satirized the gender bending that was going on—and the anxieties it provoked—by creating an outsize figure, begrimed by the effort of her labor. Rockwell's "Rosie" has muscles that bulge out of her unisex coveralls and sits with a look of superiority as she eats her lunchtime sandwich, a rivet gun aggressively positioned across her lap. The image of Rosie is toned down in J. Howard Miller's more familiar *We Can Do It!* poster (cat. 49), where the woman is cleaned up and posed less aggressively, although she still famously flexes for the viewer, matching her bicep to her stern gaze. Male workers needed no such makeovers, of course, but they shared in the celebration of the war worker. Ben Shahn, always an interested observer of the working classes and the common people, made his *Welders* (cat. 51) into anonymous but protean figures manning the war effort.[23]

The worker in J. C. Leyendecker's *Labor Day* (cat. 54) sits on top of the world and showed the labor movement at its twentieth-century apogee. (Curiously, this work looks very much like Rockwell's Rosie; Leyendecker must have known the earlier image.) Working-class households were flush with cash through the combination of increased pay and reduced spending during the war; saving money was at a high in this period. The line between the working class and the middle class was dissolving, at least in material terms. The "bread-and-butter" strategy of the unions—which focused on wages and hours and not on ideological issues or even politics—seemed to pay dividends (fig. 1.13). But labor was actually at the dawn of a long decline precipitated by a combination of shortsighted (or even corrupt) union leadership, changes in the economy, and a sustained conservative counterattack, lasting decades, on the hard-won principles of union representation and collective bargaining. In 1950, union

FIG. 1.13
Assembly Line at RCA Victor Television Factory by an unidentified photographer, gelatin silver print on RC paper, ca. 1954. Michael D. O'Hara RCA Marketing Archives, Indiana Historical Society, Indianapolis

THE FACE OF LABOR

membership was 34 percent of the labor force; by 2000, it had fallen to 9 percent (and the decline has continued into the second decade of the twenty-first century).[24]

As the economy's center of gravity shifted southwest, and with increased competition from overseas, the old industrial base of the United States began to dissolve, losing both market share for its products and jobs for laborers. Other factors, such as automation, also figured in the declining population of industrial workers. The old "spine" of American industrialism—which had stretched from Lowell through the cities serviced by the Erie Canal to Michigan, Ohio, and Illinois—began to attrite, declining physically and demographically; the area became known as the Rust Belt, a term coined in the 1980s. Photographs of cityscapes served to document the region's decline (which seemed irretrievable in the 1970s) rather than calling attention to social and political action, as they had during the Progressive Era. These images became so visually dominant that the term "ruin porn" was applied to them early in the twenty-first century (fig. 1.14). In this social climate, the heroic worker disappeared. Instead, images of the working class were shot through with pathos and sadness, documents of loss and regret as jobs disappeared. As the bard of the working class, Bruce Springsteen, sang, "They say those jobs are going boys / and they ain't coming back." The long visual trajectory of the working class had arced from the empowered artisan Paul Revere to the marginalized, vulnerable fast-food worker (fig. 1.15 and cat. 71) and the piecework laborer in the "gig economy."[25]

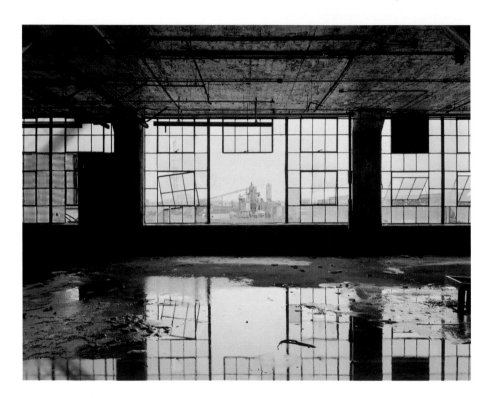

In his book of essays on portraiture, John Berger wrote that it is no longer possible for the bourgeoisie to be the subject of portraits. Berger, who retained his astringent Marxist interpretation of the connection between the economy and culture, meant that in the twenty-first century, the middle class has replicated the loss of power and autonomy that the working class suffered in the previous century. The bourgeoisie has become a dependent class as well, incapable of the agency that permitted it to depict itself in portraiture, especially during its heroic nineteenth century in the West. As with the working class, the middle class has become an object of scrutiny. Yet as we have seen, Berger's conclusion is too rigidly drawn and exclusionary. Although the working class only briefly held enough power to commission portraits and control its image on its own terms, the personification of that class during the nineteenth and twentieth centuries was a continuous part of the practice of fine artists due to the drama of industrialization (and then the pathos of deindustrialization.) These works, from Copley to Homer to Hine to Richard Avedon (see cat. 64), put faces to the economic history of the United States, serving as documents about the working world

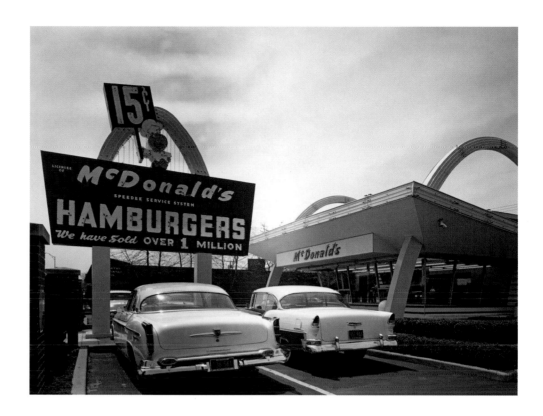

and assertions of presence and even resistance. Portraits of working people, as this book and exhibition demonstrate, have existed in an indeterminate space between history and genre painting. While never fully implicated in the traditional mechanisms of portrait painting, pictures of workers expanded portrait painting from privileged to ordinary people. Far from being acts of intrusion or cultural appropriation, these portrayals were created out of an engaged sympathy with their subjects and their world of work.

FIG. 1.15
McDonald's Store #1 Located West of Chicago, Illinois, by Carol M. Highsmith (born 1946), reproduced from original color transparency, 1984 or later. Carol M. Highsmith Archive, Prints and Photographs Division, Library of Congress, Washington, D.C.

Notes

1 "The function of portrait painting was to understand and idealise a chosen social role of the sitter. . . . The satisfaction of having one's portrait painted was the satisfaction of being personally recognized and *confirmed in one's position.*" John Berger, "No More Portraits," *New Society* 10 (1967): 164.

2 T. H. Breen, "The Meaning of 'Likeness': American Painting in an Eighteenth-Century Consumer Society," *Word and Image* 6 (October–December 1990): 325–50; Ellen Hickey Grayson, "Towards a New Understanding of the Aesthetics of 'Folk' Portraits," in *Painting and Portrait Making in the American Northeast*, ed. Peter Benes and Jane Montague Benes, Dublin Seminar for New England Folklife Annual Proceedings, June 24–26, 1994 (Boston: Boston University, 1995), 217–34.

3 This discussion of Charles Willson Peale and the siting of his career in the emergent American republic is derived from my *Charles Willson Peale: Art and Selfhood in the Early Republic* (Berkeley: University of California Press, 2004), chaps. 1 and 2.

4 Susan Rather, "Carpenter, Tailor, Shoemaker, Artist: Copley and Portrait Painting around 1770," *Art Bulletin* 79, no. 2 (June 1997): 269–90; see also Ethan W. Lasser, "Selling Silver: The Business of Copley's Revere," *American Art* 26, no. 3 (Fall 2012): 26–43. The interpretation that the American Revolution was conservative derives from the work of Bernard Bailyn, *Ideological Origins of the American Revolution* (Cambridge, MA: Harvard University Press, 1967).

5 This split occurred not only because the economy was gathering pace and industrial concentration was beginning to occur but also because social mobility was leading to a schism in the artisanal class. As Lasser's "Selling Silver" and my own work on Peale demonstrate, some skilled workers were moving into the middle class, becoming businessmen and entrepreneurs. Pat Lyon is a more complicated case because the portrait depicts someone in the guise of a working man, borrowing the "virtue" that accrued to the honest toiler. The catalogue of the Pennsylvania Academy of the Fine Arts contains the biographical details of Lyon's portrayal: www.pafa.org/collection/pat-lyon-forge.

6 See www.pafa.org/collection/pat-lyon-forge. Dress as a marker of status is a voluminous subject; comparatively little has been done on the symbolic aspects of artisanal or working-class clothing. My interpretation derives from my study of Walt Whitman and especially the frontispiece portrait of the poet in the first edition of *Leaves of Grass* (1855), which shows him as "one of the roughs." The way informality could, ironically, be formalized to mark off status is expertly treated by Brandon Brame Fortune, "'Studious Men Are Always Painted in Gowns': Charles Willson Peale's *Benjamin Rush* and the Question of Banyans in Eighteenth-Century Anglo-American Portraiture," *Dress* 29 (2002): 27–40.

7 The source for the Jacksonian urban working class and the Bowery "B'hoy" is Sean Wilentz, *Chants Democratic: New York City and the Rise of the American Working Class, 1788–1850* (New York: Oxford University Press, 1984).

8 The growth of industrialization is a major field in American economic historiography; still useful in tracing its basic parameters is George Rogers Taylor, *The Transportation Revolution, 1815–1860* (New York: Rinehart, 1951). John F. Kasson's argument, in his *Civilizing the Machine: Technology and Republican Values in America, 1776–1900* (New York: Grossman, 1976), derives from the early American studies movement, especially Leo Marx's classic *The Machine in the Garden: Technology and the Pastoral Ideal in America* (New York: Oxford University Press, 1964). The misattribution of Homer's *Old Mill (The Morning Bell)* is discussed in Nicolai Cikovsky Jr., Franklin Kelly, et al., *Winslow Homer* (Washington, DC: National Gallery of Art; New Haven, CT: Yale University Press, 1995), 92.

9 Marx, *Machine in the Garden*; the Civil War and nostalgia, escapism, and pastoral evasion are surveyed by Eleanor Jones Harvey, *The Civil War and American Art* (New Haven, CT: Yale University Press, 2012), especially chap. 1, "Landscapes and the Metaphorical War."

10 The modern historiography on African American slavery, a field that began to take shape in the late 1960s, has been one of the great landmarks in the advancement of knowledge in American history. Curiously, there has not been a great deal of scholarship on the day-to-day work regimen of the slaves, perhaps because the essentials of that labor are assumed to be widely known; my conclusion, for what it is worth, is that both the work and the day-to-day routine (excluding the wider horrors of whipping, physical abuse, and the breakup of families and communities) were much worse than we have imagined. Stanley Elkins, *Slavery: A Problem in American Institutional and Intellectual Life* (Chicago: University of Chicago Press, 1959), was provocative and controversial, but his depiction of the slave plantation as a "total institution" had heuristic value and sparked a counterargument through the examination of slave culture, especially religion. Kenneth Stampp, *The Peculiar Institution: Slavery in the Ante-Bellum South* (New York: Vintage, 1956), remains the best "structural" study of the contours of American slavery. Eugene D. Genovese, *Roll, Jordan, Roll: The World the Slaves Made* (New York: Vintage, 1976), reoriented the debate toward African American agency.

My examination of the Gittings family group portrait by Charles Willson Peale is in Ward, *Charles Willson Peale*, 58–60, 206. The discussion of Peter (formerly identified as Gordon) is based on curatorial files at the Smithsonian National Portrait Gallery; the gallery owns several generations of Peter imagery, including the iconic photograph from which print versions derived. For the new identification of the sitter's name, see Bruce Laurie, "The 'Chaotic Freedom' of Civil War Louisiana: The Origins of an Iconic Image," *Massachusetts Review* 2, no. 1 (November 2016).

11 As with industrialization, slavery, and other large areas under discussion here, the literature

on photography and culture is impossibly large. For a study that links photography specifically with American democracy in the cultural sphere, see Ed Folsom, *Walt Whitman's Native Representations* (Cambridge and New York: Cambridge University Press, 1997); for a provocative study about how photography simultaneously expanded the visual field but also restricted the scope of action, making us all observers/voyeurs, see Susan Sontag, *On Photography* (New York: Penguin, 1977).

12 Allan Sekula, "The Body and the Archive," *October* 39 (Winter 1986): 3–64, engages these questions.

13 My thoughts on Lincoln, photography, and making himself "visible" as part of the struggle for social mobility are in "'Vaulting Ambition': Poetry, Photography, and Lincoln's Self-Fashioning," *PN Review* 188 (July–August 2009): 45–49.

14 The newsboy became an archetypical feature in the social realist painting of the late nineteenth century; see his appearance especially in the work of George Bellows. For Bellows's image of Jimmy Flannigan in *The Newsboy*, see www.brooklynmuseum.org/opencollection/ objects/1266.

15 For Hine's own views on photography and social reform, see his "Social Photography," reprinted in Alan Trachtenberg, ed., *Classic Essays on Photography* (New Haven, CT: Leete's Island Books, 1980), 109–14; see also Alexander Nemerov, *Soulmaker: The Times of Louis Hine* (Princeton, NJ: Princeton University Press, 2016).

16 The first history of the labor movement was by John R. Commons et al., *History of Labour in the United States*, 4 vols. (New York: MacMillan, 1918–35). The modern version is Irving Bernstein's trilogy *A History of the American Worker* (Boston: Houghton Mifflin, 1960–85).

17 Laura Hapke, *Labor's Canvas: American Working-Class History and the WPA Art of the 1930s* (Newcastle, UK: Cambridge Scholars Publishing, 2008). Diego Rivera's mural at Rockefeller Center is a notorious episode in American art and political history, details of which can be found in every biography of the artist. See also Derek Jones, *Censorship: A World Encyclopedia* (London and Chicago: Fitzroy Dearborn Publishers, 2011), s.v. "Murals."

18 An accessible discussion and synthesis of the circumstances—historical and artistic—of the "Migrant Mother" image is on the Library of Congress website, www.loc.gov/rr/print/ list/128_migm.html; see also Linda Gordon, *Dorothea Lange: A Life beyond Limits* (New York: W. W. Norton, 2009); Don Nardo, *Migrant Mother: How a Photograph Defined the Great Depression* (Mankato, MN: Compass Point Books, 2011).

19 The historiography of African Americans after slavery has now become a subject on a par with the historiography of antebellum slavery. Much of this work emphasizes the continuity of oppression as slavery was replaced by other coercive forms of labor. However, African American resistance, including the commemoration of the history of the freed people, has also been covered; see Steven Hahn, *A Nation under Our Feet: Black Political Struggles in the Rural South from Slavery to the Great Migration* (New York: Oxford University Press, 2005); Klare Scarborough, ed., *Elizabeth Catlett: Art for Social Justice* (Philadelphia: LaSalle University Art Museum, 2015); Ruth Fine et al., *The Art of Romare Bearden* (Washington, DC, and New York: National Gallery of Art, in association with Abrams, 2003); and Elizabeth Hutton Turner et al., *Jacob Lawrence: The Migration Series* (Washington, DC: Rappahannock Press, 1993).

20 On Lindbergh, technology, and the spirit of Western individualism, see John William Ward, "The Meaning of Lindbergh's Flight," in *Red, White, and Blue: Men, Books, and Ideas in American History* (New York: Oxford University Press, 1967). For the beginnings of California in the twentieth century, including Hollywood, see Kevin Starr, *Material Dreams: Southern California through the 1920s* (New York: Oxford University Press, 1990); that volume is part of Starr's multivolume history of California, *Americans and the California Dream* (New York: Oxford University Press, 1973–2009), one of the great achievements in American historiography and popular culture.

21 Don Mitchell, *The Lie of the Land: Migrant Workers and the California Landscape* (Minneapolis: University of Minnesota Press, 1996). On Asian migration to California, see Kevin Starr, *Americans and the California Dream, 1850–1915* (New York: Oxford University Press, 1973); and Starr on both migrant labor and the Asian American population, including during World War II, throughout the histories in the volumes that make up his *Americans and the California Dream*. Another strand in the history of labor that has recently been explored by historians of both the working class and the law is the use of convict labor in large-scale agricultural production; see Robert Perkinson, *Texas Tough: The Rise of America's Prison Empire* (New York: Metropolitan Books, 2010).

22 David M. Kennedy, *Freedom from Fear: The American People in Depression and War, 1929–1945*, Oxford History of the United States 9 (New York: Oxford University Press, 1999), 321–72.

23 Donna B. Knaff, *Beyond Rosie the Riveter: Women of World War II in American Popular Graphic Art* (Lawrence: University Press of Kansas, 2012).

24 David Halberstam, *The Fifties* (New York: Villard Grand, 1993); James T. Patterson, *Great Expectations: The United States, 1945–74* (New York: Oxford University Press, 1999).

25 It's not clear who coined the term "ruin porn." The "Rust Belt" arose as a term to describe the geographical line of America's first and second industrializations, from the cotton mills north of Boston, the New England manufactories (Colt Firearms in Hartford, for instance), and then along the Erie Canal (opened 1825) to the Old Northwest, which included the twentieth century's megaindustrial city, Detroit. For the aesthetic treatment of this collapsed industrial base, see www.huffingtonpost.com/news/ detroit-ruin-porn/.

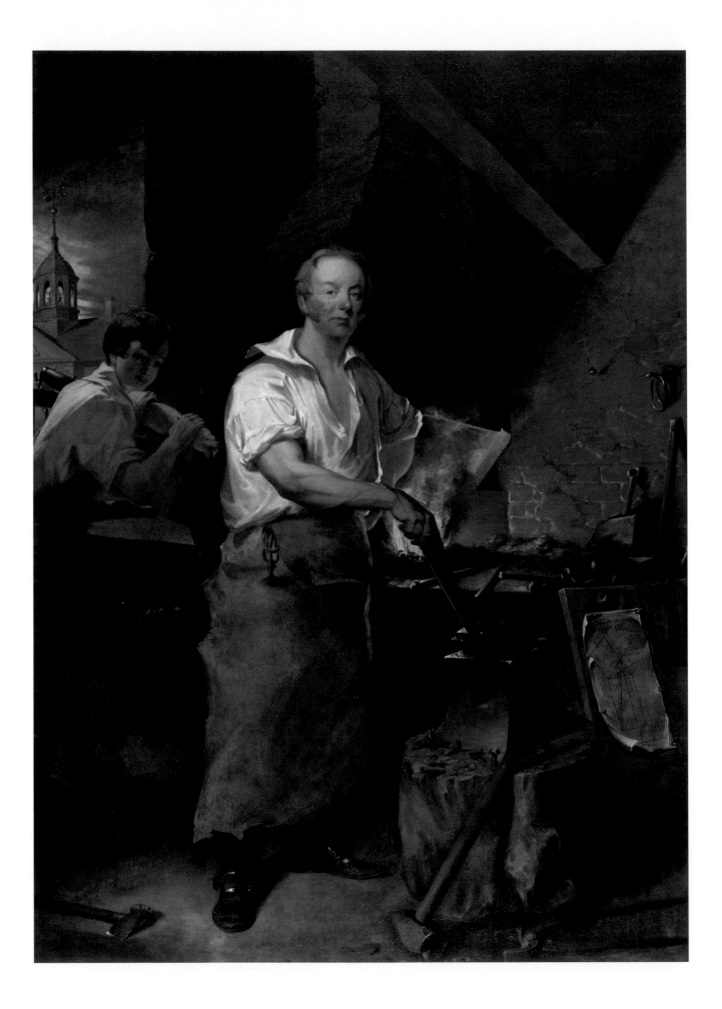

UNIT AND GROSS

PICTURING INDIVIDUAL WORKERS AND COLLECTIVE LABOR

John Fagg

PAT LYON STANDS IN HIS APRON and polished shoes commanding the space of his smithy and of John Neagle's *Pat Lyon at the Forge*, both the 1826 original and the version he painted in 1829 (cat. 2). The work is an assertion of self-made manhood wrought from toil and iron; of open-shirted, brawny-armed masculinity; and of a workingman's pride in having himself portrayed. The right hand that puts hammer to anvil is as gently assured in its grip as the steady gaze that meets the viewer's eye. Lyon's weight rests on those two planted feet and just a little on his tools.

In the decade after this picture was made, at the close of his speech "The American Scholar" (1837), Ralph Waldo Emerson asked, "Is it not the chief disgrace in the world, not to be an unit;—not to be reckoned one character;—not to yield that peculiar fruit which each man was created to bear, but to be reckoned in the gross?"[1] Stooping, throwing an uncertain glance, leaning awkwardly on a beam, the figure of the apprentice to Lyon's right and rear is in all kinds of ways subservient. He may move on one day to become his own master, but there is no sense that these two are in a shared and equivalent enterprise. With its defiant inclusion of Philadelphia's Walnut Street Jail, where as a young man Lyon had been wrongfully incarcerated, the painting is a collaborative narration and performance of an individual's struggle and rise to late-life mastery. It declares an equivalence to portraits such as those made by Neagle around the same time of the Philadelphia lawyer John Kintzing Kane (fig. 2.1) and the British architect John Haviland. But whereas these men hold books and pens as symbols of the intellectual endeavors that have elevated them to a status that demanded commemoration by a fashionable portrait painter, the Scottish-born Lyon proudly—and unusually among sitters in this period—binds his identity to manual labor. "I want you to paint me at work at my anvil," he told Neagle, "with my sleeves rolled up and a leather apron on."[2]

Inspired by Emerson's call for individual expression but also by the interconnectedness of the mass or crowd or gross felt on the Brooklyn ferry or in bustling city streets or when surveying laborers at abundant harvest, Walt Whitman, in the notebook dated 1847 that over a number of years would become *Leaves of Grass*, declared:

Pat Lyon at the Forge by John Neagle (cat. 2, p. 67)

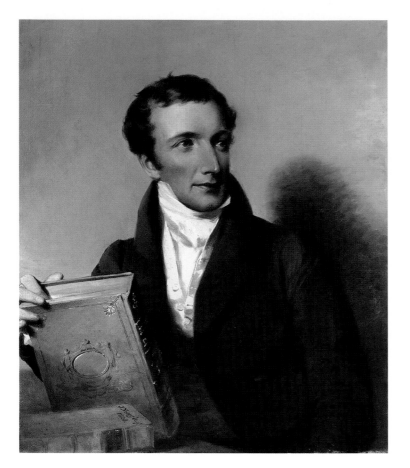

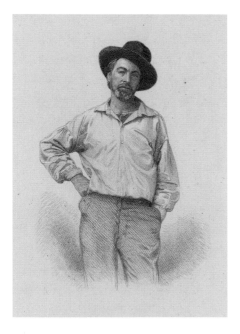

"I will not descend among professors and capitalists,—I will turn up the ends of my trowsers around my boots, and my cuffs back from my wrists and go with drivers and boatmen and men that catch fish or work in fields. I know they are sublime."[3] The frontispiece engraving for the first edition of *Leaves of Grass* (fig. 2.2) finds the poet in the open-shirted, cocksure stance of the self-possessed laborer. These acts of identification with the working class presage the complex questions of individuality and collectivity worked through in Whitman's epic poem.

Similar questions arise in antebellum genre paintings. If Pat Lyon is assured, even complacent, in his standing as a unit, the men who loaf and make music and dance as they drift down the Missouri River in *The Jolly Flatboatmen* by George Caleb Bingham (fig. 2.3) have surely been "reckoned in the gross." Where Lyon and his tools form an insular, balanced tripod, the messy sprawl of men's bodies here overlap and intersect to compose, with the deck of their boat as its base, a neat pyramid, a many-bodied unit, a compound noun, a collective identity: *The Jolly Flatboatmen*. Commonalities in dress and disposition, together with the way that several of the men's faces are notably obscured, emphasize the anonymity of Bingham's subjects, who seem less studies in individual character than in the type of the Missouri boatman. The figure to the right who stares out from the canvas is in various ways set apart from the mass of men—though still teasingly connected to them by the tip of the peak of his cap. The presentation of his face, which exemplifies what art historian David Peters Corbett has termed the "frontal" quality of Bingham's river scenes, together with the powerfully individuated presence of the fellow who dances so freely with hair and shirt flowing at the apex of the pyramid, gives cause to think of this painting as containing portraits.[4] Bingham elevated or annexed these two individuals from their party.

In stranger ways, too, boatmen and other workers were individuated, elevated, and made heroes in antebellum America, as in the folklore that grew around Mike Fink, a larger-than-life "Alligator Horse" boatman who became a repository for all the anecdotes and tall tales of the riverine frontiers.[5] Like the later legendary north-country lumberjack Paul Bunyan, Mike Fink could work, eat, and fight prodigiously. One function of such stories was to reconcile the great collective labors of the frontier with a culture keen to celebrate individual rise and achievement.

The tensions and questions that emerged from this nexus of antebellum painting, philosophy, poetry, and mythmaking would occupy American images of labor over the subsequent century and more. The individual against the mass; the rags-to-riches rise or the strivings of a class; work as heroic, and work as banal: these oppositions map to the difference in kind between Neagle's and Bingham's paintings. Neagle's *Pat Lyon at the Forge* is unique among the works in this exhibition in that it adheres so closely

to the paradigm of conventional portraiture exemplified by his *John Kintzing Kane*: it depicts in oil on canvas a sitter who commissioned and collaborated in the creation of a work that represents him and bears his name. As this was an opportunity afforded to the few, a survey of the portrayal of American workers must make use of many other modes of picture making. Portrait daguerreotypes and then photographs provided an affordable option for workers who wished to have themselves portrayed (see David C. Ward's essay, pages 22–24, for more on this point), but portraitlike images occur also in ethnographic and documentary photography; paintings, photographs, and illustrations for advertising and propaganda; and genre paintings like Bingham's. The latter is a complex and contested form—as is apparent even in the awkwardness of a genre called *genre*—that tends to be glossed as the painting of everyday life.[6] Such works thicken out and complicate the portrait record of American labor.

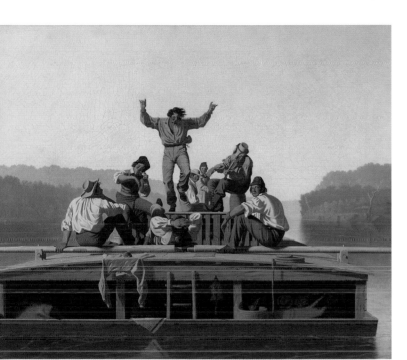

Bingham started out as an itinerant portrait painter in Missouri. It was only after he spent time studying and viewing other painters' work in Washington, D.C., that he began the paintings of the 1840s for which he is now best known and that take as their subject Missouri's state politics and Missouri River life, as depicted in *The Jolly Flatboatmen*. His flatboatmen and fur traders seem the product of long observation and of the artist's willingness to, like Whitman, roll up his "trowsers" and immerse himself in their way of life. Bingham's beautiful sketchbooks contain numerous studies of the tasks, bodies, attitudes, and attire of individual figures that he then combined to create scenes of sociability and shared enterprise.[7] That process emphasizes the distance between Bingham's genre work and the more individuated portrait making with which he began.

Eastman Johnson, like Bingham, moved between portraiture and genre painting over the course of his long career. His early *Corn Husking* from 1860 (fig. 2.4), like *The Jolly Flatboatmen*, shows a group gathered in shared enterprise. Johnson's painting is, like Bingham's and so many other American genre paintings of the mid-nineteenth century, imbued with a golden-hued nostalgia, a sense of a serene world passing before the painter's eyes, of work in a preindustrial idyll. But it is not romantic in quite the way of *The Jolly Flatboatmen*. Where Bingham set carefree men in fresh shirts out at venture and at leisure in the expansive landscapes of frontier myth, Johnson offered the contained, domestic setting of the barn and yard. Three generations—three men, a woman, and a little girl—are joined in a long, laborious task. The little girl watches, and the young man who has just laid down his gun and the two game birds he shot with it pauses to talk to the woman, but there is little sense of rest or leisure here. Where nineteenth-century American genre paintings, from William Sidney Mount's *Farmer's Nooning* (1836) to John George Brown's *The Longshoremen's Noon* (cat. 17), have a canny habit of catching workers at rest, this group sweats away at the painstaking, time-consuming husking and lugging of corn.

From opposite top:

FIG. 2.1
John Kintzing Kane by John Neagle (1796–1865), oil on canvas, 1828. Princeton University Art Museum, Princeton, N.J.; Museum purchase (y1945-207)

FIG. 2.2
Walt Whitman, frontispiece to *Leaves of Grass* (1855 edition). National Portrait Gallery, Smithsonian Institution

FIG. 2.3
The Jolly Flatboatmen by George Caleb Bingham (1811–1879), oil on canvas, 1846. National Gallery of Art, Washington, D.C.; Patrons' Permanent Fund (2015.18.1)

Like Johnson's large-scale celebrations of Nantucket husking bees from the mid-1870s, this is an image of collective labor. Johnson's standing figure is as frontal, and as central to the composition, as Bingham's dancer. But he seems weighed down in ways that man is not, tied as he is by familial bonds and the demands of a multistage, multiperson process. A contemporary commentator described him as "a sturdy young farmer . . . bearing on his shoulder a basket full of the golden ears."[8] While he certainly has the heft to meet the task, he does seem, with his downcast eyes and grubby overalls, beleaguered. If cropped against the dark backdrop of the barn interior, this figure could stand as a representation of an individual worker, but that would go against the spirit of Johnson's painting, in which so much calls him back to and insists upon his relationship with others.[9]

In this, he differs from the young man Winslow Homer pictured in *Haymaking* some four years later (cat. 10). Homer made numerous studies portraying workers alone—this painting, *Man with a Scythe* (1867), and *The Return of the Gleaner* (1867)—and in groups marked by complex social interactions, as in *Harper's Monthly* illustrations such as *New England Factory Life—"Bell-Time"* (cat. 12), and genre paintings including *Old Mill (The Morning Bell)* (cat. 15).[10] His young haymaker, torn overalls turned up and shirt cuffs turned back, is a vision of Whitman's sublime worker, blessed by the sun of a bright New England day, his eyes closed as he swings his pitchfork. There are signs of work and a wider process here: a haycock some distance back up the pasture indicates the scale and duration of his task; other hands have cut the grass and will later bring the hay to the barn as part of the year-long cycle of agrarian labor; toil registers in the steep slope of the land that even the trees seem to struggle against. But, with his beatific expression encircled by the broad brim of his straw hat, he withholds something of himself from his task, some selfhood interior yet present to Homer and his viewers.

In its transcendence, in its elevation of this young worker seen from below so as to stand up above the land and out against the sky, this American scene takes on some of the reverence for rural labor found in the French peasant painting that had already established its transatlantic popularity when Homer made *Haymaking*.[11] As art historian Randall Griffin writes in a study partly concerned with the American artistic identity of Homer and his Gilded Age contemporaries Thomas Eakins and Thomas Anshutz, Homer's "monumental farmwomen and, later, English fisherwomen clearly owe a debt to the popular pictures of Jules Breton, whose peasant women are similarly invested with heroic purpose."[12] In slightly later works such as *Cotton Pickers* (fig. 2.5), as in *Haymaking*, Homer shared some of the pictorial strategies with which Breton and Jean-François Millet made rural laborers iconic.

Griffin suggests that where "*Cotton Pickers*' message of hopelessness is mitigated by its figures' Millet-like monumentality," Anshutz's *The Way They Live* (fig. 2.6), made three years later, offers a far bleaker vision.[13] While Anshutz, in another of the series of paintings he made around Wheeling, West Virginia, had contributed to the history of depicting workers at rest with *The Ironworkers' Noontime* (1880), *The Way They Live* shows hard, harsh labor. Like *Cotton Pickers*, it concerns itself with the lives of African Americans in the South and acknowledges that emancipation and Reconstruction had not diminished the toil and impoverishment of the daily round. The *They* in the title hints at the acts of typing, othering, and distancing that are so much a part of the American genre tradition. While the painting does not render the woman and children in the crude stereotyping that shaped many white artists' depictions of African Americans in this period, neither does it see these figures as other than types or representatives of a particular condition. Anshutz did not seek to individuate them in the way that Homer imbued his *Cotton Pickers* with signs of agency and character.

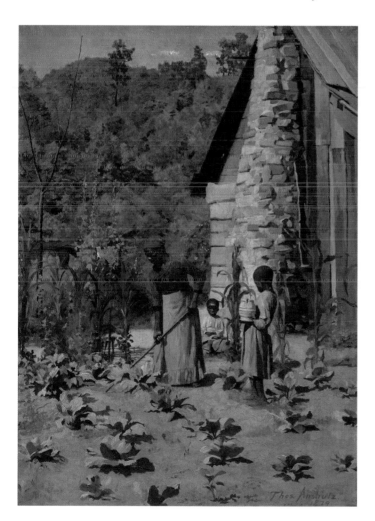

FIG. 2.6
The Way They Live by Thomas P. Anshutz
(1851–1912), oil on canvas, 1879. The
Metropolitan Museum of Art, New York City;
Morris K. Jesup Fund, 1940 (40.40)

Whereas some interpretations of Homer's painting glimpse hope in the way the women's bodies and thoughts seem oriented away from their current circumstances, Anshutz's confined scene suggests little prospect or world beyond subsistence farming in poor soil behind a dilapidated shack.

These differing approaches to picturing African American working women in the 1870s once again point to the contrast between treating workers, as Homer arguably did, as portrait subjects or depicting them, like Anshutz, within the genre tradition: between, that is, portraiture's emphasis on individuated character and investment in a particular life story and the genre's use of stock types intended to stand for common experience.

In Pat Lyon's lifetime, in Whitman's eulogies to "Blacksmiths with grimed and hairy chests," and in twentieth- and twenty-first-century nostalgic reveries, the artisan labor of the forge conferred cultural and social status.[14] Self-employment enabled Lyon to rise to the point where he could engage John Neagle's services. Other workers and other kinds of work lacked this status and access to aggrandizing portraiture but were pictured instead in genre painting's effort to record and interpret everyday life. Anshutz's woman seems less heroic, less a part of history, less alive with possibility than Homer's women in part because the domestic sphere of yard work and housework was not valorized or made iconic in the way that fieldwork was. In *The Jolly Washerwoman* (cat. 7) and a long series of similarly jubilant paintings, Lilly Martin Spencer depicted forms of invisible, overlooked, culturally undervalued everyday labor.[15] Despite this, the domestic chores in these paintings tend to be conducted with a smile and a sense of play, as in her 1856 canvas *Kiss Me and You'll Kiss the 'Lasses*. In both of these works, Spencer suggests a degree

41

of wealth, excess, or abundance in the bright, fine garments the washerwoman launders and in the array of fruit and other produce to be prepared alongside the molasses. Spencer's paintings complicate the issue of what it is to portray a worker: while its title and scruffy "below-stairs" setting clearly identify the subject of *The Jolly Washerwoman* as a hired hand, the protagonist of *Kiss Me*, standing in fine clothes on a carpeted floor, is most likely the mistress of the house taking on a high-status domestic task. Is work conducted on this basis not still work? Are Mary Cassatt's numerous studies of maternal care from the years around 1900, or the later returns to this theme made in Alice Neel's mid-twentieth-century paintings of mothers breast-

feeding and providing other forms of nurture, not in a strong sense portraits of work and of workers, too?[16]

John Sloan concerned himself with women's work in a series of early-twentieth-century paintings that began with *Scrubwomen, Astor Library* (fig. 2.7) and featured several studies of women drying laundry on tenement roofs and fire escapes, including *A Woman's Work* (1912) and *Red Kimono on the Roof* (1912). Sloan's depictions of domestic labor were firmly located in the low genre painting tradition of Jan Steen and other seventeenth-century Dutch painters whose work he knew well, and they are marked by the earthiness and groundedness exemplified by the three foreground figures in *Scrubwomen, Astor Library*. One figure looks up from where she scrubs on hands and knees to share in some talk that that has provoked a varied reaction in her companions. Theirs are labors that Sloan had observed in detail, firsthand and over many days, as he sat in the Astor Library's South Hall reading room with his friend John Butler Yeats.

A 1909 profile of Sloan in *The Craftsman*—penned by another friend, Charles Wisner Barrell—notes that "the strong, heavy, patient figures of Millet's peasants have at times the immensity of Titans, so close are they to the great primal things of earth and of life," and thus contain "a sense of universality," while Sloan's art "shows no tendency to grasp human wretchedness in the mass, but rather to show here and there a detached bit of life which has the power of suggesting the whole turbid current."[17] The scrubwomen are, in their stature and foregroundedness—and, given that they are likely first- or second-generation immigrants from Europe, in their recent history, too—not wholly removed from Breton's and Millet's peasants, but Sloan resisted making them stand for anything other than themselves. There is a complexity to the range of emotions that play across the three women's faces that resists reduction or naming. They are neither simply jolly, like Spencer's washerwoman, nor stoical, nor heroic. Caught, as in so many genre representations of workers, in a moment of pause and seeming levity,

FIG. 2.7
Scrubwomen, Astor Library, by John Sloan (1871–1951), oil on canvas, ca. 1910–11. Munson-Williams-Proctor Arts Institute, Utica, N.Y.; Museum purchase (58.87)

THE SWEAT OF THEIR FACE

the scrubwomen have an ambiguous relationship to their work and to the appellation by which their employers, and Sloan and his viewers, knew them.

Some years Sloan's junior, but like him among the circle of painters who gathered around Robert Henri (see cat. 21) in New York City and were later dubbed the Ashcan School, George Bellows shared Sloan's concern with faces shaped by complex, irreducible character and bodies marked by the demands of work and contact with a harsh world. The Astor Library scrubwomen's bodies are strong and sturdy, contravening the era's idealized visions of womanhood but corresponding closely to the personal ideal of healthy, solid working-class bodies that Sloan praises again and again in his diaries from this period. One of the first paintings Bellows made after leaving Henri's classroom at the New York School of Art, *Nude, Miss Bentham* (1906), depicts the naked body of a working-class woman, with patches of red paint suggesting sore feet and raw knees, and with scrawny muscles likely built from manual labor. Signs of lives lived outdoors, of the absence of nurturing hands, and of the strength and damage accrued by young bodies through constant toil mark, too, Bellows's subsequent series of portrait studies of street children that includes *Frankie the Organ Boy* (1907), *Paddy Flannigan* (1908), and *The Newsboy* (cat. 23).

In so identifying the final sitter in this group, Bellows stepped into a long tradition that goes back at least to Henry Inman's 1841 contribution to the antebellum representation of American workers, *News Boy* (cat. 5). In Inman's day, the newsboy was something of a novelty, a recent addition to America's sidewalks following the advent of the penny press in the early 1830s. Other artists, including Pittsburgh's David Gilmore Blythe, took up the motif, but in the decades after the Civil War, the English-born genre painter John George Brown (see cat. 17) made the newsboy and his cousin the bootblack synonymous with his name. In 1885, *Puck* lampooned the repetitiveness of Brown's entries to the annual National Academy of Design exhibition with a cartoon consisting of an empty frame captioned, "J. G. B—n. Same as last year—fill in the blank with bootblacks to suit yourself."[18] The following decade, in an encomium to Brown that illuminates the contrast between his treatment of the subject and Bellows's, Nym Crinkle (the pen name of Andrew Carpenter Wheeler) explained that the viewer does not "detect in these urchins the dark side of their lives. For the most part Mr. Brown sees them in the sunshine. They are exuberant, sportive, reckless, mischievous, never vicious, deformed, or awry with an inheritance."[19] That list of traits delineates the parameters of an ossified type. The sense that Brown's street children were generic, fungible representatives of a sentimental vision of child labor was underscored in Crinkle's article—for which the artist provided original drawings and thus presumably

FIG. 2.8
Page of illustrations by John George Brown (1831–1913) from an article by Nym Crinkle, "The Arabs of New York," *Quarterly Illustrator* 2 (1894): 128. Smithsonian Libraries, Washington, D.C.

his tacit approval—by a page that reproduces nine paintings of these boys in a grid layout (fig. 2.8).

Bingham's flatboatmen, Spencer's houseworkers, and even Homer's fieldworkers risked becoming types of this kind. This was the danger in universalizing, in making paintings of workers that stand for something more than the individual subject, that Sloan and Bellows sought to avoid, with varying degrees of success. While not folkloric in the way of Mike Fink and Paul Bunyan, Brown's newsboys and bootblacks, like author Horatio Alger's contemporaneous matchbook-seller Ragged Dick, were, as art historian Martha Hoppin has noted, "upwardly striving entrepreneurs" and, as such, embodiments of the rags-to-riches myth.[20] Brown's boys lend themselves to use in this way when presented in isolation, as they are in the grid layout and as they were with increasingly frequency in canvases made toward the end of the artist's career. The painting *One of Mulligan's Guards*, included in the grid (at the right of the middle row), relates closely to a large multifigure work, *On Dress Parade* (1878), in which an

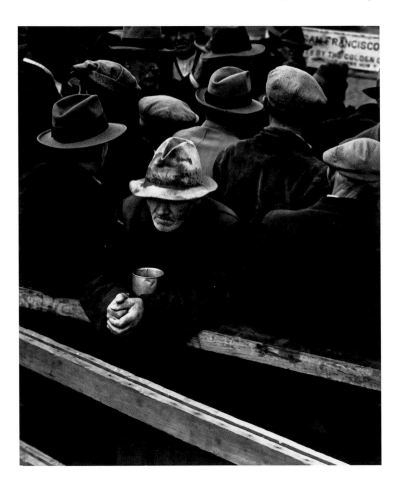

array of boys act out soldierly poses with brooms, sticks, and other improvisations. While certainly seen "in the sunshine," the specificity of this group's interactions—and Brown's references, traced by Hoppin, to songs, theater sketches, and children's games popular in 1870s New York—grounds its figures as representations not of myths or ideals but of a particular time and place.[21]

In the first decades of the twentieth century, Lewis Hine took up the subject—but also the moral imperative to look unflinchingly at the "dark side"—of newsboys and other child laborers in pioneering documentary photographs such as *Child Labor, c. 1908* (cat. 24). Here and in his explorations of industrial labor (see cats. 25, 27, 29, and 32), Hine reconsidered for a new era and in a new medium the questions of individual and collective identity in the portrayal of workers and so laid the groundwork for the expansion of documentary techniques and the explosion of worker imagery that took place in the 1930s. The Depression decade witnessed what cultural historian Michael Denning terms "the laboring of American culture," wherein the visual and verbal (and cinematic) representation of working people became a prominent feature of the cultural landscape.[22] Economic crisis led to reconsiderations of work and identity and to art that heightened the tensions and reframed the questions raised by the portrayal of American workers over the preceding century.

White Angel Breadline, San Francisco (fig. 2.9), among the first photographs Dorothea Lange made of workers caught in the grip of the Depression, provides a stark image of the individual in and apart from the mass, and it set in motion themes she would come to explore in a series of complex and committed documentary projects. As Geoff Dyer puts it, "Most of the people in the crowd have their backs to the camera.

The man in the centre has turned away, has, so to speak, turned his back on any idea of collective action, preferring instead to face the Langean truth of stoic resignation."[23] That stoicism, together with the extraordinary ability to frame compelling faces that recalls her earlier career as a commercial portraitist, recurs again and again in the pictures Lange made over the subsequent decade. Most obviously, these qualities shape her iconic photograph known as "Migrant Mother" (cat. 34). Florence Owens Thompson looks out from a face etched with the demands of mother work in the oppressive, makeshift conditions of a migratory labor camp with just enough grit and self-possession to come to personify a social crisis in a culture attuned to individuals' stories. "Migrant Mother" took on an iconicity and identity that, in the era's mass media and populist politics and in subsequent histories of the decade, transcended the more prosaic documentary aims communicated by Lange's original title for the work, *Destitute Pea Pickers in California. Mother of Seven Children. Age 32.* Thompson, in this formulation, was just one of many displaced workers.

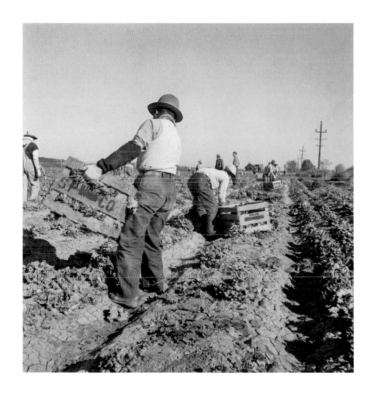

Many shots made by Lange and the other documentary photographers employed by the Farm Security Administration (FSA) frame and make iconic individual workers' faces. But they lose much of their meaning when uncoupled from the far larger archive that records anonymous and mass-scale labor and movement, as in Lange's *Stoop Labor in Cotton Field, San Joaquin Valley, California* (cat. 41), or the numerous photographs, such as her *Filipino Crew of Fifty-Five Boys Cutting and Loading Lettuce, Imperial Valley, California* (fig. 2.10), in which anonymous bodies bend in repeated gestures down a long row of crops or multiply out in some other many-handed task.[24] In the 1930s, genre painting and genre painting–like works—such as Ben Shahn's mural studies (see cat. 43) and the so-called Sunday Paintings that he derived from his photographs for the FSA and other agencies—continued to show labor as a communal process. And artists working in other, more stylized and graphic forms found new ways to express that perspective.

Elizabeth Olds—who worked with Shahn's wife, Bernarda Bryson Shahn, at the Works Progress Administration–Federal Art Project Graphic Arts Division in New York—developed an iconography of collective rather than individual labor. *Forging Axles* (fig. 2.11), one of a series of works made following Olds's 1937 visit to the Carnegie-Illinois steelworks at Homestead, Pennsylvania, shows a group of men engaged in a complex industrial process.[25] They are individuated to a point by their facial features and markers of age and race. But the sparse graphic style minimizes without eradicating that individuality, making it secondary to the wider process and the scale of the surrounding works. In an essay entitled "Prints for Mass Production," Olds argues for the collaborative artistic production of "picture textbooks." These "integrated visual images" would give the viewer "a fresh sense of how he lives, how he gets his water, gas, electricity, food. . . . All should be recorded so that both adults and students could become more keenly aware of the world in which

FIG. 2.10
Filipino Crew of Fifty-Five Boys Cutting and Loading Lettuce, Imperial Valley, California, by Dorothea Lange (1895–1965), reproduced from original nitrate negative, 1937. Prints and Photographs Division, Library of Congress, Washington, D.C.

UNIT AND GROSS

they live."[26] This is an art committed to everyday life and work and process. Olds's portrayal of labor downplays the role of the individual and resists the possibility of the worker who is isolated, individuated, or elevated from his or her surroundings to emphasize instead the interconnected and systemic nature of the modern world.

Sharing Olds's left-wing commitments but caught up too in the 1930s revival of interest in Americana and folklore, William Gropper explored other means of creating compelling visual images of workers while resisting the pitfalls of the heroic, iconic, or universalized individual. His 1938 studies for the mural *Construction of a Dam*, like Shahn's mural studies and Olds's steel mill series, show workers engaged in projects and processes of overwhelming scale. But Gropper also looked back for iconography and precedent to the similarly vast undertakings of the frontier and to the folkloric representation of larger-than-life figures who gave voice and body to multitudes of faceless, nameless boatmen, traders, lumberjacks, and laborers. Gropper's *American Folk Heroes* lithograph series and his 1946 lithograph *Folklore Map of America* feature Paul Bunyan, Mike Fink, Joe Magarac, John Henry, and others.[27] His *Mike Fink* (fig. 2.12) is bare chested and superhumanly muscular, with his head tipped back in full-bodied laughter while behind and beneath him three anonymous figures go about the workaday tasks of mooring and loading a flatboat.

Gropper knowingly articulated the myth processes by which Mike Fink comes to stand for all the anonymous toil of Southern boatmen, by which the portrayal of one worker becomes all workers and one unit is reckoned apart from but at the same time comes to represent the gross. Standing before John Neagle's *Pat Lyon at the Forge* and other portraits of workers similarly conceived, it is easy to miss the myth and see the image of self-possession and mastery, of the worker risen, as simply the story of one man's life.

FIG. 2.11
Forging Axles by Elizabeth Olds (1896–1991), lithograph, 1935–43. Metropolitan Museum of Art, New York City; gift of the Work Projects Administration, New York, 1943 (43.33.1110)

FIG. 2.12
Mike Fink by William Gropper (1897–1977), lithograph, not dated. Smithsonian American Art Museum, Washington, D.C.; gift of David Schiffer

Notes

1 Ralph Waldo Emerson, "The American Scholar" (1837), in *The Collected Works of Ralph Waldo Emerson*, vol. 1: *Nature, Addresses, and Lectures*, ed. Robert E. Spiller and Alfred R. Ferguson (Cambridge, MA: Belknap Press of Harvard University Press, 1971), 69.

2 Quoted in Laura Rigal, *The American Manufactory: Art, Labor, and the World of Things in the Early Republic* (Princeton, NJ: Princeton University Press, 2001), 181. This study provides detailed analysis and context regarding Lyon, his incarceration, and the complexities of worker identity in Neagle's painting (179–96).

3 Walt Whitman, "Notebook LC #80," 1847, Manuscript/Mixed Material, Library of Congress, Washington, DC, www.loc.gov/item/whitman.080. On the notebook and Whitman's evolving class identification, see Andrew Lawson, *Walt Whitman and the Class Struggle* (Iowa City: University of Iowa Press, 2006), 51–55.

4 David Peters Corbett, "The Face of Time: Facingness and Absorption in George Caleb Bingham's River Paintings," lecture given at Facing America: Viewing the Face in American Art and Visual Culture, a SAVAnT Symposium, Eccles Centre, British Library, London, July 10, 2015.

5 Michael R. Allen, *Western Rivermen, 1763–1861: Ohio and Mississippi Boatmen and the Myth of the Alligator Horse* (Baton Rouge: Louisiana State University Press, 1994), 9–14. On these folkloric laborers, see Susan Stewart, *On Longing: Narratives of the Miniature, the Gigantic, the Souvenir, the Collection* (Durham, NC: Duke University Press, 1984), 99–100.

6 See Elizabeth Johns, *American Genre Painting: The Politics of Everyday Life* (New Haven, CT: Yale University Press, 1991).

7 For recent commentary on Bingham's techniques, see Margaret Conrads et al., *Navigating the West: George Caleb Bingham and the River* (New Haven, CT: Yale University Press, 2014).

8 Quoted in Lee M. Edwards, *Domestic Bliss: Family Life in American Painting, 1840–1910* (Yonkers, NY: Hudson River Museum, 1986), 72.

9 Patricia Hills points to Johnson's resistance of caricature and typing and emphasis on "dignified country people engaged in chores on their own farms," in contrast to both earlier American genre painting and European peasant paintings, in *Eastman Johnson* (New York: Whitney Museum of American Art, 1972), 40.

10 On social interactions in Homer's *Old Mill (The Morning Bell)*, see Nicolai Cikovsky Jr., "Winslow Homer's (So-Called) 'Morning Bell,'" *American Art Journal* 29 (1998): 4–17; and Bryan Wolf, "The Labor of Seeing: Pragmatism, Ideology, and Gender in Winslow Homer's The Morning Bell," *Prospects* 17 (1992): 273–318.

11 The American patron William T. Walters commissioned Jules Breton's *The Close of the Day* (1865, Walters Museum) the year after Homer painted *Haymaking*. See Josephine Landback, "Breton's *The Song of the Lark*: A Transcultural American Icon," in *A Seamless Web: Transatlantic Art in the Nineteenth Century*, ed. Cheryll May (Newcastle: Cambridge Scholars Publishing, 2014), 40.

12 Randall C. Griffin, *Homer, Eakins, and Anshutz: The Search for American Identity in the Gilded Age* (University Park: Penn State University Press, 2004), 48.

13 Ibid., 65.

14 Walt Whitman, *Leaves of Grass* (Brooklyn: 1855), 20. *The Walt Whitman Archive*, ed. Ed Folsom and Kenneth M. Price, www.whitmanarchive.org. On Whitman's uncertain relationship to the qualities of personality and self-possession Lyon embodies, see David Haven Blake, *Walt Whitman and the Culture of Celebrity* (New Haven, CT: Yale University Press, 2006), 74–79.

15 See David M. Lubin, *Picturing a Nation: Art and Social Change in Nineteenth-Century America* (New Haven, CT: Yale University Press, 1994).

16 On Cassatt, see Anne Higonnet, *Pictures of Innocence: The History and Crisis of Ideal Childhood* (London: Thames and Hudson, 1998), 57–58; on Neel, see Denise Bauer, "Alice Neel's Portraits of Mother Work," *NWSA Journal* 14, no. 2 (summer 2002): 102–20.

17 Charles Wisner Barrell, "The Real Drama of the Slums, as Told in John Sloan's Etchings," *Craftsman* 15, no. 5 (February 1909): 559.

18 Quoted in Jennifer A. Greenhill, *Playing It Straight: Art and Humor in the Gilded Age* (Berkeley: University of California Press, 2012), 70. Greenhill points to ways in which Brown nuanced and broke with his formulae, particularly in multifigure works.

19 Nym Crinkle [Andrew Carpenter Wheeler], "The Arabs of New York," *Quarterly Illustrator* 2 (1894): 125–31.

20 Martha Hoppin, *The World of John George Brown* (Chesterfield, MA: Chameleon Books, 2010), 76.

21 Ibid., 150–51.

22 Michael Denning, *The Cultural Front: The Laboring of American Culture in the Twentieth Century* (New York: Verso, 1996), xvii, passim.

23 Geoff Dyer, *The Ongoing Moment* (New York: Vintage, 2007), 105.

24 On FSA photography as an institutionalized, collaborative, and archival project, see John Raeburn, *A Staggering Revolution: A Cultural History of Thirties Photography* (Chicago: University of Illinois Press, 2006), 143–93.

25 On Olds's "radical" and "more benign" images of labor in this period, see Helen Langa, *Radical Art: Printmaking and the Left in 1930s New York* (Berkeley: University of California Press, 2004), 26–27.

26 Elizabeth Olds, "Prints for Mass Production," in *The New Deal Art Projects: An Anthology of Memoirs*, ed. Francis V. O'Connor (Washington, DC: Smithsonian Institution, 1972), 144.

27 William Gropper, *William Gropper's America, Its Folklore*, Library of Congress, Washington, DC, accessed June 1, 2016, www.loc.gov/item/2011592193/.

UNIT AND GROSS

THE WORKER IN THE ART MUSEUM

Dorothy Moss

Dorothea Lange's photographs of poor peasants, desperate, trying to feed their families, trying to migrate to a better land, to California, were like the Chinese peasants. It doesn't make a difference to me if they were Irish, Mexican, or African American.... I felt the connection was profound, not just historically but personally.

—Hung Liu in *Hung Liu: American Exodus*
 (New York: Nancy Hoffman Gallery, 2016), 102

THE AMERICAN WORKER and the American art museum have a storied history. Viewing portrayals of workers through the lens of artist as worker reveals a relationship between the artist and subject often lacking in formal, commissioned portraits, where business and social dynamics may create a distance. In viewing portraits of workers as visualizations of shared experience and understanding, the questions that emerge are twofold: To what extent has the cultural status of workers and artists aligned over time? And how has the role of the art museum factored into broader perceptions of the cultural value of the American worker?

Exploring the relationships among the American art museum, the artist, and the worker reveals a depth of connections. An important thread that runs through artists' examinations of work and identity in portraiture is the use of appropriation, or quoting earlier artists' portrayals of laborers, to assert the artist's own identity as a cultural worker. Gordon Parks, Hung Liu, and Ramiro Gomez have used this method to address the invisibility of those workers and artists whose labor goes unappreciated or unrecognized. In the process, their portrayals acknowledge a history of workers' lack of agency and reclaim workers' humanity. By quoting source material created by mainstream artists—mainly white males—and reinventing and reimagining iconic images while metaphorically inserting their own stories into those images, they have recognized the shift in the relationship between the artist and the worker over time, both in the context of the work's institutional presentation and in terms of race, gender, and cultural affiliation.

Woman Cleaning Shower in Beverly Hills (after David Hockney's *Man Taking Shower in Beverly Hills*, 1964) by Ramiro Gomez (detail of cat. 70, p. 203)

In late-nineteenth-century America, when museums such as the Metropolitan Museum of Art, the Museum of Fine Arts, Boston, and the Philadelphia Museum of Art were still new and administrators and board members were defining their missions, workers were not always welcomed in these "sacred" cultural spaces. An incident at the Metropolitan Museum of Art in 1897, involving a plumber who entered the museum, incited "flaming headlines and startling pictorial protests."[1] The *New York Times* reported that the plumber, who was on a break from a job on Fifth Avenue, was asked to leave the building on the grounds that he was wearing overalls, which were considered offensive in the context of the museum.[2] The news of this episode spread across the country. One critic questioned whether the plumber had been asked to leave because he violated a clothing policy or because of his status as a laborer. According to the *Milwaukee Journal*, museum director Louis Palma di Cesnola claimed that in his seventeen years at the institution "not a single individual in overalls has been allowed to look at the pictures" and that "the rules forbid drunken or disorderly persons from being allowed in the museum, and that a man in working clothes is as bad as either."[3] In a biting call to action in the *Butte* (MT) *Weekly Miner*, an outraged writer commented: "The workman who desired to visit the museum is not charged with being dirty. There was not a word to the effect that he was not gentlemanly in his demeanor. The only crime which he committed was to wear overalls and to attempt to look upon the works of art, most of which were produced by men who wore homespun."[4] The writer continued, "The laboring men of the city of New York should make an example of General [di] Cesnola and his hair-brained subordinates. Any man so guilty of so gross a violation of the spirit of American institutions should be considered a political issue until his complete obliteration from official life is effected."[5]

This occurrence provides a picture of the uneasy relationship between the worker and the art museum at the end of the nineteenth century. It was an era in which mass reproduction raised new questions among the American public about the role of art in education and in the domestic and public spheres. It was also an important period in the development of American art, one that art historian and Smithsonian curator of prints Sylvester Rosa Koehler described in his 1886 publication *American Art* as "a period of awakening, of high hope, and of honest endeavor."[6]

Throughout the 1870s and 1880s, discussions about the role of the artist, the art museum, and the worker would concern museum officials and board members, who sought to achieve cultural and social improvement through education in museums. In the process of coming up with an effective strategy and in determining who would benefit from such an education, museum administrators contended with what historian Paul DiMaggio describes as the "tension between monopolization and hegemony; between exclusivity and legitimation."[7] In other words, they wanted to maintain cultural control while influencing broad audiences. As officials grew more comfortable with the use of museums as educational laboratories through the exhibition of "true" art, they began to place increasing emphasis on codes of behavior in the museum and on the importance of original artworks.[8]

The cultural distinction of the artist as worker in American industrial and post-industrial society is seen in art created in response to the changes in attitudes toward

authorship. As Julia Bryan-Wilson has pointed out, following Michael Baxandall's seminal work *Painting and Experience in Fifteenth-Century Italy* (1972), there has been a history of separation between craft and "true" labor in Western art since the Renaissance. At that time, the notion of the "author" of a work of art emerged, and objects that were created by hand were no longer attributed to anonymous workers but to the people who made them.[9]

American artists have identified with workers and at times organized labor since the late nineteenth century. The many groups and organizations that have formed over the years aligning artists with workers attest to this commitment. As Bryan-Wilson has described, examples persist of individual artists or organized groups of artists, often drawing on Marx, who have insisted that their work was a form of labor—whether following the craftsmanship model of William Morris and the Art Workers Guild that grew from it in 1884 or the later example of the Mexican muralists of the 1920s, who founded the Revolutionary Union of Technical Workers, Painters, and Sculptors.[10] In reaction to the Great Depression, the numerous artists who were influenced by socialist ideology and the labor movement organized themselves as cultural work-

ers, following the strategic tactics of the trade unions. By the summer of 1933, a small group of artists had formed the John Reed Club.[11] During that summer, the artists associated with the Works Progress Administration (WPA) identified with the laborers they depicted and created images that were not only about labor but also were easily relatable to laborers in narrative and form. The founding of the Artists' Union in the 1930s was key to artists' perception of themselves as workers. As Andrew Hemingway suggests, "It was this collective enthusiasm and the identification with other workers that made union members such an active presence in demonstrations and on picket lines."[12]

Aside from membership in organizations, artists also took typically blue-collar jobs to support themselves. For example, Honoré Sharrer's experience as a welder in shipyards in California and New Jersey during World War II deeply informed her art, which reflects her commitment to the working class, especially her *Tribute to the American Working People* (1943). While artists drew on lived experiences of working in their choice of process, form, and subject matter, they also used their materials and processes to critique work and working. As Helen Molesworth has argued, in the period following World War II, "the concern with artistic labor manifested itself in implicit and explicit ways as much of the advanced art of the period managed, staged, mimicked, ridiculed, and challenged the cultural and societal anxieties around the shifting terrain and definitions of work."[13] An example of this is Robert Morris's *Box with the Sound of Its Own Making* (fig. 3.1), a minimal sculpture that is essentially a portrait of work—or a portrait of the artist working—consisting of a wooden box with a tape recording of the sounds of sawing and hammering. As Morris

FIG. 3.1
Box with the Sound of Its Own Making by Robert Morris (born 1931), wood, internal speaker, 3 hr. 30 min. audiotape, 1961. Seattle Art Museum, Washington; gift of the Virginia and Bagley Wright Collection (82.190)

THE WORKER IN THE ART MUSEUM

and other artists of his generation experienced the change from a manufacturing to a service economy in the 1960s and 1970s, artists and critics took on the role of "art workers" and understood the practice of making art in a variety of mediums, including performance, as a form of social critique and commentary about the relationship between art and work.

Women artists particularly focused on performance art as a strategy to comment on the gendered division of labor from a feminist point of view and to ask audiences to consider the cultural value of domestic work. Among those who have been pioneers in addressing work from the feminist perspective through performance is Martha Rosler, who throughout the 1970s took as her subject matter traditional forms of women's labor and domesticity. For example, her Super 8 film *Backyard Economy I and II* (1974) shows her performing the domestic labor of watering plants, mowing the lawn, and hanging laundry to dry on a clothesline. She enacts these monotonous duties in the safe, comfortable context of her own sunny backyard, which projects a seemingly ideal environment. Through the peaceful beauty of the setting, she turns these chores into works of art. As Molesworth asserts, "Like many feminist artists of her generation, Rosler insists that these everyday jobs perform double duty inasmuch as they stand as both housework and artwork."[14] Cindy Sherman is another woman artist who has explored her persona and identity as an artist. In *Scale Relationship Series—The Giant*

FIG. 3.2
Scale Relationship Series—The Giant by Cindy Sherman (born 1954), cutout gelatin silver prints mounted on board, 1976. Solomon R. Guggenheim Museum, New York City; purchased with funds contributed by the International Director's Council and Executive Committee Members: Eli Broad, Elaine Terner Cooper, Ronnie Heyman, J. Tomilson Hill, Dakis Joannou, Barbara Lane, Robert Mnuchin, Peter Norton, Thomas Walther, and Ginny Williams, 1997

(fig. 3.2), made during what Eva Respini has described as Sherman's "early days of experimenting with the plasticity of identity,"[15] Sherman presents herself as the folklore hero Paul Bunyan, the lumberjack with superhuman strength. While the project was meant to explore scale and satirize "the myth of the proud American 'big Man,'" there is a sense of identification through transformation of the self into an alter ego.[16]

Male artists during the 1960s and 1970s also employed the strategy of performance to address their identity in terms of work. For example, Frank Stella—who, like many artists, at times adopted an executive model and employed assistants—presented himself as a working-class person both in his outward appearance and in the tools and materials he chose to use, such as house paints. He famously said, "It sounds a little dramatic, being an 'art worker.' I just wanted to do it and get it over with so I could go home and watch TV."[17] This comment points to the notion of the

artist as existing to create a commodity, as described by Marx: "The worker works in order to live. He does not even reckon labor as part of his life; it is rather a sacrifice of his life. It is a commodity which he has made over to another. . . . What he produces for himself is not the silk that he weaves, not the gold that he draws from the mine, not the palace that he builds. What he produces for himself is wages."[18]

Throughout the 1960s, many of the most prominent artists in New York presented themselves as workers in their appearance as well as in their personal lives, doing "odd jobs" that sometimes inspired their conceptual artwork. Dan Flavin worked as a mailroom clerk at the Guggenheim Museum and as an elevator operator and a guard at the Museum of Modern Art. His 1960 portrait *Gus Schultze's Screwdriver (to Dick Bellamy)* was inspired by his friendship with a fellow MoMA staff member and dedicated to an art dealer (fig. 3.3). It features Schultze's actual screwdriver attached to the surface of the painting. As a conceptual portrait, it pays homage to those who exist behind the scenes of a museum, the wall painters, maintenance workers, and dealers. In a letter housed in the Archives of American Art, Flavin writes of another experience as a museum guard, this time at the American Museum of Natural History: "Day by day, I filled my notebook with diagrams for that fall. My first black icon with electric light emerged that December."[19] Reflecting on that experience, Flavin writes, "I crammed my uniform pockets with notes for an electric Light art. 'Flavin, we don't pay you to be an artist,' warned the custodian in charge. I agreed and quit him."[20]

On the one hand, this anecdote demonstrates that Flavin's custodial job inspired an important body of work in his career and in the history of art, and it testifies to the synergy between his identities as artist and worker and the ways the two are interrelated and ultimately integral. On the other hand, Flavin's recollection points to the separation between art and work and the struggle that artists supporting themselves through day jobs contend with in reconciling their identities as artists and workers.

It is that sense of straddling identities that characterizes the identification of artist and worker in the quotations or appropriations of Gordon Parks, Hung Liu, and Ramiro Gomez, artists who have worked as laborers and discussed their art in terms of their autobiographical connections with the working subjects of their portraits. In *On Longing*, cultural theorist Susan Stewart describes the significance of the act of "quotation" as a form of "interpretation" of the "original." She explains that while granting the initial source a sense of "authenticity," quotation also creates opportunities for new interpretations of the original material. By studying themes of work in historic

FIG. 3.3
Gus Schultze's Screwdriver (to Dick Bellamy) by Dan Flavin (1933–1996), screwdriver, oil, and pencil on Masonite, and acrylic on balsa, 1960. Courtesy of David Zwirner, New York/London

THE WORKER IN THE ART MUSEUM

FIG. 3.4
American Gothic by Grant Wood (1891–
1942), oil on beaver board, 1930. Friends of
American Art Collection (1930.934), The
Art Institute of Chicago, Illinois

or iconic images by other artists and creating new images that reference the past, Parks, Liu, and Gomez extend earlier discussions about the role of the artist, the status of work, and the museum's role in shaping perceptions about work and workers.

In Parks's iconic *Washington, D.C., Government Charwoman (American Gothic)* (cat. 48), an African American cleaning woman named Ella Watson is shown standing before an American flag holding a broom in her right hand and a mop in her left hand. The portrait is loosely based on Grant Wood's iconic *American Gothic* (fig. 3.4), yet the experience of viewing this portrait is very different from that of looking at Wood's work, in which the viewer is thrust into what Wanda Corn has called a "narrative of confrontation."[21] By this Corn means that viewers engage with a bygone era through subjects who are types or archetypes. Parks instead presents a woman who wears contemporary clothes and exists in a contemporary setting. She is immediate and relatable; she does not confront the viewer but stands resigned before the viewer with a pose and expression that conjure alienation and exclusion while echoing Wood's portrait. At the time Parks made the photograph, he was working for the Farm Security Administration's (FSA) photographic team. This experience prompted him to capture the working person from a perspective of identification and empathy, as he was himself a government worker and had taken odd jobs throughout his life; in fact, his life experiences contributed to the urgency of the human- and civil-rights messages he conveyed in his photographs. As he explained in a 1964 interview: "After my mother died, I went to Minnesota where I was brought up. I brought myself up, rather. I took odd jobs up until 1942, until I joined the F.S.A. as a Rosenwald Fellow. Of course, I didn't start photography until about 1939 and up until that time I had worked as a waiter on the railway, bartender and road gangs, played semi-professional football, worked in a brick plant, you name it, you know, just about everything."[22]

Washington, D.C., Government Charwoman is charged by Parks's experience of discrimination in Washington and his desire to expose the inequalities that pervaded the nation's capital. Moving from the Midwest to Washington, he explained, "suddenly you were down to the level of the drug stores on the corner, where I went to take my son for a hot dog or a malted milk, and suddenly they're saying, 'We don't serve negroes,' or 'niggers' in some sections, and 'You can't go to a picture show.'"[23] Parks used his camera to process this treatment and expose it to the nation with Watson as his proxy. He traced the narrative of Watson's experience as a woman and a worker through eighty-five images of her daily life. As Nicholas Natanson has explained,

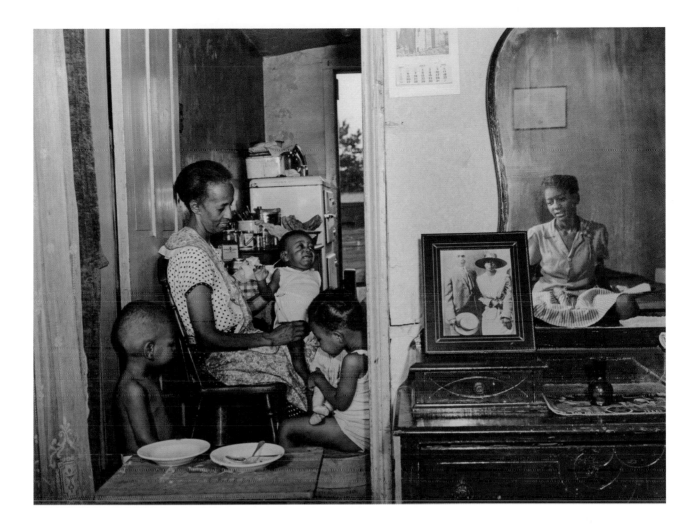

FIG. 3.5
*Washington, D.C., Mrs. Ella Watson, a
Government Charwoman, with Three
Grandchildren and Her Adopted Daughter* by
Gordon Parks (1912–2006), reproduced from
original safety negative, 1942. Prints and
Photographs Division, Library of Congress,
Washington, D.C.

"Parks's repeated mention of Watson's name in the captions (as well as the names of other members of her church and of blacks with whom she dealt in her neighborhood) underscored his intentions. Interplays between images, interplays between captions and pictures, gave this visibility a critical edge."[24] In contrast to the images of Watson cleaning Treasury Department offices, pictures of her life at home as a mother and a grandmother, as a churchgoer and a citizen, reveal the dimensions of her life and humanity and create for the viewer an instantly relatable story (fig. 3.5).

Roy Stryker, head of the Information Division of the FSA, encouraged Parks and other photographers to seek connection and empathy with their subjects. As Parks explained, "I didn't know much about Washington so he gave me my first assignment. I was to go to a big department store downtown and buy a topcoat, go from there across the street and have lunch and then see a motion picture. And he wanted me to give him a report on it."[25] When Parks reported back to Stryker that he had been denied entry at each of these places, he was met with the response "What are you going to do about it?" Stryker pressed him to photograph the people in Washington who had endured this treatment their entire lives. His image of Watson in front of the flag was Parks's response to this challenge, yet Stryker told the photographer the image was too inflammatory, saying, "You've got the right idea, but you are going to get us all fired!"[26] Despite the fact that Stryker thought the image was too forced and controversial and that the negative was filed away for many years, it is the one portrait

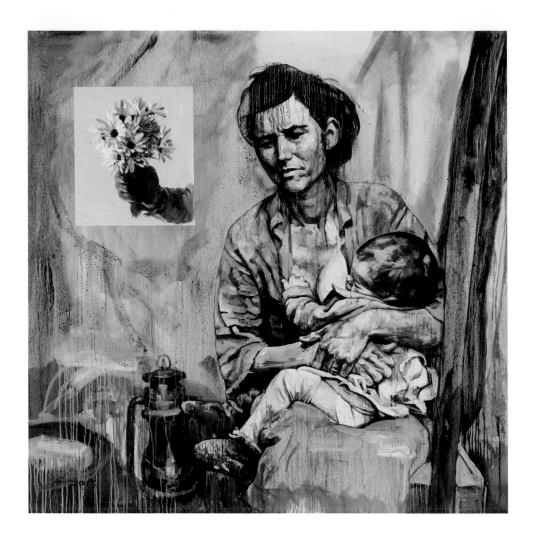

FIG. 3.6
Migrant Mother by Hung Liu (born 1948), oil on canvas, 2015. Courtesy Nancy Hoffman Gallery, New York City

from the series that is etched in the American popular imagination, in large part due to its association with an iconic American painting. Years after he made the portrait, Parks saw the image published in a newspaper and retrieved the negative from the FSA archives.[27] The fact that the image first reached broad audiences through publication in the mass press rather than through museum display is significant.

In a review of the 2016 exhibition *Invisible Man: Gordon Parks and Ralph Ellison* at the Art Institute of Chicago, critic Richard B. Woodward claims that "Parks never got much respect from art museums when he was alive."[28] As photographer Dawoud Bey has pointed out, this claim misunderstands and overlooks the original purpose of Parks's photographs, which were meant to be documentary and were not created for museum display. Bey explains that "their original absence in the provinces of those institutional spaces where we now find them was in no way egregious, it was quite deliberate and consistent with the circumstances of their authorship."[29] Parks's portrayals of Watson were instead part of a larger visual culture, one that Lawrence Levine has articulated as "a world of documentary expression that includes movie newsreels, radio news programs, the Federal Theatre's documentary plays called 'Living Newspapers,' the WPA's *American Guide* series which produced geographical and cultural road maps for every state and major city as well as a host of interesting byways, the blossoming of photojournalism in *Life* and *Look* magazines, and such

quasi-documentary expression as radio soap operas."[30] In his documentary portraits of Watson, Parks revealed his concern for the individual, emphasizing her dignity and humanity in this broader visual culture of documentary expression. Through this process and the image's publication, Parks relieved Watson—and, by extension, himself—from being defined by her work and empowered her image with agency. With the artist's act of appropriating *American Gothic*, Watson's story encompasses the American worker's invisibility more than any of the other pictures in the series precisely because Parks's own story of struggle in the nation's capital is also told through that image.

Similarly, Hung Liu creates autobiographical portraits that reference and appropriate images from the past—in this case, Dorothea Lange's photographic archive housed at the Oakland Museum of Art—and imbues them with her own experiences as a worker and an immigrant. In considering the subjects of her ongoing body of work, *After Lange*, Liu addresses the shifting nature of her identity as she immigrated from China to America: "Those people, the migratory mother and the families, they're all part of my history, part of our history."[31] These adopted ancestors, "ghosts" to whom Liu feels deeply connected, are the workers Lange documented during the Depression in photographs taken for the FSA. Through quotation and appropriation, Liu not only gives the subjects personal meaning that connects them with her own autobiography but also extends agency to the subjects, in essence rescuing them.

Liu's experience as a woman raised in Communist China has played a crucial part in her career. After attending graduate school at the Central Academy of Fine Art in Beijing, where she was one of the few women students, she came to America while her son stayed behind with his grandmothers. As a woman who left her family "in search for herself," she identified with such American films as *Kramer vs. Kramer*, *The Grapes of Wrath*, and *Sophie's Choice*. Of the latter she writes, "I did identify with Sophie's choice, her internment, her migration to a new land, and, in the end, her ghosts. As a child of the Communist Revolution, and as an immigrant to this country, I have ghosts of my own, and I summon them day after day in my paintings."[32]

For Liu, transferring a black-and-white documentary photograph related to "Migrant Mother" (cat. 34) in an archive to a large-scale color painting with a cropping that forms a new composition intended for museum display (fig. 3.6) merges source, subject, and self in meaningful ways:

> The scale, the composition, as well as the color, are all a departure from an original photo. Using the "original," I started thinking that Dorothea Lange had the first-hand experience of shooting the photos. She talked to them [the subjects], listened to their stories and wrote down their words. During the painting process, looking hard into the photos and examining every detail carefully, I felt that I could transfer some of Lange's first-hand experience to me. Therefore, sometimes I feel as if I was traveling with her as an observer and even a collaborator, together we try to understand the "Migrant Mother."[33]

Liu has said that the practice of transferring the "first-hand experience" of Lange to canvas reminds her of the time she was sent to the Chinese countryside to work in the fields during the Cultural Revolution. Creating the lines around the figures as she sketches them onto the canvas visualizes a "kind of topography" in Lange's photographs, linking them to the land and metaphorically mapping her own story: "I'm traveling through the landscape with Lange and opening up a much bigger landscape of the Great Depression."[34] Lange took multiple photographs of the migrant pea picker Florence Owens Thompson. Rather than choosing the iconic "Migrant Mother," one of the most famous and most reproduced images of the twentieth century, Liu appropriated an image of Thompson that is not as well known, showing her from another angle in front of a tent with a child. Liu also included in the composition another, lesser-known and more personal photograph by Lange, one of her son's hand holding a bouquet of daisies on Mother's Day, as a kind of offering to the photographer and her subject. Through the bouquet, the painting becomes a portrait of subject, photographer, and painter.

Like Liu and Parks, Ramiro Gomez draws on iconic images created by other artists to insert his family's story as immigrants and workers into the dominant narrative of history as told through art. Gomez was born into a working-class Mexican family in San Bernardino, California. The son of a janitor and a truck driver, he experienced his parents' daily struggle to make a living; as a young man he, too, contributed to the family income, by working as a nanny. While navigating the practice of his art with his work caring for the children of affluent families, he became keenly aware of the way he moved between his identities as artist and worker, identifying as "working class" yet also being part of the "leisure class." "I can move between classes, which is not available to many. The realization was formed while I worked in the home, simultaneously being able to enjoy a glass of wine and conversation with my employers, but also having to take directions and being able to speak with the housekeeper and gardener."[35] Referencing artists he admires, Gomez inserts into well-known compositions by the likes of Velázquez, Manet, and Millet the people around Los Angeles who "will always be working to keep it nice."[36]

Particularly striking are his painted pastiches inspired by the work of British-born artist David Hockney (fig. 3.7), in which Gomez has replaced the wealthy Californians

FIG. 3.7
Man in Shower in Beverly Hills by David Hockney (born 1937), acrylic on canvas, 1964. Collection Tate, London, England

in the source images with housemaids and groundskeepers and other primarily Latino laborers (cat. 70). He leaves them faceless for a reason, explaining, "Most of the people I did work with were Latino, but there were people from Pakistan and other places. Plus, this isn't just an L.A. reality. In other parts of the world, the cast is different but the reality is the same. So for people in Turkey or France or Pakistan, to see this, the issue is the same. Visualizing this labor is necessary."[37]

Gomez does not shy away from questions about whether his images reinforce the idea of Latinos as manual laborers, admitting that "the fear is there." Yet he sees his own story so clearly in the images he creates that the works serve as autobiographical documents. As he told *Los Angeles Times* reporter Carolina A. Miranda, "As an artist, I want to represent truth without stereotyping and reinforcing. [But] when I hear a student from Harvard come up to me and say, 'I'm at Harvard because of my dad's construction job' or 'I'm at UCLA because of my mom's housekeeping job' that fear subsided. I'm just putting something in a context that allows for contemplation of the issue. I'm painting my own mother. I'm painting about my dad. I'm painting about myself."[38] This kind of autobiographical work carries a broader message about making the invisible visible and, in the process, highlights the experiences of millions of immigrants whose stories have been excluded from history or who feel their voices are ignored by politicians.

As artists who use appropriation and quotation to bring into focus the identification between artist and worker, Parks, Liu, and Gomez intervene in the narratives of history and art history whenever their work is acquired or exhibited. Because all three are well represented in museum collections, their self-referential art serves to remind museum visitors and administrators of the critical status of the worker and the role of the artist in relationship to the worker. Their work, when placed in the context of a museum, also serves as an institutional critique, prompting the question of how much has changed since the plumber was removed from the Metropolitan Museum of Art in 1897. On this point, a look at the Instagram account of the Met's former director and CEO Thomas Campbell is revealing. Embedded among details of artworks from the museum's collection and those of other museums, pictures of donors and fundraising parties, and shots of visitors viewing art or performance in the museum is an image of an unnamed custodian pushing a mop in the atrium near the reception desk, calling to mind Ella Watson's pose in Gordon Parks's portrait. Campbell's text accompanying the image says that "900,000 square feet of gallery space generates a lot of dust bunnies! Our custodial staff get to work as soon as the last visitor leaves." Many of the comments that follow thank Campbell for his tribute to those who work behind the scenes. But what kind of tribute is it? The subject, Vadim Mitin, is shown from a distance, working, not looking at art or talking with staff members or board members or enjoying a party or opening in the elaborate spaces of the museum. This snapshot suggests that the worker still inhabits a separate, precarious place within the structure of the museum, one that continues to deny him agency. By inserting their connection with workers into the spaces of museums such as the Metropolitan Museum of Art—or the Smithsonian National Portrait Gallery—artists such as Parks, Liu, and Gomez have begun the process of changing that marginal position.

Parks, Liu, and Gomez have worked as laborers, and their immediate family members or ancestors were subjected to brutal working conditions; each is haunted by how iconic images in the history of art speak to their experiences of alienation, exile, and discrimination. In essence, they are looking back in time to navigate their identities through the stories of others in order to create an archetypal form of self-portraiture. They reference the history of images of workers as a form of criticism and a way of opening a space to address what is missing in their source materials, whether that is the humanity of the subject or the worker himself. In the process, they visualize stories that have been excluded from the dominant historical narratives that art museums tell and bring viewers into a conversation about the status of American workers and artists, offering a critique that art institutions must heed in order to remain relevant to the broad audiences that administrators hope to attract.

Notes

1 E. S. Martin, "This Busy World," *Harper's Weekly* 41, no. 2095 (February 13, 1897): 151. I am grateful to Michael Leja for introducing me to the story of the plumber at the Metropolitan Museum of Art.

2 Editorial, *New York Times*, February 4, 1897, http://search.proquest.com/docview/95533683?accountid=46638.

3 "Salmis Journalier," *Milwaukee Journal*, February 5, 1897.

4 "Despised Homespun," *Butte* (MT) *Weekly Miner*, February 11, 1897.

5 Ibid.

6 Sylvester Rosa Koehler, introduction to *American Art: Illustrated by Twenty-Five Plates, Executed by the Best American Etchers and Wood Engravers, from Paintings Selected from Public and Collections*, ed. Sylvester Rosa Koehler (New York: Cassell & Co., 1886), unpag.

7 Paul DiMaggio, "Cultural Entrepreneurship in 19th-Century Boston, Part 1: The Creation of an Organizational Base for High Culture in America," *Media, Culture, and Society* 4 (1982): 48. See also Paul DiMaggio, *Nonprofit Enterprise in the Arts: Studies in Mission and Constraint* (New York: Oxford University Press, 1986). DiMaggio is primarily concerned with the dichotomy in Boston between high culture and popular culture.

8 This point is expanded on in Dorothy Moss, "Translations, Appropriations, and Copies of Paintings at the Dawn of Mass Culture in the United States, circa 1900" (Ph.D. diss., University of Delaware, 2012).

9 Julia Bryan-Wilson, *Art Workers: Radical Practice in the Vietnam War Era* (Berkeley: University of California Press, 2009), 26–27.

10 Ibid., 27.

11 Gerald M. Monroe, "Artists as Militant Trade Union Workers during the Great Depression," *Archives of American Art Journal* 14, no. 1 (1974): 7.

12 Andrew Hemingway, *Artists on the Left: American Artists and the Communist Movement, 1926–1956* (New Haven, CT: Yale University Press, 2002), 86.

13 Helen Molesworth, "Work Ethic," in *Work Ethic*, ed. Helen Molesworth (Baltimore: Baltimore Museum of Art; University Park: Penn State University Press, 2003), 25.

14 Ibid., 137.

15 Eva Respini, "Will the Real Cindy Sherman Please Stand Up?" in *Cindy Sherman*, ed. Eva Respini, Cindy Sherman, Johanna Burton, John Waters, and Kate Norment (New York: Museum of Modern Art, 2012), 17.

16 Gabriele Schor, *Cindy Sherman: The Early Works, 1975–1977* (New York: Metro Pictures, 2012), 58.

17 Quoted in Molesworth, "Work Ethic," 35–36.

18 Karl Marx and J. L. Joynes, *Wages and Capital* (Glasgow: Labour Literature Society, 1893), 4–5.

19 Dan Flavin to Samuel J. Wagstaff, 1961, Samuel Wagstaff Papers, 1932–1985, Archives of American Art, Smithsonian Institution, www.aaa.si.edu/collections/items/detail/dan-flavin-letter-to-samuel-j-wagstaff-14730.

20 Dan Flavin, *Dan Flavin: "Monuments" for V. Tatlin: January 10–February 8, 1997* (New York: Danese Gallery, 1997), 12.

21 Wanda Corn, "Grant Wood: Uneasy Modern," in *Grant Wood's Studio: Birthplace of American Gothic*, ed. Jane Milosch and Cedar Rapids Museum of Art (New York: Prestel, 2005), 122.

22 Gordon Parks, interview by Richard Doud, December 30, 1964, New York, Archives of American Art, Smithsonian Institution, www.aaa.si.edu/collections/interviews/oral-history-interview-gordon-parks-11480.

23 Quoted in Nicholas Natanson, *The Black Image in the New Deal: The Politics of FSA Photography* (Knoxville: University of Tennessee Press, 1992), 178.

24 Ibid.

25 Quoted in Paul Trachtman, "Too Hot to Handle," *Smithsonian* 34 (2003): 27–28.

26 Stryker, quoted by Parks in ibid., 28.

27 Trachtman, "Too Hot to Handle."

28 Richard B. Woodward, "'Invisible Man: Gordon Parks and Ralph Ellison in Harlem,' Review: Fruits of a Creative Friendship," *Wall Street Journal*, July 5, 2016.

29 Dawoud Bey, in a Facebook discussion with the author, July 8, 2016, in response to Woodward's "'Invisible Man.'"

30 Lawrence Levine, "The Historian and the Icon: Photography and the History of the American People in the 1930s and 1940s," in *Documenting America, 1935–1943*, ed. Carl Fleischhauer, Beverly W. Brannan, Lawrence W. Levine, and Alan Trachtenberg (Berkeley: University of California Press, 1988), 26–27.

31 Hung Liu, interview by Samantha Page, November 2015, Smithsonian National Portrait Gallery, Washington, DC.

32 Hung Liu, artist statement for the Smithsonian National Portrait Gallery, Washington, DC, regarding an invitation to create a commissioned portrait of Meryl Streep.

33 Hung Liu, e-mail to the author, July 10, 2016.

34 Hung Liu, in discussion with the author, July 11, 2016.

35 Quoted in Hrag Vartanian, "The People behind Your Images of Luxury," *Hyperallergic*, December 13, 2013, http://hyperallergic.com/99056/the-people-behind-your-images-of-luxury/.

36 Quoted in Susan Stamberg, "Gardens Don't Tend Themselves: Portraits of the People behind LA's Luxury," *NPR Morning Edition*, April 11, 2016, www.npr.org/2016/04/11/473384990/gardens-dont-tend-themselves-portraits-of-the-people-behind-las-luxury.

37 Quoted in Carolina A. Miranda, "From Nanny to International Art Star: Ramiro Gomez on How His Paintings Reveal the Labor That Makes California Cool Possible," *Los Angeles Times*, May 4, 2016.

38 Ibid.

CATALOGUE

Unless otherwise noted, measurements indicate stretcher size for paintings, height for sculpture, plate size for daguerreotypes and ambrotypes, image size for photographs, and sheet size for other works on paper.

Mine America's Coal by Norman Rockwell
(cat. 52, p. 167)

MISS BREME JONES

"Grave in her steps / Heaven in her eye's / And all her movement / Dignity and Love." So reads the faded inscription at the upper left of this sketch, based on a passage from John Milton's *Paradise Lost* referencing Adam's adoration of his bride, Eve. (It is worth noting that the artist changed Milton's word "Grace" to "Grave" in his version of the quoted passage.) South Carolina plantation owner John Rose appropriated the affectionate words for his portrait of Breme Jones, a slave who may have helped raise his children after his first wife died. This delicate watercolor pictures Jones, midstride and in profile, clad in an apron and a blue-striped dress.

Rose was not a professional artist but created artwork as a hobby that he took seriously. At the time of his death, his will indicated that he owned oil paints, brushes, and Reeves watercolor pigments imported from England. A deeply religious man, Rose supported his church in a variety of capacities, including serving as deacon and playing the barrel organ. He also was known to be civic minded and supported voting rights, qualities that are evident in the sympathy and grace with which he executed this portrait.

John Rose (1752–1807)
Watercolor and ink on paper, 19.1 × 15.6 cm (7½ × 6⅛ in.), 1785–87
Abby Aldrich Rockefeller Folk Art Museum, Williamsburg, Virginia; Museum purchase, the Friends of Colonial Williamsburg Collections Fund

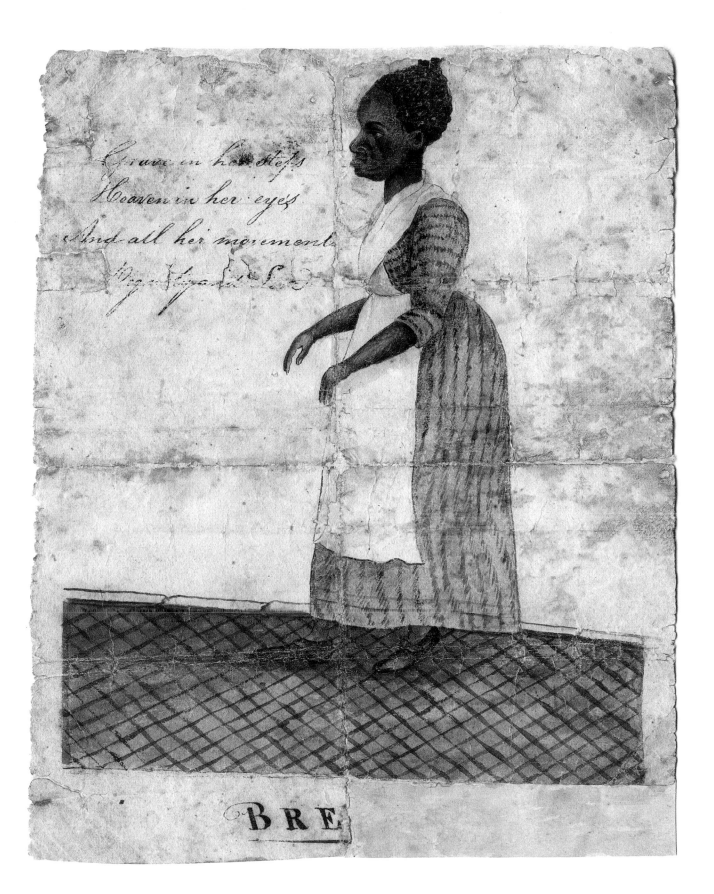

Grace in her steps
Heaven in her eyes
And all her movements
………………………

BRE

PAT LYON AT THE FORGE

Early in his career, blacksmith and entrepreneur Pat Lyon made locks for the Bank of Pennsylvania. After being wrongfully accused of robbing the bank, he spent three years in prison on high bail. Though Lyon successfully sued the bankers who wrongfully accused him, the experience drove him to form a lifelong prejudice against men of the upper class, who to him represented duplicity and injustice. Years later, after achieving wealth and success of his own, he commissioned his portrait from Philadelphia-based artist John Neagle, insisting that he be depicted as a worker. Lyon proclaimed, "I do not desire to be represented in the picture as a gentleman—to which character I have no pretention. I want you to paint me at work at my anvil, with my sleeves rolled up and a leather apron on."[1] The laborer had come to represent honesty, integrity, and the values of the young country—an association favored by Lyon over the upper-class citizens who had had him imprisoned. Neagle configured the life-size portrait to Lyon's liking, portraying him as a working blacksmith surrounded by the implements of his trade. The cupola in the background represents the Walnut Street Jail, where Lyon had been imprisoned.

Neagle's early formal training with portraitist Bass Otis confirmed his desire to become an artist. Encouraging his talents, American romantic painters Gilbert Stuart and Thomas Sully left their mark on the young Philadelphian, and it was through these men that Neagle learned to compose portraits in this large-scale Old Master style. Though unconventional in subject matter, the picture relates to European traditions in the dark, atmospheric setting of the workshop and Neagle's soft, painterly technique.

John Neagle (1796–1865)
Oil on canvas, 240 × 174 cm (94½ × 68½ in.), 1829
Pennsylvania Academy of the Fine Arts, Philadelphia; gift of the Lyon family (1842.1)

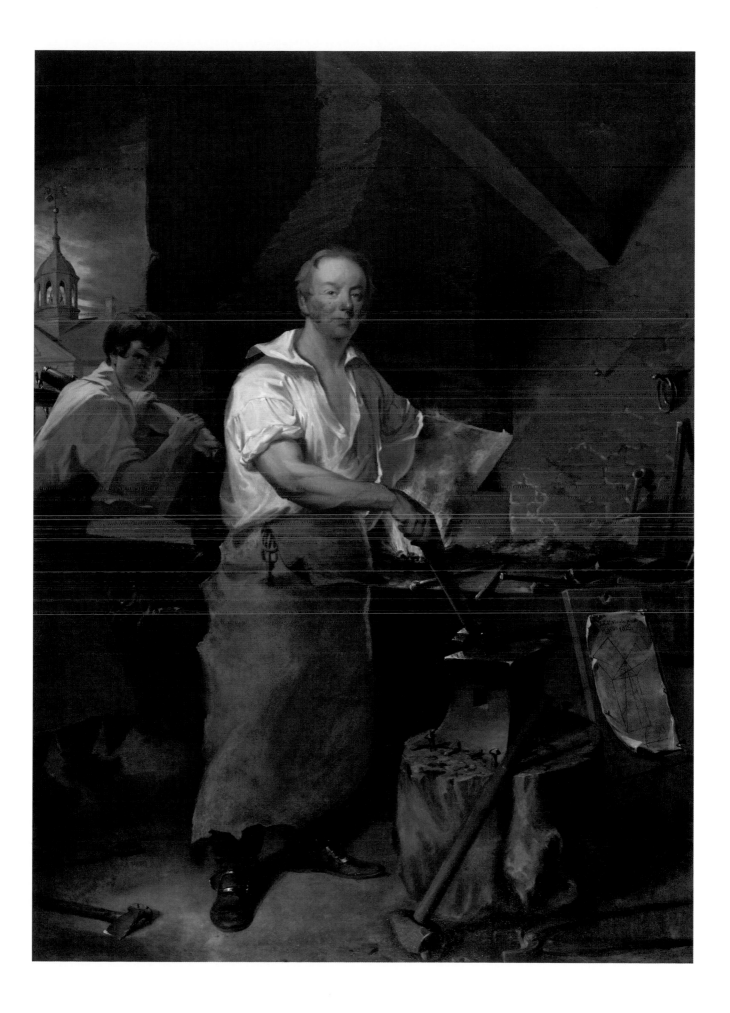

MARIA BOYD (HOLDING A WEAVING SHUTTLE)

In 1846, Walt Whitman wrote about the "great legion of human faces" that surrounded him in a daguerreotype gallery, as he was seeing not just portraits of the elite but images that contained "more variety, more human nature, more artistic beauty."[2] The daguerreotype, invented by Frenchman Louis-Jacques-Mandé Daguerre, was an early form of photography popular in the mid-1800s. The process eventually reached America—the first form of photography to do so—in 1839 by way of painter and inventor Samuel F. B. Morse, who learned of it during a trip to Paris. A skilled portraitist, Morse successfully created daguerreotypes of his daughter within weeks of learning the technique, despite having been warned by Daguerre that producing such portraits would be impossible due to the blurring that would result from the long exposure time needed for early plates.

Maria Boyd, pictured here and listed in the 1860 federal census as a twenty-nine-year-old weaver from Rhode Island, stands as a testament to the industrialization of New England and its empowering effects on women in the mid-nineteenth century. Factory work offered women monthly cash wages and changed their lives in ways prior generations could not have imagined, as they knew primarily farming, handwork, and domestic labor. Depicting Boyd with her weaving shuttle, a tool that stores thread and is used in the production of fabric, this portrait emphasizes the close connection between her employment and her identity.

Unidentified artist

Ninth-plate daguerreotype, hand colored, 6.4 × 5.1 cm (2½ × 2 in.), 1840–60
Prints and Photographs Division, Library of Congress, Washington, D.C.

OCCUPATIONAL PORTRAIT OF A COOPER

Standing with various tools and a cask he likely made himself, this cooper—an artisan who makes containers from wood—appears to take great pride in the products of his trade. Coopers in urban areas often found themselves fully occupied meeting the needs of shipping industries, which required large quantities of crates and barrels. In rural areas, however, the demand for barrels, buckets, and the like did not provide full-time work, and farmers often turned to cooperage as a source of supplementary income. The workload of these rural coopers changed seasonally, as produce from farms was available at different times of the year and required different types of containers for transport and storage.

This portrait melds the new technology of the daguerreotype with traditional conventions of portraiture. Here, the inclusion of tools used to fit metal hoops on barrels gives viewers a sense of the sitter's profession and suggests his craftsmanship and precision. The cooper's clothing reveals his ties to wealthy industries connected with the transatlantic trade of tobacco, wine, and gunpowder, while his pose emphasizes the importance of his handiwork.

Unidentified artist
Sixth-plate daguerreotype, 8.9 × 6.4 cm (3½ × 2½ in.), 1840–60
Prints and Photographs Division, Library of Congress, Washington, D.C.

NEWS BOY

A young newsboy, leaning against the front steps of a wealthy estate, gazes out confidently, peeling off another copy of his paper, ready to make a sale. In this painting, Henry Inman, a prominent American portraitist and genre painter, illustrated the characteristic raggedness and gumption expected of a newsboy. The position of the child next to the luxurious sphinx alludes to the potential prosperity that may result from the newsboy's entrepreneurship and work ethic. Inman painted at a time when such depictions of working-class life were becoming popular subjects for fine art. This painting marks the start of the trend of depicting the newsboy as a metaphorical figure in American art, one representing the increasing dissemination of information and the budding youth of the country.

Inman's depictions of children were a vehicle through which he contrasted the seedy side of urban life with the bucolic life of the country. In opposition to this portrait, Inman created a scene titled *Dismissal of School on an October Afternoon* (1845), an idealized view of childhood in a rural setting. The carefree children in that scene set the ragged newsboy here in sharp relief in order to highlight the evils that urban life might bring, especially for poor children who were liable to become involved in child labor.

Henry Inman (1801–1846)
Oil on canvas, 77 × 63.8 cm (30⅝₁₆ × 25⅛ in.), 1841
Addison Gallery of American Art, Phillips Academy, Andover, Massachusetts;
Museum purchase (1955.14)

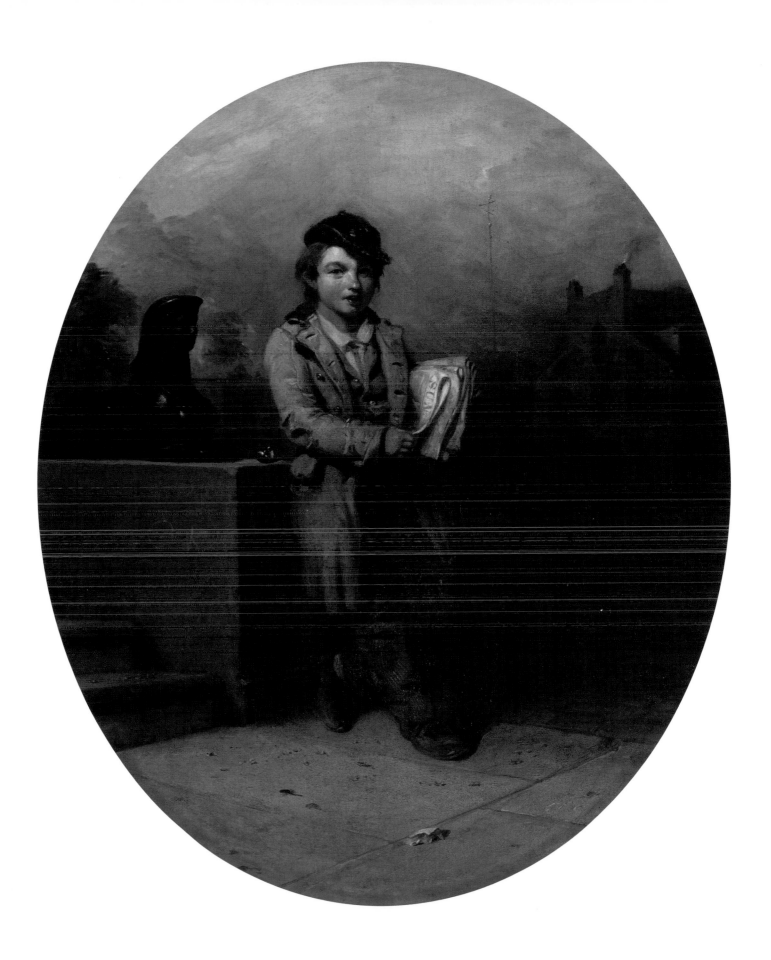

FRANCIS S. CHANFRAU

Comic actor Francis S. Chanfrau made his first theatrical appearance as the Bowery "B'hoy" Mose in Benjamin Baker's *A Glance at New York* (1848), the first of many plays about a folkloric character based on the real-life Moses Humphrey, a volunteer fireman and printer at the *New York Sun*. In this watercolor, Chanfrau plays the role of Mose at the Arch Street Theatre in Philadelphia, which attracted a loyal working-class audience with its low ticket prices. With a soap-lock hairdo and brightly colored clothing, Chanfrau takes on the recognizable features of Mose, a young man who engaged in gang-like activities in Manhattan's Fourth Ward. Having been a Bowery B'hoy himself, Chanfrau related to his character and gave a skillful performance that was celebrated for its authenticity. The actor played the part for a remarkable two decades, until he became too old to act as this virile protagonist. A contemporary critic's words best capture his performance:

> For a moment the audience eyed him in silence; not a hand or foot gave him welcome. Taking the cigar stump from his mouth and turning half-way round to spit, he said:
>
> "I ain't a goin' to run wid dat mercheen [machine] no more!"
>
> Instantly there arose such a yell or recognition as had never been heard in the little house before. Pit and galleries joined in the outcry. It was renewed several times, and Mose was compelled to stand, shifting his coat from one arm to the other, and bowing and waiting. Every man, woman, and child recognized in the character all the distinctive external characteristics of the class.[3]

Chanfrau's performance was so convincing that the audience saw itself in every detail of his gestures, poses, and expressions.

Unidentified artist

Pencil, ink, and watercolor on paper, 32.3 × 24.6 cm (12¹¹⁄₁₆ × 9¹¹⁄₁₆ in.), ca. 1848
National Portrait Gallery, Smithsonian Institution, Washington, D.C.

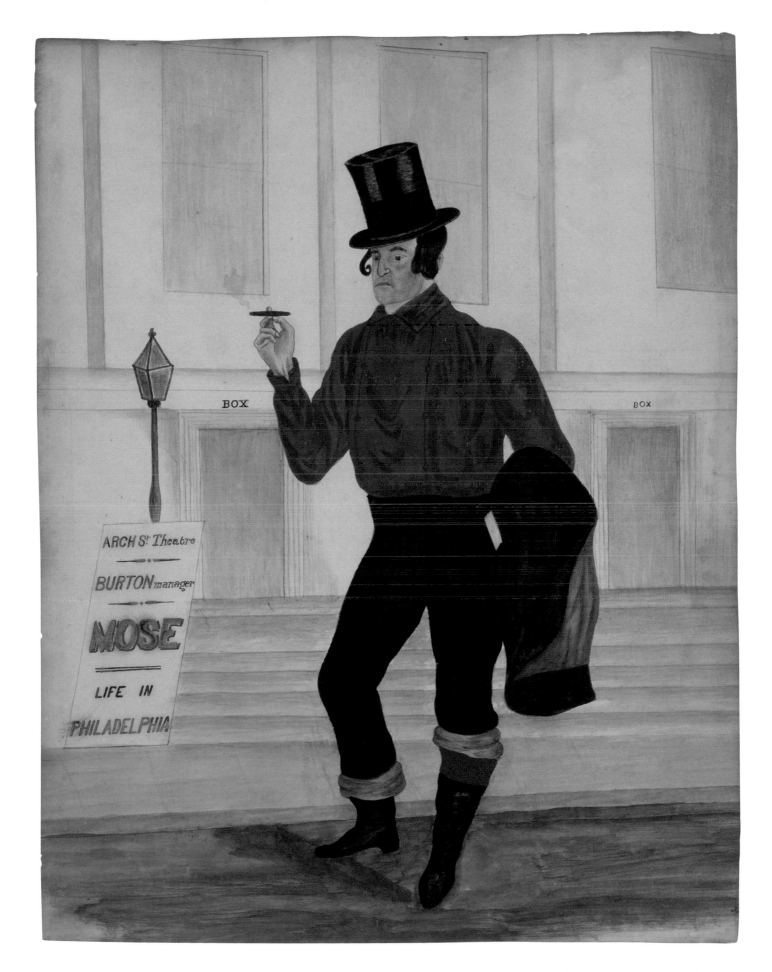

THE JOLLY WASHERWOMAN

Originally from England, artist Lilly Martin Spencer moved in 1830 to Ohio, where she learned her trade studying with Cincinnati artist John Insco Williams. Following this training, she moved to New York, where she supported her husband and thirteen children through sales of her art. Here Spencer illustrates her servant doing laundry with both effort and delight, as evidenced by the thin film of sweat on her skin and her sensationally wide grin. An admirer of mid-nineteenth-century German painting, Spencer channeled a similar realism in this portrait of her jovial domestic aide.

With this painting, Spencer realized that she could command high prices for scenes of domestic work: after *The Jolly Washerwoman* sold in 1852 at auction for a price that was substantially more than she had expected, she focused on this subject matter. Like the woman shown here, Spencer's domestic subjects were strong and in command of their tasks. Often these women are shown engaging the viewer with a clear gaze and a sometimes startling directness that viewers often understood as humorous. Not all critics appreciated Spencer's domestic images, however. Of one such painting a reviewer wrote, "Mrs. Spencer has a truly remarkable ability to paint, but unfortunately ruins all her pictures by some vulgarism or hopeless attempt at expression. . . . Is there in her woman's soul no serene grave thought, no quiet happiness, no tearful aspiration, to the expression of which she may give her pencil? Being a woman, she should have some deeper, tenderer conceptions of humanity than her brother artists, something, at all events, better worth her painting, and our seeing, than grinning house-maids or perplexed young wives."[4]

Lilly Martin Spencer (1822–1902)
Oil on canvas, 62.2 × 44.5 cm (24½ × 17½ in.), 1851
Hood Museum of Art, Dartmouth College, Hanover, New Hampshire;
purchased through a gift from Florence B. Moore in memory of her husband,
Lansing P. Moore, Class of 1937

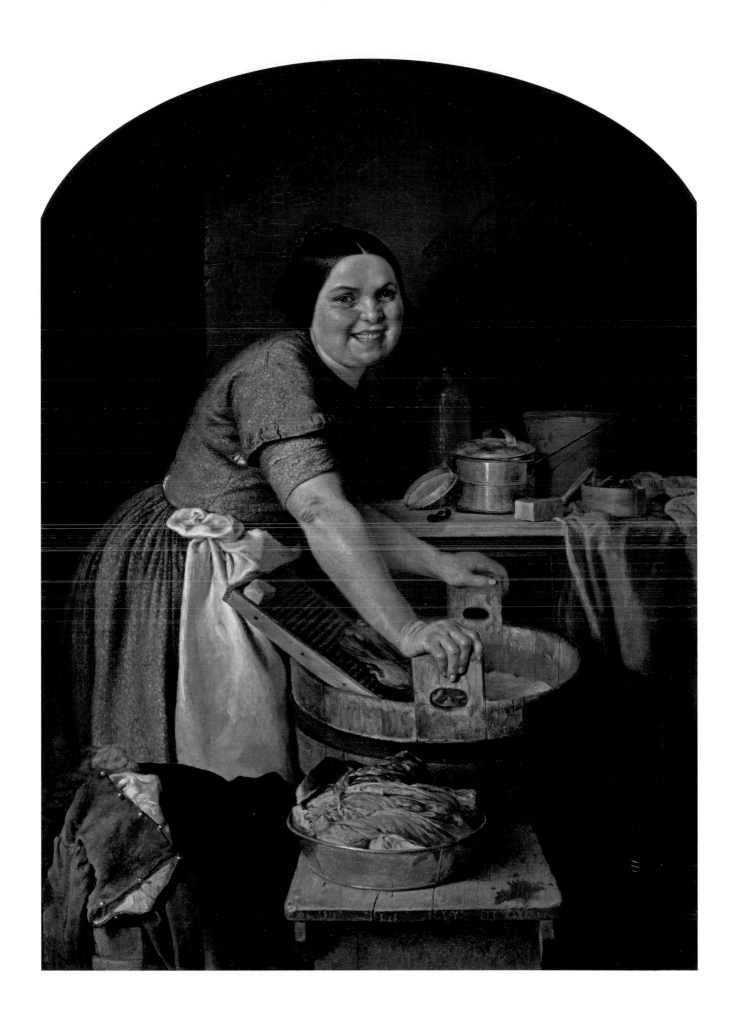

CHARLES WILSON FLEETWOOD JR.

Thomas Waterman Wood was a portrait painter, etcher, and art school administrator. As a young man, he apprenticed with his father, a cabinetmaker, who trained him to make drawings for furniture orders. As his technical abilities developed, his father recognized his skill and potential and sent him to Boston to live with an uncle and take classes in the studio of prominent portrait artist Chester Harding. This training enabled Wood to make a living as a painter, and eventually he opened a portrait studio in New York. Ultimately, Wood settled in Baltimore, where he portrayed many African American subjects. Maryland at this time was known to have 84,000 "free persons of color," many of whom lived in Baltimore.[5] Art patron John C. Brune commissioned Wood to create this portrait of his domestic worker and "chief steward" Charles Wilson Fleetwood Jr., among other African American subjects. These portraits were later exhibited at the National Academy of Design, and the acclaim they brought Wood furthered his reputation and career.

Fleetwood is portrayed in a dignified manner, apparently in control of his work environment and engaging the viewer directly with a confident pose and a good-natured expression. Fleetwood was born "a free Negro" in Baltimore in 1812 and died there in 1884. Between 1842 and 1846, Baltimore city directories listed him as a "bay trader," "barber of hair," "waiter," "confidential servant," and "Negro Householder."[6]

Thomas Waterman Wood (1823–1903)
Oil on canvas, 61 × 40.6 cm (24 × 16 in.), 1855
Howard University Gallery of Art, Washington, D.C.

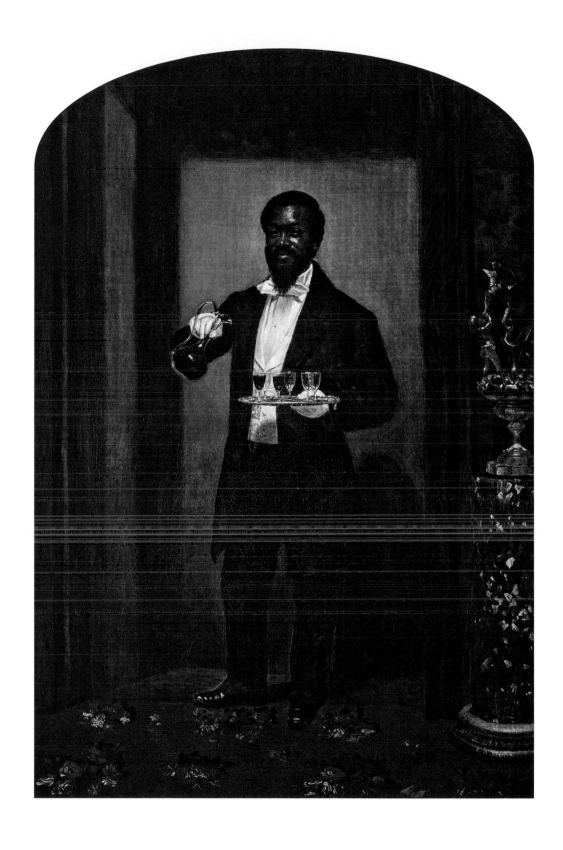

AFRICAN AMERICAN WOMAN WITH TWO WHITE CHILDREN

Portrait images of enslaved people are extremely rare precisely because of their social position: they were legally considered chattel (i.e., "things"), not human beings. With the advent of photography, enslaved people did appear in scientific literature as anthropological figures illustrating racial and physiognomic characteristics; examples of these are found in the archive of the Peabody Museum of Archaeology and Ethnology at Harvard University (see figs. 1.4–1.5). When enslaved people appeared in fine-art portraits, genre paintings, and landscapes, it was often as signifiers of status that advertised the richness of owners' holdings, ranging from buildings to furnishings to human beings. Although legally "invisible," they were part of the scenery and were depicted as valuable appurtenances to plantations; visual pride of place was frequently given to those who ran the household, especially butlers or majordomos such as George Washington's manservant William Lee. The complexity of status and emotional life in this society derived from the fact that in practice it was impossible to adhere to the theoretical status of enslaved people as nonbeings: that the master class had to interact with these nonbeings on a daily basis undermined, to a greater or lesser degree, the invisibility of African Americans.

This rare document features a nanny with two of her charges. The ethos of paternalism—the justification that slaveholders cared for their "people"—engendered a sense among whites that enslaved workers were part of the family. They were not: their presence in the household was coerced. The testimony of a photograph such as this one mutes and domesticates the violence that was the basis of the slave-holding regime.

Unidentified artist
Quarter plate ambrotype, 6.4 × 8.9 cm (2½ × 3½ in.), ca. 1860
Promised gift of Paul Sack to the Sack Photographic Trust for the
San Francisco Museum of Modern Art

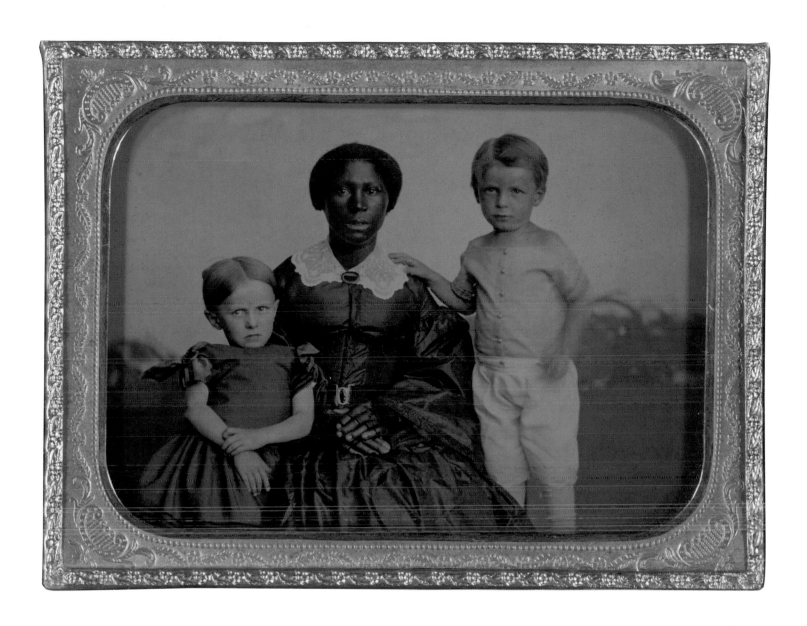

HAYMAKING

Winslow Homer documented daily life in the Union army during the Civil War as an artist-correspondent for *Harper's Weekly*, and some of his earliest oils were inspired by these experiences as well as his fondness for the countryside. Marked by realism, his paintings embody a truth born of direct observation.

In this painting, Homer portrays a young farmer engaging in honest labor, prodding his pitchfork at the pile of hay before him, and creates a strong contrast between the intense shadow of the foreground and the saturated colors of the farmer's blouse. In depicting this countryman against the rural landscape, Homer followed the precedent of pre–Civil War artist William Sidney Mount, who frequently painted pastoral scenes that include rural workers. Homer's composition—notably the farmer's closeness to the viewer—suggests that the artist also drew on the battlefield photography of Mathew Brady, whose works often feature similar arrangements. This painting was the first in a series that concluded with Homer's well-known *Veteran in a New Field* (1865), which portrays a former Union soldier returning to his farm after the war. The figure of the rustic laborer illustrated the postwar ethos of returning to a quieter and more peaceful life. Homer's early paintings received much acclaim and contributed to his appointment as an academician at the National Academy the year this work was completed.

Winslow Homer (1836–1910)
Oil on canvas, 40.6 × 27.9 cm (16 × 11 in.), 1864
Columbus Museum of Art, Ohio; Museum purchase, Howald Fund (1942.083)

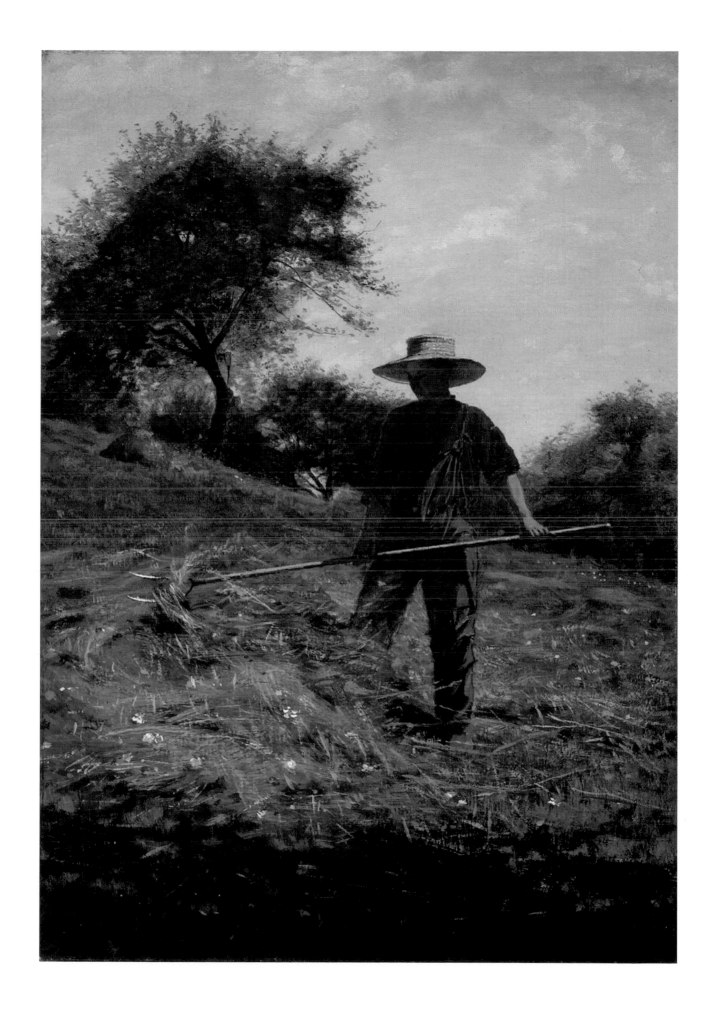

GIRL WITH PITCHFORK

Late in 1866, Winslow Homer made his first trip to Europe, spending ten months in France. There he—like many of his contemporaries, including Eastman Johnson and George Inness—became inspired by the Barbizon School. A central focus of this art movement, which took root in rural villages, was an attention to the connection between humans and nature. The artist of this school Homer most emulated was Jean-François Millet, whose peaceful agrarian landscapes caused a sensation at the Universal Exposition of 1867 in Paris.

Strongly paralleling Millet's art in subject and composition, *Girl with Pitchfork* was painted toward the end of Homer's French sojourn in the small village of Cernay-la-Ville, northeast of Paris. Artists often came to the town to paint its pastoral countryside and laboring peasant community, and by the time Homer arrived, a thriving colony of painters had established itself there. Dressed in traditional attire, the subject of Homer's work stands resolute in the midst of her haymaking with pitchfork in hand. The strong verticality of the composition hints at Homer's recent interest in Japanese art. The solid white highlight of the girl's apron accentuates her profile against the simple background, a technique the artist perhaps transferred from his training in woodcut engraving. Homer's contact with agrarian subjects continued into the next decade as the popularity of this genre escalated internationally.

Winslow Homer (1836–1910)
Oil on canvas, 61 × 26.7 cm (24 × 10½ in.), 1867
The Phillips Collection, Washington, D.C.

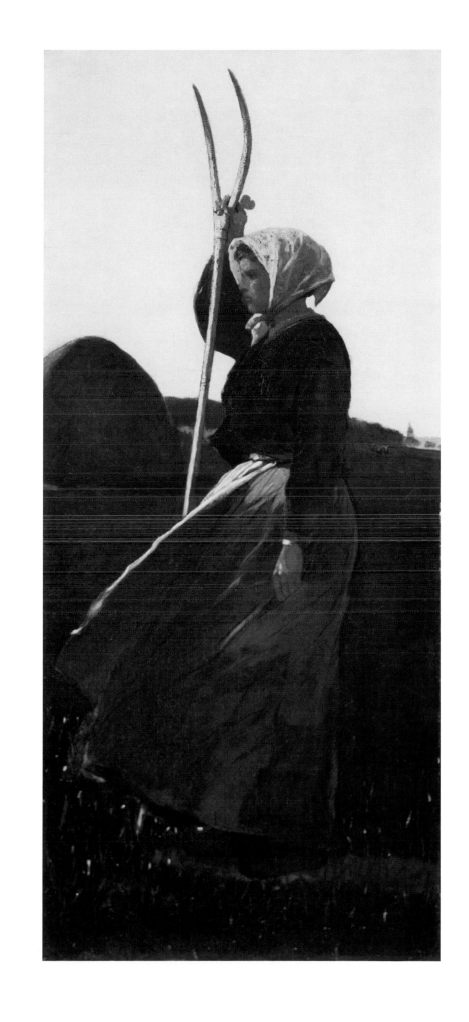

An 1868 article in *Harper's Weekly* quoted an 1842 essay by Charles Dickens on his impression of life in the mills of Lowell, Massachusetts: "From all the crowd I saw in the different factories that day, I cannot recall or separate one young face that gave me a painful impression."[7] The English author and social critic expressed greater approval of factory life in New England than he did of that in his native Manchester, whose industrial landscape harbored some of England's lowest standards of living. Despite Dickens's general optimism, this wood engraving by Winslow Homer, which accompanied the 1868 article, gives a less enthusiastic view. Homer depicts employees of all ages proceeding home from a mill at the end of the day, a march that, prompted by the sound of the factory's bell, would have taken place six days a week after the workers had engaged in thirteen hours of labor. The pale face of the prominent woman in the foreground seems to evoke concern and distress as she strains her neck and furrows her brow. Homer's illustration—likely depicting the Washington Mills in Lawrence, Massachusetts, ten miles north of the factories Dickens had reviewed—originated as a drawing made by the artist of his own accord; only later was it paired with Dickens's essay for publication.[8]

Homer sold his first drawing to *Harper's* in 1858. Despite being offered a full-time position as a documentary illustrator, the Boston-bred artist preferred his status as a freelancer, which allowed him more control of his compositional choices. He continued to earn a living as an illustrator for the magazine for the next sixteen years.

Winslow Homer (1836–1910)
Wood engraving, 22.9 × 34.6 cm (9 × 13⅝ in.), published July 25, 1868
David C. Ward

MINER AT WORK, VIRGINIA CITY, NEVADA

Describing the purpose of his 1867 government-funded survey, geologist Clarence King said, "The Explorations of the Fortieth Parallel promised, first, a study of all the natural resources of the mountain country near the Union and Central Pacific railroads."[9] Calling upon Timothy O'Sullivan to serve as chief documentary photographer for the project, King chronicled the abundant resources of the mining regions of the Southwest with an ultimate goal of settling the West. Throughout his body of work, O'Sullivan successfully captured the subtleties of geology, transforming physical features into dramatic photographic experiences—and in turn contributing to the then widely held ideal of Manifest Destiny.

O'Sullivan, often willing to put himself in extreme situations in order to capture a moment, descended nine hundred feet beneath the town of Virginia City, Nevada, to photograph this industrious miner and his partner toiling away by the light of a candle. Working in the most valuable silver deposit in the United States, these miners likely had traveled to the mines of the Comstock Lode with hopes of prosperity. In his photographs of miners, O'Sullivan revealed their claustrophobic working conditions, and, having learned from Civil War photographer Mathew Brady, incorporated such techniques as close cropping of images to heighten the sense of confined space and to evoke discomfort in the viewer.

Timothy O'Sullivan (1840–1882)
Albumen silver print from glass negative, 16.4 × 13.7 cm (6⁷⁄₁₆ × 5⅜ in.), 1868
The Metropolitan Museum of Art, New York City;
Gilman Collection, Museum purchase, 2005

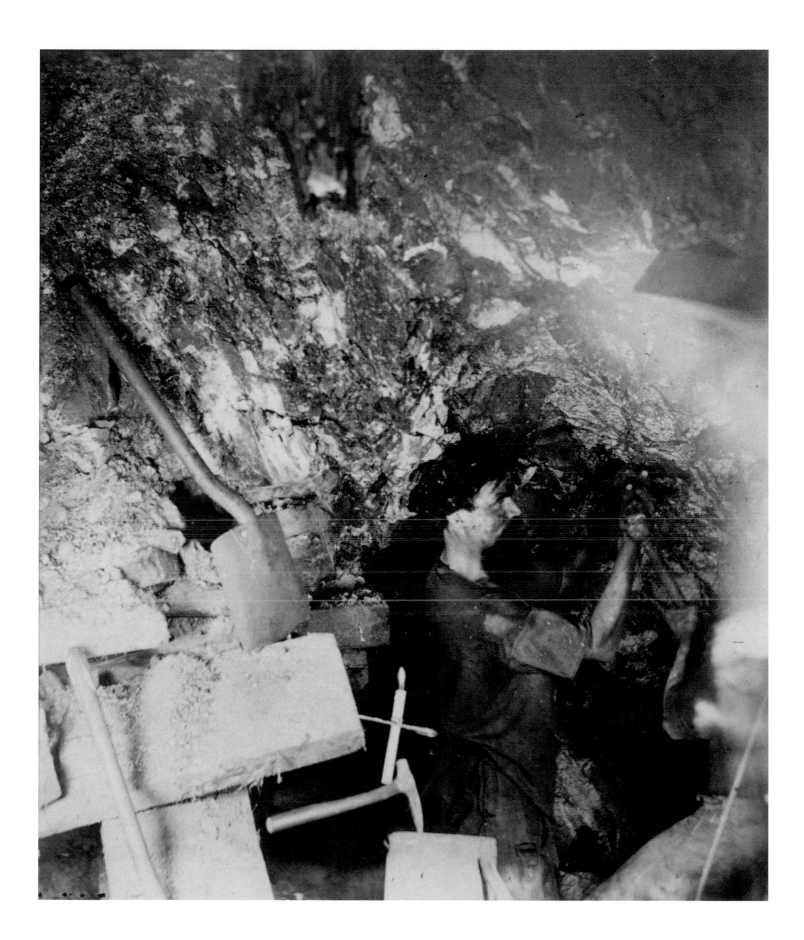

"The great railroad problem of the new age is solved; the continental iron band now unites the distant portions of the Republic and opens up to commerce, navigation and enterprise the vast unpeopled plains and lofty mountain ranges that divide the East from the West."[10] So reported photographer Andrew J. Russell upon the completion of the Transcontinental Railroad in 1869. He had journeyed west to document the building of the Union Pacific portion of the line, and, using an outdoor camera of his own invention, the former Civil War photographer captured pictures of the tireless crew of railroad workers. His work on this project cemented his position as the official photographer for the Union Pacific Railroad.

This photograph, Russell's most famous work, depicts the laborers who facilitated the joining of the Union Pacific and Central Pacific lines at Promontory Point, Utah. The completion of the railroad reduced a six-month journey from New York City to San Francisco to a mere six days. Posed before Union Pacific Engine 119, left, and Central Pacific Engine Jupiter, right, workers and luminaries celebrate the meeting of the two trains, some tipping their hats in respect, one raising a bottle. At the center of the image, Union Pacific chief engineer Grenville M. Doge extends a handshake to his Central Pacific counterpart, Samuel S. Montague, underscoring the machine-driven linkage with a more human connection. Collectively, the efforts of tens of thousands of laborers were necessary to complete the railroad's lengthy and dangerous construction; many deaths on the project resulted from unfair labor practices, particularly those directed toward immigrants.

Andrew J. Russell (1830–1902)
Albumen silver print, 30.5 × 40.5 cm (12 × 15¹⁵⁄₁₆ in.), 1869
The Gilder Lehrman Institute of American History, New York City

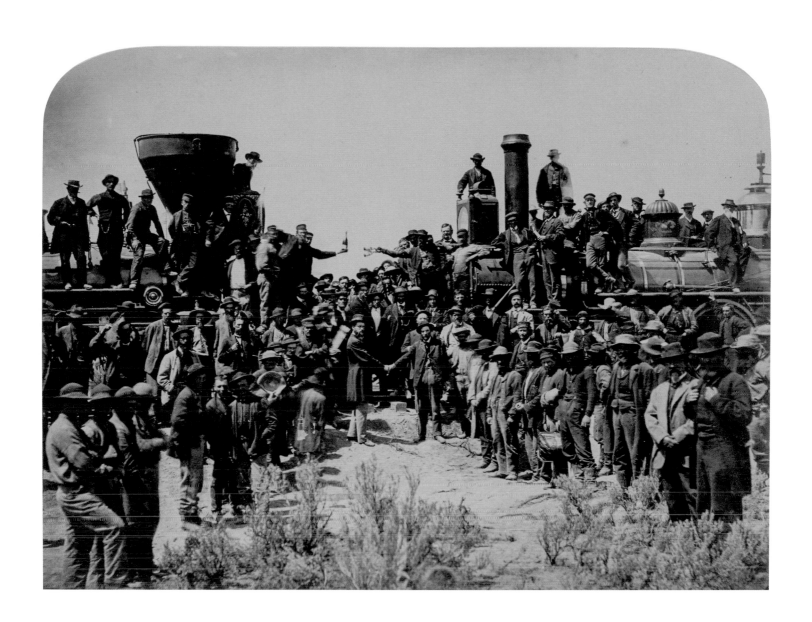

OLD MILL (THE MORNING BELL)

After some brief training in oil painting, Winslow Homer worked on the front lines in Virginia during the Civil War as an artist-correspondent for *Harper's Weekly*. This painting exemplifies American nostalgia for a simpler life before the war. Overlooking the harsh realities of mill work, Homer pacifies America's unease with the new industrial landscape by creating an idyllic pastoral scene. Walking away from the somberly dressed rural women on the right, a woman in colorful, fashionable "town" dress ascends to her job in a mill. She symbolically departs from an agrarian past and enters into a present of industrialization and heightened social and economic status for women. The mill's chiming bell indicates the start of a work day—and the beginning of a new, commercial America.

Critics often focused on Homer's choice of subject matter, and *Old Mill* was received harshly for what was perceived to be its unclear purpose. The figures were said to lack gracefulness, and Homer was accused of using the scene as an excuse to paint a landscape. While the artist's choice to make work the subject of the painting was not a focus of contemporary critical discourse, it is the theme he expanded upon in a later engraving based on this painting; in that print, male and female mill workers of varying ages are included to emphasize the lifelong toil brought on by industrialization.

Winslow Homer (1836–1910)
Oil on canvas, 61 × 96.8 cm (24 × 38⅛ in.), 1871
Yale University Art Gallery, New Haven, Connecticut;
bequest of Stephen Carlton Clark, B.A. 1903

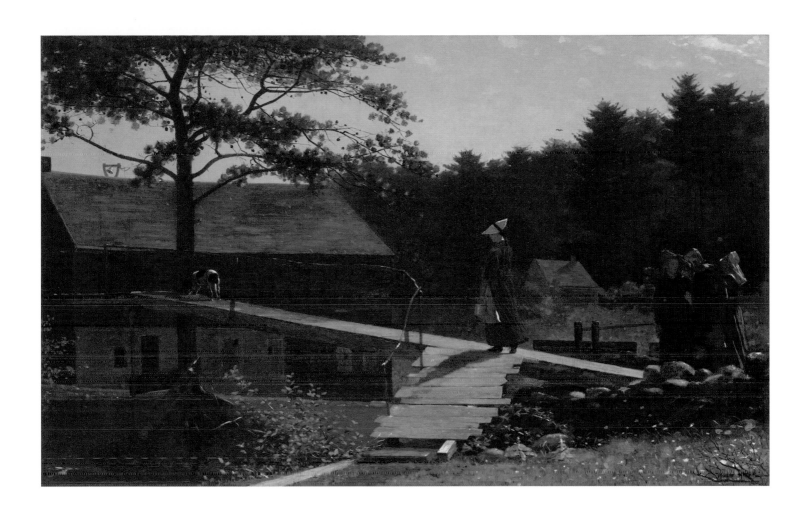

THE SONG OF THE SOWER (BOBBIN GIRL)

"Fling wide the grain for those who throw / The clanking shuttle to and fro, / in the long row of humming rooms, / And into ponderous masses wind / The web that, from a thousand looms, Comes forth to clothe mankind."[11] This excerpt from William Cullen Bryant's "Song of a Sower" is a jovial celebration of the American laboring class. Winslow Homer created this 1871 woodcut to accompany Bryant's descriptive, romantic words. Homer, who began his career as a lithographer apprenticing at the firm of J. J. Bufford in Boston, freelanced as a woodcut artist for several renowned authors and magazines at the time of this commission.

Replacing filled bobbins with empty ones in a spinning frame, the young girl in the illustration engages in her daily tasks in a textile mill. Piled high in the wicker basket beneath her is the product of her labor: a plentiful reserve of neatly threaded spindles. This task, called doffing, was well suited to young girls, as it demanded agility and dexterity as opposed to the physical strength required in other occupations. Dismayed by the cumbersome and monotonous work, poet and author Harriet Hanson Robinson described this task as "the lowest among women."[12] However, textile mills paid two dollars a day and allowed "doffers" a degree of financial independence.

Winslow Homer (1836–1910), after John Karst
Wood engraving in *Song of the Sower* (New York: D. Appleton & Co., 1871)
Lowell National Historical Park, Lowell, Massachusetts

THE LONGSHOREMEN'S NOON

Enjoying their midday rest, the motley crew shown here are longshoremen, the dock workers responsible for loading and unloading cargo being transported through their local port—in this case a Hudson River wharf. The physically laborious work of a longshoreman was unpredictable, as it depended on the shipments coming in or going out of the port. With some men napping, some smoking, and others enthralled in the storytelling of the man in the red shirt at the center left of the scene, this painting illustrates America's increasing diversity in the workplace through the differing appearances and attitudes of the men. In the foreground, a crinkled *Sun* newspaper rests on the ground, as if the men have been reading it and perhaps passing it around. The prominence of the newspaper suggests the longshoremen have been talking about the news on their break. The presence of strong forearms and burly bodies beneath the men's dirty and tattered clothes conveys impressive strength and physicality, yet the men are shown not as heroic workers but as a community of individuals engaged in the issues of the day, such as union strikes, which were prevalent at this time. Brown's upbringing in a working-class family and his experience as a craftsman influenced this sensitive portrayal of fellow laborers, which conveys a certain identification with his subjects.

John George Brown (1831–1913)
Oil on canvas, 84 × 127.3 (33⅟₁₆ × 50⅛ in.), 1879
National Gallery of Art, Washington, D.C.;
Corcoran Collection (Museum purchase, Gallery Fund), 2014.136.2

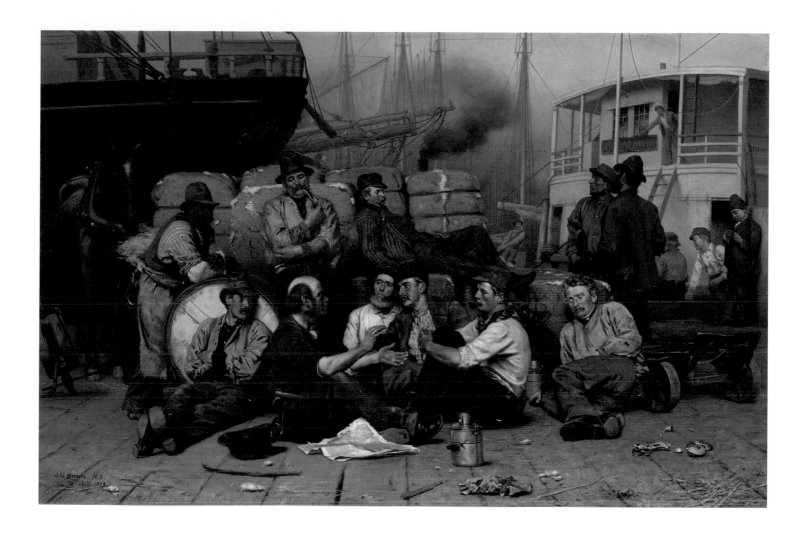

CHINESE BUTCHER AND GROCERY SHOP, SAN FRANCISCO

Born in New Bedford, Massachusetts, Isaiah Taber established a photography business and studio in San Francisco in 1871. While it was not his primary subject, Taber often turned his camera on Chinatown in the 1870s and 1880s and compiled a significant body of images of shopkeepers and street views during that period. He was one of the many non-Chinese artists who flocked there to capture what art historian Anthony Lee has described as a "suitable image" of an exotic place for those who did not live in it. Unfortunately, his studio was destroyed in the San Francisco earthquake of 1906, and his glass plate negatives were lost.

In the mid-nineteenth century, San Francisco's Chinatown was centered on one block of Sacramento Street. Later in the century, it expanded, particularly along Dupont Street (now Grant Avenue). Chinese Americans made their way from the wharf along Sacramento Street and found a temporary home in the neighborhood, which was filled with shops like the one pictured here. As Lee explained, "Chinatown quickly became the physical fulcrum around which San Francisco, as it became the urban scene, worthy of the name, took shape."[13] In addition to being a destination for newly arrived Chinese in San Francisco, Chinatown was a passageway for non-Chinese urban dwellers as they traveled from their jobs on the docks to their homes in the hills. At the time this photograph was taken, more than twenty thousand Chinese lived in California, with a high concentration of residents in San Francisco's Chinatown.

Isaiah W. Taber (1830–1912)
Albumen print, 18.4 × 23.5 cm (7¼ × 9¼ in.), ca. 1880s
Promised gift of Paul Sack to the Sack Photographic Trust for the
San Francisco Museum of Modern Art

TOMMY (HOLDING HIS BOOTBLACK KIT)

"The street, with its ash-barrels and its dirt, the river that runs foul with mud, are their domain," wrote photographer Jacob Riis of the difficult lives of immigrants in his 1890 book *How the Other Half Lives*.[14] The subject of this photograph embodies the artist's description, as he wields his shoe-shining equipment in a dingy New York alleyway. He stands disheveled, with hat askew and clothing torn and tattered, yet proudly primed for business. Riis took pictures using his wooden box camera to raise awareness about the experiences of immigrants on New York's Lower East Side. Although this portrait depicts a dignified, dedicated young man making his own way, Riis has been criticized for his tendency to skew photographs with personal prejudices. He was indeed empathetic to the people he encountered, writing, "For it is as pictures from the life in which they and we, you and I, are partners, that I wish them to make their appeal to the neighbor who lives but around the corner and does not know it."[15] As an activist for social reform, Riis advocated building parks, playgrounds, and ultimately what became the Jacob A. Riis Houses public housing project. He also lobbied to formalize health codes that ensured clean water and sanitation, among other necessary reforms. So powerful were his photographs that Theodore Roosevelt famously called him "the most useful citizen of New York."[16]

Jacob Riis (1849–1914)
Modern gelatin silver chloride printing-out-paper print from dry plate negatives, 10.2 × 12.7 cm (4 × 5 in.), ca. 1890
Museum of the City of New York, New York City; gift of Roger William Riis, 1990

THE CLOCK MAKER

An elderly clockmaker sits at his turn bench, activating a lathe by depressing the pedal under his right foot. With an intent gaze, he examines the object of his craftsmanship, the wooden case of a cuckoo clock. A small etching of St. Jerome, revered for his adept and independent labor, is tacked on the wall—perhaps motivation for the clockmaker, who shares similar attributes. Wilmington, Delaware, artist Jefferson David Chalfant created this painting in 1899, a century after timepieces had begun to be produced on an industrial scale in the United States. By 1830, the main components of timepieces were made entirely by machines. Looking back at an earlier period, a contributor to *Harper's New Monthly* in 1869 wrote, "Let pencil and graver fix its humble features ere the place where one knew it shall know it no more forever. The tiny building with its sign . . . the single room, eight by ten, with its counter . . . and its one workman. . . . Here and there one of these establishments yet exists, but it is as really a relic of antiquity as a hand-loom or a wooden plow."[17] By choosing to depict a traditional craft in an era of mass production and then infusing the image with literal references to time, Chalfant emphasized changing notions of labor during the Gilded Age.

Jefferson David Chalfant (1856–1931)
Oil on copper, 33.3 × 24.1 cm (13⅛ × 9½ in.), 1899
Fine Arts Museums of San Francisco, California;
gift of Mr. and Mrs. John D. Rockefeller 3rd

WILLIE GEE

Child workers were the subject of much popular attention in newspapers and magazines through the efforts of social reformers such as Jacob Riis (see cat. 19). The most prominent child laborers on city streets across the United States were newsboys. As industrial child labor began to decline, these young street merchants became increasingly visible. The son of two former slaves, Willie Gee was a newsboy in New York City. He met Robert Henri while delivering a newspaper to his studio near San Juan Hill, an area known for disputes between African American residents and police officers. Although some depictions of newsboys at the end of the nineteenth century cast them as dangerous delinquents, Henri shows Gee as a wide-eyed, shy young boy, capturing his humanity in the face of hard work in a touching and sensitive portrait devoid of racial caricature.

This humanizing representation aligns with Henri's aim, as a member of the Ashcan School, to capture the authenticity of urban life and the innocence of childhood even in the grittiest of settings. The artist had a particular fondness for depicting children of all backgrounds and explained that he approached them with

> humility, wonderment, and infinite respect. In the faces of children I have seen a look of wisdom and of kindness expressed with such ease and such sincerity that I knew it was the expression of a whole race. . . . I never try to "play down" to the child. I merely try to place myself on his level. . . . When a child poses for me I let him know unconsciously my respect for him. I may try to amuse him, but it is not as if he were an inferior. To me a child is a wonderful thing.[18]

Robert Henri (1865–1929)
Oil on canvas, 81.3 × 66.7 cm (32 × 26¼ in.), 1904
Newark Museum, Newark, New Jersey; anonymous gift, 1925

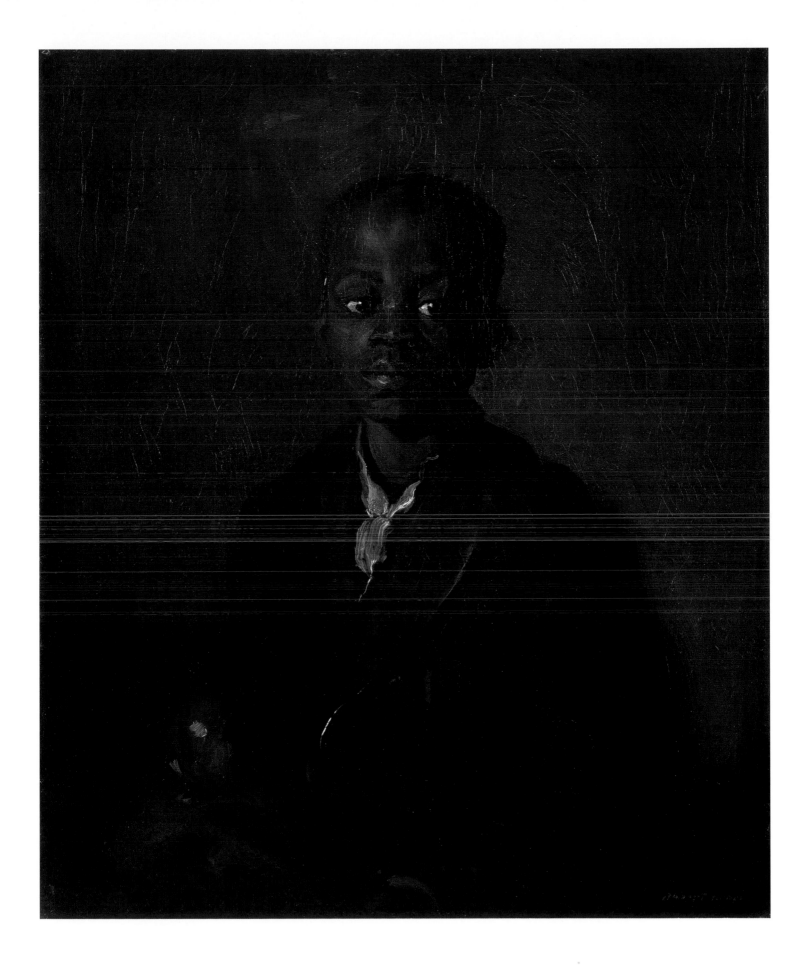

In 1903, Lewis Hine was hired to teach at the Ethical Culture School in Manhattan by Frank Manny, an important education reformer in the Progressive Era. Manny provided Hine with a five-by-seven-inch view camera, a tripod, glass negatives, and flash powder and encouraged him to use the camera as an educational tool. Together they went to Ellis Island to capture images of immigrants arriving in the United States. Hine recalled Manny asking his students to "feel the same regard for . . . Ellis Island that they had then for Plymouth Rock." The caption Hine published with this portrait of a young Jewish woman was taken from Walt Whitman: "Inquiring, tireless, seeking what is yet unfound. . . . / But where is what I started for so long ago? / And why is it unfound?"[19]

By photographing his subject at eye level as she gazes almost directly at the camera—and despite not naming her in the title—Hine insists on his subject's individuality rather than characterizing her as a type. In its haunting beauty and fragility, the image conjures a vision of what would assuredly be a difficult life ahead as the woman joined the workforce and recalls an anonymous writer's summary of a report for the New York Immigration Commission in 1908: "Difficulty in securing work, schooling, and justice is shown to be almost inevitable."[20] Hine empathized with his subjects and brought forth their struggle in his portraits. There is, he wrote to Manny, "a crying need for photographers with even a slight degree of appreciation & sympathy."[21]

Lewis Hine (1874–1940)
Gelatin silver print, 25.4 × 20.3 cm (10 × 8 in.), 1905
Courtesy Alan Klotz Gallery; Photocollect Inc., New York City

THE NEWSBOY

Newsboys were popular subjects for early twentieth-century American artists and documentary photographers such as Lewis Hine, whose photographs were part of his crusade against child labor (see cats. 24 and 27). Bellows's portrait of young Jimmy Flannigan draws inspiration from the format and liveliness of portraits of "types" painted by Frans Hals in seventeenth-century Holland. As art historians Robert W. Snyder and Rebecca Zurier have pointed out, the painting's tendency toward grotesqueness also references Spanish Old Master paintings of beggars.[22] Bellows perceived the newsboy as a savvy salesman, his sly smile that of a conniving entrepreneur who strives to attract and persuade passersby. While other images of newsboys in this exhibition show sitters with the disheveled appearance one would expect of young boys working on the streets, Bellows's depiction is more gruff and mischievous.

This painting illustrates Bellows's recognition of a "streetwise" type from his New York neighborhood, relying in part on stereotypes of certain ethnic groups to achieve a desired impression. Although the artist's tendency to typify his subjects pushes this portrait toward a stereotypical view of a scrappy young Irish boy rather than honoring the individual child, the boyish energy that he captured conveys the newsboy's prowess, as he raises an eyebrow and sizes up his next customer.

George Bellows (1882–1925)
Oil on canvas, 76 × 55.5 cm (29¹⁵⁄₁₆ × 21⅞ in.), 1908
Brooklyn Museum, New York; gift of Daniel and Rita Fraad Jr. (65.204.1)

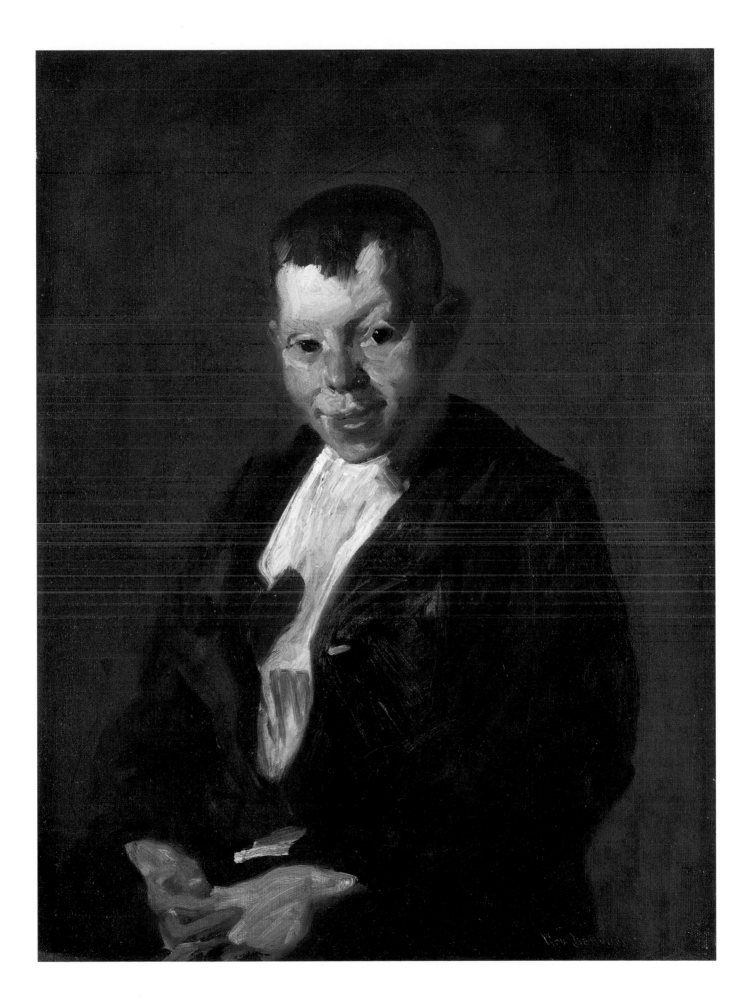

CHILD LABOR, C. 1908

Lewis Hine used his camera as an instrument for social change, sharing with the world images of the harsh realities of child labor. He aimed to make his audience "so sick and tired of the whole business that when the time for action comes, child-labor pictures will be records of the past."[23] A member of the National Childhood Labor Committee (NCLC), an organization devoted to the abolishment of the practice, Hine traveled more than twelve thousand miles over his decade of photographing child workers around America. The NCLC proved to be an important organization in urging the U.S. government to institute reforms and regulate child labor. Through his photographs, Hine brought the terrible truths of child labor to the attention of the American people.

Hine carefully recorded information about the children he photographed on the back of each print. On the reverse of this photo, Hine wrote: "Sadie Pfeifer, 48 inches high, has worked half a year. One of the many small children at work in Lancaster Cotton Mills. Nov. 30, 1908. Location: Lancaster, South Carolina."[24] At the time, children such as this young girl were permitted to take jobs during the summer months, no matter their age, as long as they attended four months of school and could read and write.

Lewis Hine (1874–1940)
Gelatin silver print, 35.6 × 38.1 cm (14 × 15 in.), ca. 1908
Bank of America Collection

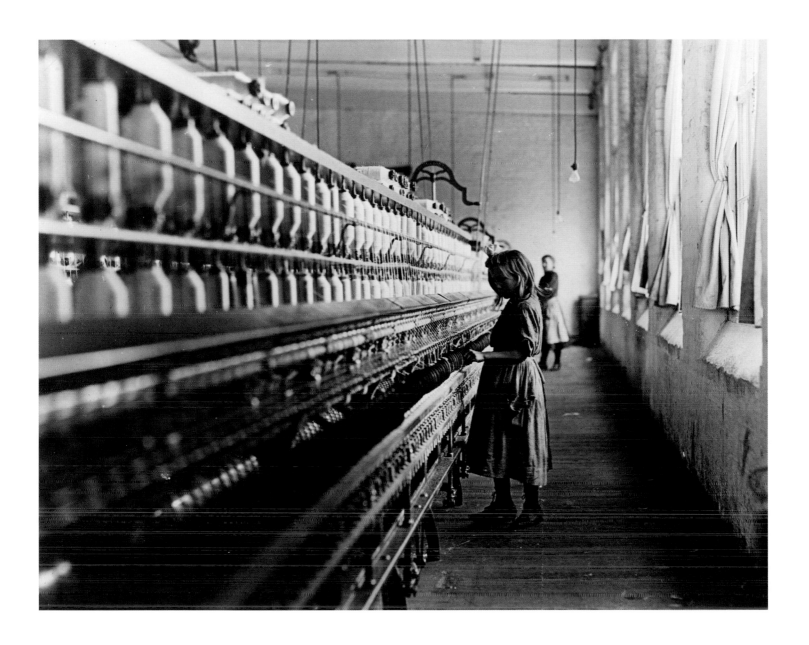

RUSSIAN STEEL WORKERS, HOMESTEAD, PENNSYLVANIA

With a rise in immigration and the rapid expansion of the steel industry, the city of Pittsburgh became a site of serious social and welfare problems for foreign-born workers during the Progressive Era. The factories that bordered the three rivers of the city's industrial downtown witnessed many violent accidents as workers spent long hours in hot, hazardous conditions—circumstances compounded by frequent misunderstandings resulting from language barriers. Despite these hazards, the laborers portrayed here by Lewis Hine maintain a sense of dignity and self-respect. Hine included this photo as part of his contribution to the Pittsburgh Survey (1910–14), a landmark sociological study led by journalist and social reformer Paul U. Kellogg intended to inspire urban and industrial reform.

In his introduction to the volume of the survey, entitled *The Steel Workers* and written by John Fitch, Kellogg wrote, "Mr. Fitch makes articulate what the steel industry means to the men who are employed in it—for whom it makes up the matter of life, and who have no voice. . . . It is full time to bring these issues out in the open, where a man will not risk his livelihood by discussing it. That is the manner of America."[25] This statement aligns with Hine's approach to the steelworkers shown here.

Lewis Hine (1874–1940)
Gelatin silver print mounted on paperboard, 11.7 × 16.8 cm (4⅝ × 6⅝ in.), 1909
Smith College Museum of Art, Northampton, Massachusetts;
transfer from Hillyer Art Library

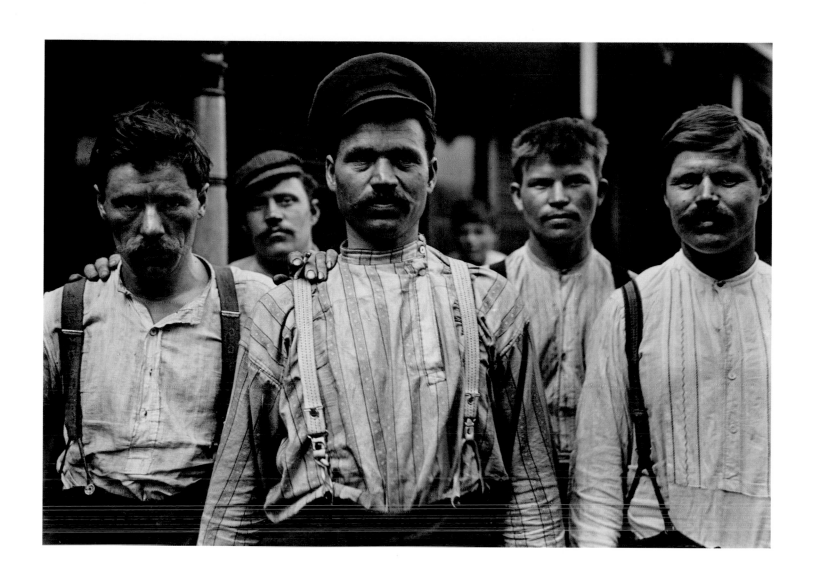

Known for his efforts as an investigative photographer for the National Child Labor Committee (see cat. 24), Lewis Hine documented the harsh living and working conditions of children in the United States from 1908 to 1924. Many of the pictures he made for the project were accompanied by his reports, which enhanced the affecting nature of his photographs. In this image, a girl balances precariously on one bare foot, soot covering her tiny gingham dress. The surrounding architecture dwarfs her, exemplifying how Hine used composition to heighten the impact of his pictures.

In the late 1940s, the Photo League of New York gave the photograph its title, referencing the 1924 comic-strip character Little Orphan Annie, who was forced to work in order to keep her place in an orphanage. As a significant historical document and an iconic artwork, this composition has been the subject of much discussion by critics and photographers alike, who have noted its emotional power. The celebrated early twentieth-century photographer Berenice Abbott wrote of it, "How magnificently the figure of the child is placed. The perspective is distorted; yet . . . the visual compulsion exercised by this distorted perspective is such that the eyes rush to this little orphan. Her situation in life is brought inescapably to the attention. A legitimate pathos is transmuted into a more profound emotion, the tragedy of disinherited children."[26]

Lewis Hine (1874–1940)
Gelatin silver print, 16.5 × 11.4 cm (6½ × 4½ in.), ca. 1910
Smithsonian American Art Museum, Washington, D.C.

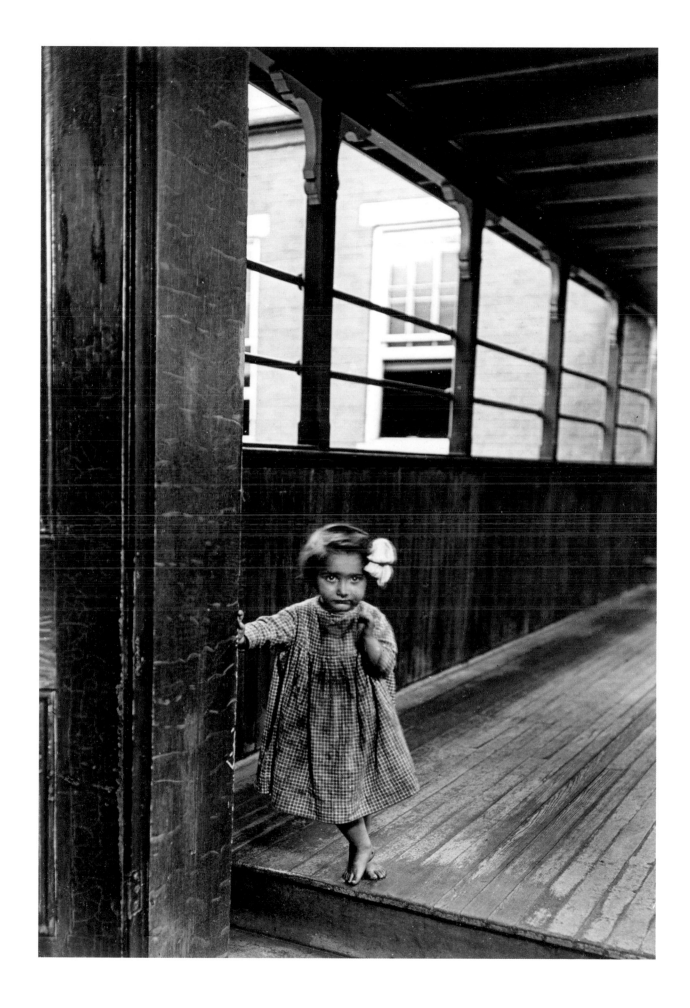

THREE GIRLS IN A FACTORY

"There is a prevailing impression that in the matter of child labor the emphasis on the labor must be very slight, but let me tell you right here that these processes involve work, hard work, deadening in its monotony, exhaustive physically, irregular, the workers' only joy the closing house."[27] So wrote Lewis Hine, who documented the brutal conditions child workers suffered in his visits to factories across the country and made public his findings with the goal of influencing the government to put an end to the practice of child labor.

Here three young girls wearing bows in their hair stand on the bare dirt floor of a factory while sewing tobacco leaves. Once strung together, the leaves would be hung from the rafters of a barn or shed to cure before they were further processed. The scene is as heart-wrenching as it is poetic in its composition. Hine seems to suggest that these little girls should be sewing a pattern together in a schoolroom rather than toiling in a factory. As art historian Alex Nemerov has noted, Hine was acquainted with the writings of socialist John Spargo, who in 1908 said, "To free the wage-worker from economic exploitation is indeed the primary object, the immediate aim of socialism, but it is not the sole object. It is not the end but a means to the end that is higher, the liberation of the soul."[28]

Lewis Hine (1874–1940)
Gelatin silver print, 11.1 × 15.4 cm (4⅜ × 6¹⁄₁₆ in.), ca. 1910
Collection of the Sack Photographic Trust for the
San Francisco Museum of Modern Art, California

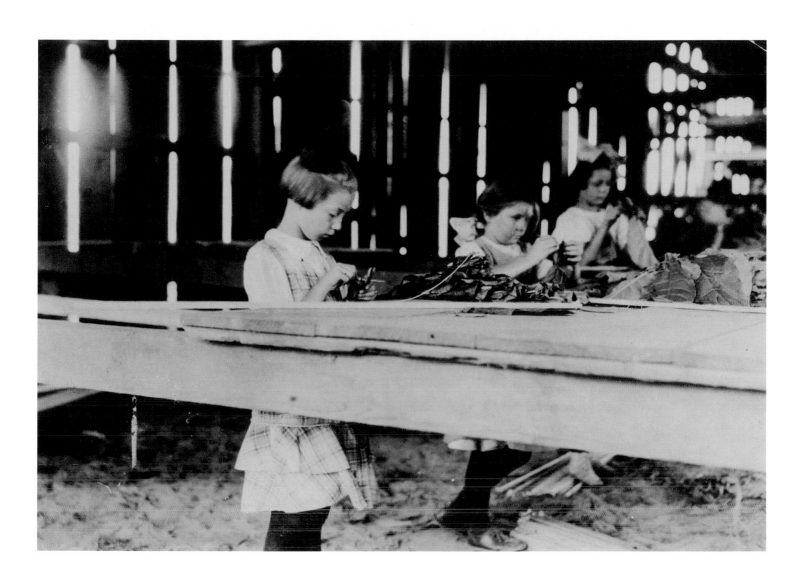

THE PIERCE ARROW

J. C. Leyendecker, a pioneering illustrator of magazine covers (see cat. 54) and advertisements, was born in Germany, immigrating to Chicago with his family as a child. His interest in illustration grew after he apprenticed in a Chicago print shop. Eventually his studies took him to Paris, where he drew inspiration from magazine and advertising illustrators. Not long after his return to America, Leyendecker began working as a commercial artist and was soon commissioned to create illustrations for advertisements. Quickly gaining popularity, especially for his menswear illustrations, Leyendecker also became well known for the more than three hundred covers he created for the *Saturday Evening Post* and other magazines.

In this advertisement for the Pierce Arrow Motor Car Company, Leyendecker portrays the automobile as an indication of wealth. A driver awaiting his patrons sits in the dark of the car's cab. His uniform conveys a sense of professionalism, while he remains physically separate and anonymous. In the early 1900s, such status-heightening vehicles often required a personal professional driver. At that time, automobiles were not only difficult to start; their heavy steering and stiff brakes made such drivers a necessity for elite passengers. These drivers were likely to have transitioned from a mechanical background, a common path following the advent of the automobile.

J. C. Leyendecker (1874–1951)
Tipped in monochrome mini-poster, 15.2 x 11.4 cm (6 x 4½ in.), 1909
David C. Ward

The Pierce Arrow

POWER HOUSE MECHANIC

In this photograph, a muscular man bends his body to grip a massive metal wrench in a Pennsylvania power plant, the curve of his back echoing the shape of the machinery. This model was thoughtfully selected by Lewis Hine, and they collaborated on this pose for what Hine called "interpretive photography." The photographer created this portrait for his series *Powermakers; Work Portraits* to highlight the beauty of what he called "the Human Side of the System." In a stark departure from his former tough and honest documentary approach, Hine now sought to elevate workers by tactfully staging pictures that revealed their positions in relation to the massive machinery they handled, ultimately showing that humans are the driving force behind machines. Hine wrote to journalist and social reformer Paul U. Kellogg, "The industrial lead I have been following is tremendous and virgin soil. It is possible that you might make use of some of this material in the new pictorial."[29]

When this image was published in *The Survey* in December 1921, Hine included this caption: "Just as stage coach and stable give way to locomotive and roundhouse, so these are passing before power plant and electrically driven train. Machinists, electricians, toolmakers, engineers are of the ancient line of grooms, and hostlers, and veterinarians. Why not, for they are the trainers of ten thousand horsepower."[30] This iconic image is less a portrait of a worker than it is a portrait of work as it was evolving in response to the rise of the machine.

Lewis Hine (1874–1940)
Gelatin silver print, 34.9 × 24.8 cm (13¾ × 9¾ in.), 1920–21
Brooklyn Museum, New York; gift of Walter and Naomi Rosenblum (84.237.7)

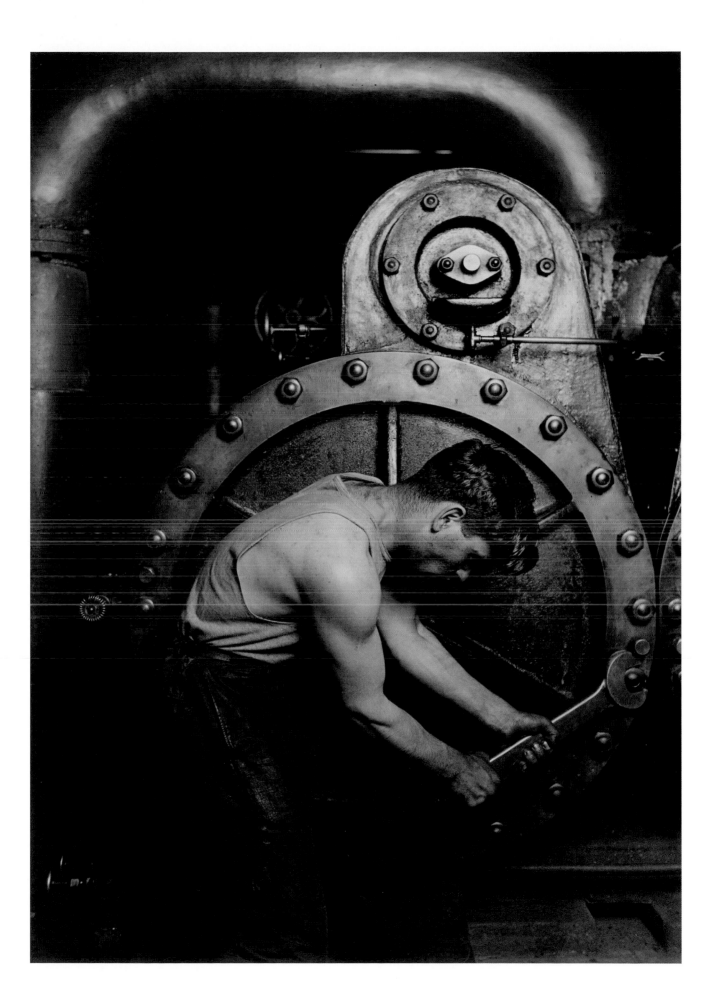

A WORKMAN

This portrait of Simon Staten—an unemployed steelworker, World War I veteran, and Ozark, Arkansas, native—records the hardships of unemployment that affected millions of American workers during the Great Depression. "Somehow both the great wars are in his eyes," observed Ada Miller, a secretary at the Red Cross in Dallas, where this painting was once displayed.[31] The two great wars she referred to are the Depression and World War I. The painter of this work, Olin Herman Travis, observed that Staten's pose recalled that of Abraham Lincoln.

Born and raised in Texas, Travis was a prominent member of the Dallas Nine, a circle of artists who found inspiration in the landscape and life of the Southwest in the 1930s and 1940s. This influence can be seen in the objective, unromantic style of his paintings and his choice of subject, namely working people and the land. Travis and his first wife, Kathryne Hail, founded the Dallas Art Institute, the first major art school in the South, offering courses in a variety of disciplines, and a summer artists' colony in Arkansas.

Olin Herman Travis (1888–1975)
Oil on canvas, 88.9 × 76.2 cm (35 × 30 in.), 1929
George and Beverly Palmer

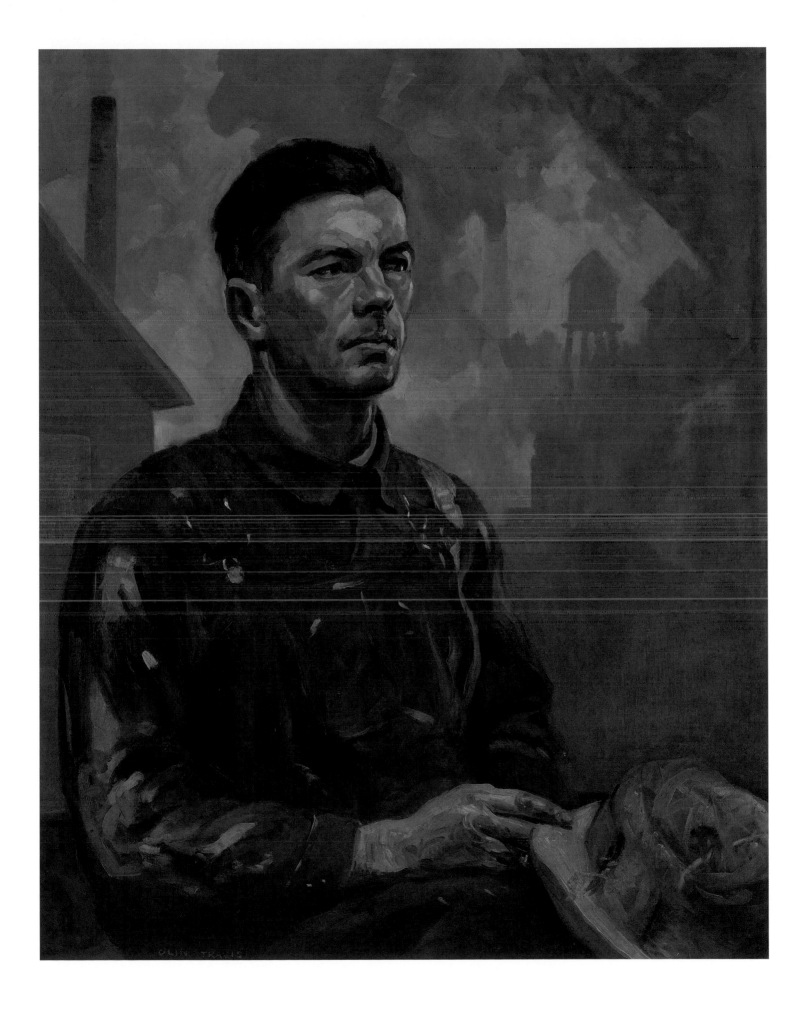

THE END OF DAY

Max Kalish emigrated from Lithuania to Cleveland with his family as a young boy. As a teenager, he attended the Cleveland Institute of Art, eventually moving to New York and later to Paris in order to further his education. After traveling domestically and abroad, Kalish returned to Cleveland in 1915, where he began studying dentistry. Though he left school soon afterward, this course of study provided Kalish with an excellent understanding of anatomy, which ultimately contributed to his work as a sculptor.

This laborer's slumped shoulders and hanging hands suggest the end of an exhausting workday. Although he appears weary and worn, the man's solid stance and muscular arms show strength and resilience. "As I mingle among the workers in factories or in the open, I find them in their natural poses," said Kalish. "While at rest there is a sense of rhythm and beauty that compares favorably with the great sculptural themes of the past."[32] Appreciating the rhythm and beauty of laborers—particularly the riveters and steelworkers of the Great Depression—Kalish represented these figures as heroic for their efforts in industrial America. His use of bronze acknowledged his subjects' mastery of metal while also immortalizing them in the material traditionally reserved for wealthy, accomplished sitters. Kalish sculpted a series of sixty-one one-third-scale portraits of American laborers from 1920 to 1937, for which he received critical acclaim.

Max Kalish (1891–1945)
Bronze, 39.1 (15⅜ in.) height, with socle, 1930
Smithsonian American Art Museum, Washington, D.C.; gift of Max Kalish

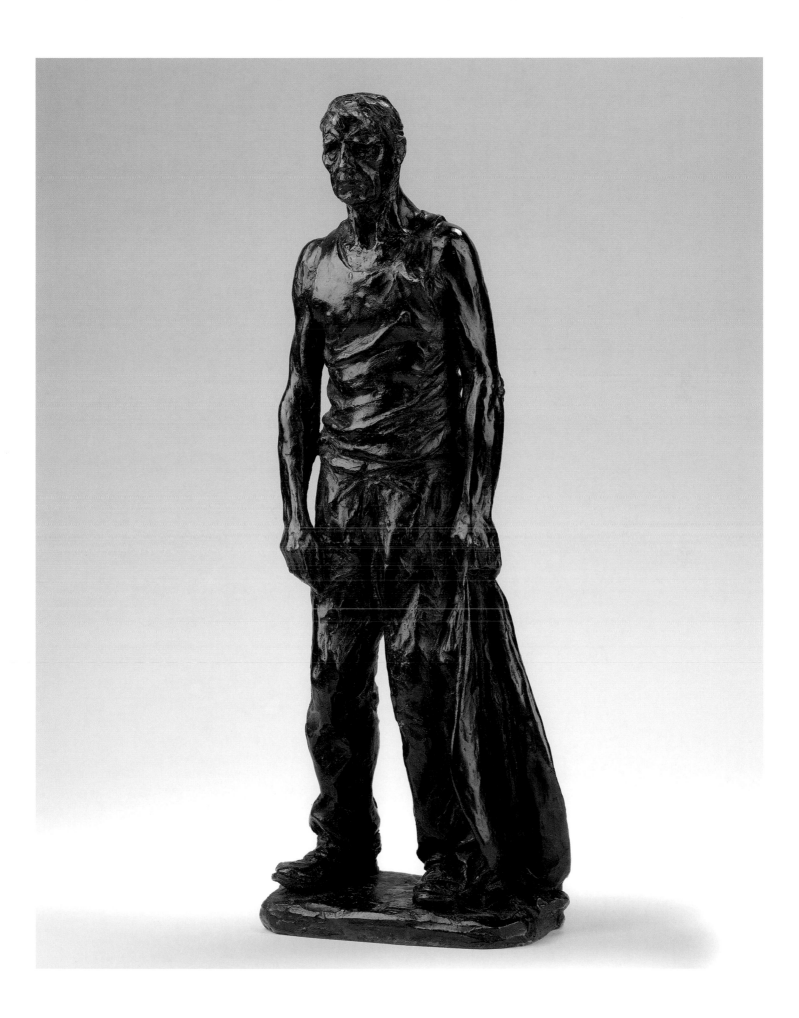

WORKERS ON THE EMPIRE STATE BUILDING

"Cities do not build themselves, machines cannot make machines, unless back of them all are the brains and toil of men,"[33] said Lewis Hine in regard to the 102-story Empire State Building. Hine spent most of his career exposing social injustice through documentary photography, but here he turned his lens on the phenomenal feats of laborers to chronicle the construction of the landmark skyscraper. In order to obtain the nearly one thousand exposures captured during the project, Hine ascended to the height of the workers in a rigged steel box of his own invention. At an altitude of nearly a quarter mile, the photographer documented these youthful laborers as they lifted thousands of tons of steel to seemingly unreachable heights.

Perched on a loop of cable, this worker soars above the New York City skyline, dwarfing multistory buildings, factory smokestacks, and the Hudson River, his unstable footing revealing the precarious nature of his job. "Strolling on the edge of Nothingness"[34] was the phrase *New York Times* reporter C. G. Poore used to describe this sort of undertaking. Hine celebrated manual labor by focusing his four-by-five-inch Graflex camera on construction workers, who went about their jobs without harnesses or much physical support. These photographs were later compiled into a volume titled *Men at Work* (1932), which explores the power dynamic between manual labor and the modern machine.

Lewis Hine (1874–1940)
Gelatin silver print, 40.4 × 50.3 cm (15⅞ × 19¹³⁄₁₆ in.), ca. 1930
Museum of Modern Art, New York City; Committee on Photography Fund

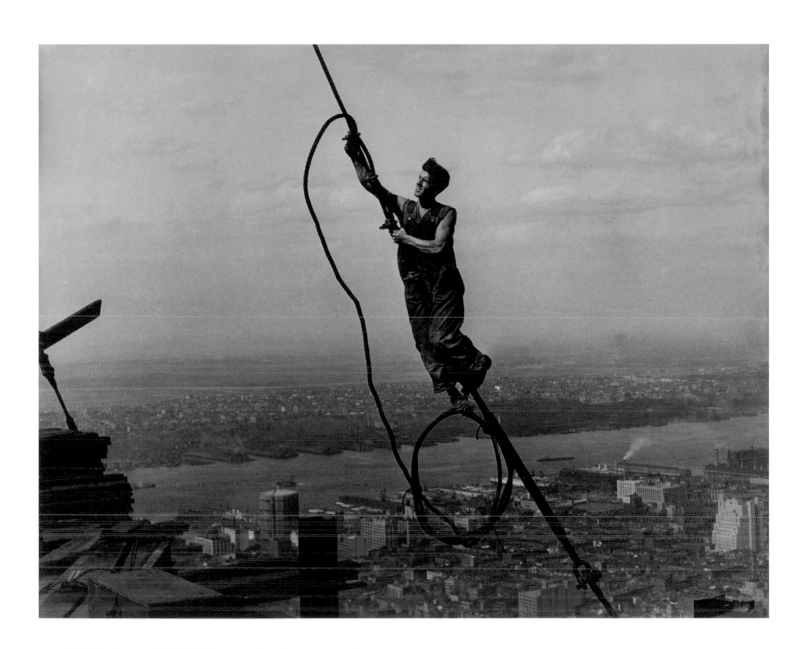

ALMA SEWING

London-born American artist Francis Hyman Criss was one of many artists commissioned by the Federal Art Project during the Great Depression. Under Franklin Roosevelt's New Deal, laborers, including artists, received government support to alleviate the devastation caused by the stock market crash of 1929. As the victims most affected by the economic crisis, middle—and lower—class workers were a subject of interest for Criss and many of his contemporaries.

In this image, Criss depicted a dignified African American seamstress surrounded by her tools and diligently engaging in her trade. Making the point that artists and workers should be aligned, he inserted his own image into the painting by including his reflection in the lamp. With this gesture, Criss declared himself and other artists—like the seamstress—important yet underappreciated members of the workforce. In an essay articulating his thoughts on the status of the artist in society, he wrote of "the poet-artist who restructures reality, the . . . forgotten window . . . which no one else would have . . . honored even with a side glance."[35] This painting offers a glimpse into what might be considered a "forgotten window" and refocuses the viewer's gaze on a scene that might not otherwise come into view.

Francis Hyman Criss (1901–1973)
Oil on canvas, 83.8 × 114.3 cm (33 × 45 in.), ca. 1935
High Museum of Art, Atlanta, Georgia; purchase with funds from the Fine Arts Collectors, Mr. and Mrs. Henry Schwob, the Director's Circle, Mr. and Mrs. John L. Huber, High Museum of Art Enhancement Fund, Stephen and Linda Sessler, the J. J. Haverty Fund, and through prior acquisitions (2002.70)

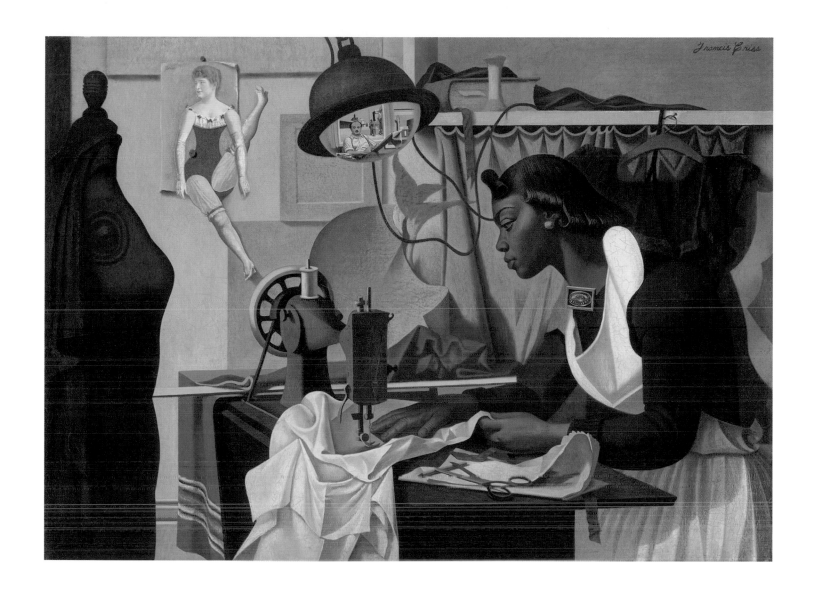

DESTITUTE PEA PICKERS IN CALIFORNIA. MOTHER OF SEVEN CHILDREN. AGE 32. ("MIGRANT MOTHER")

I saw and approached the hungry and desperate mother, as if drawn by a magnet. I do not remember how I explained my presence or my camera to her, but I do remember she asked me no questions. I made five exposures, working closer and closer from the same direction. I did not ask her name or her history. She told me her age, that she was thirty-two. She said that they had been living on frozen vegetables from the surrounding fields, and birds that the children killed. She had just sold the tires from her car to buy food. There she sat in that lean-to tent with her children huddled around her, and seemed to know that my pictures might help her, and so she helped me. There was a sort of equality about it.

—Dorothea Lange, "The Assignment I'll Never Forget: Migrant Mother," *Popular Photography*, February 1960

Originally from San Francisco, Dorothea Lange became well known for her documentary photography for the Farm Security Administration, a government program formed during the Great Depression to raise aid for and awareness of rural American poverty. While visiting a pea-picking camp in Nipomo, California, Lange captured this image of Florence Owens Thompson, a widowed mother and itinerant farmer. Though reluctant to have her picture taken for fear of being showcased as a specimen of poverty, Thompson eventually relented, believing the image might benefit those in similar situations. Capturing five exposures of the woman with her clinging children, Lange showed the pictures to her supervisor, which in turn led authorities to send aid to the pea-pickers' campsite. This image, widely distributed in newspapers and magazines, stands as a reminder of the economic turmoil and the resilience of American workers during the Great Depression.

Dorothea Lange (1895–1965)
Gelatin silver print, 33.7 × 26.4 cm (13¼ × 10⅜ in.), 1936
Prints and Photographs Division, Library of Congress, Washington, D.C.;
gift of the photographer

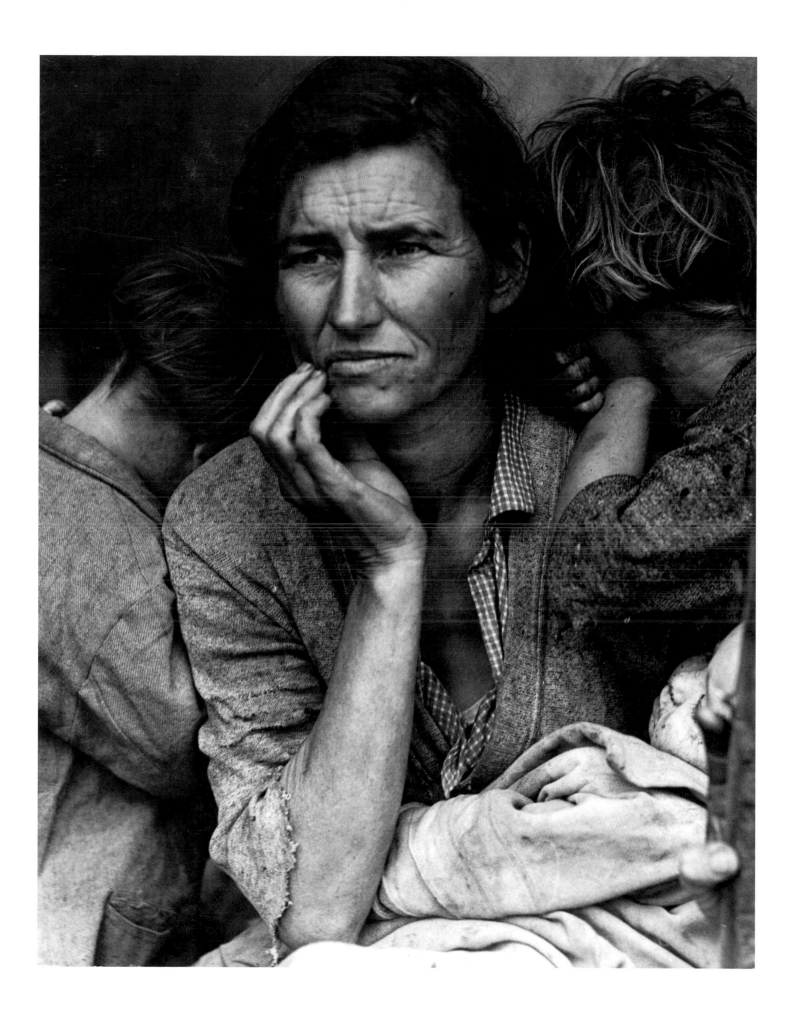

IRON MINER, BESSEMER, ALABAMA

Born in Copenhagen, Peter Sekaer immigrated to the United States in 1918. Upon his arrival, he rode freight trains across the country, taking odd jobs in order to make a living. Eventually landing in New York, Sekaer opened a sign-painting and printing workshop where he produced posters and advertisements. He later enrolled in the Art Students League, where he studied painting for five years.

It wasn't long before Sekaer took an interest in photography and began working with Berenice Abbott, a photographer best known for capturing New York's architecture, at the New School for Social Research. In 1936, he was a documentary photographer for the Rural Electrification Administration, a federal agency responsible for providing underresourced regions with access to power. Known for his outgoing personality, Sekaer was attuned to the minute details of everyday life, capturing often overlooked moments of intimacy and beauty. He also believed in the importance of capturing the true essence of his surroundings, a principle well articulated in this photograph. Here he displays the grittiness of an iron miner in Alabama, the close rendering of the man's face bringing attention to the harsh realities of his working conditions. Worn and weary, with head keeled to the side, this worker represents the millions of people who struggled to survive through the Great Depression.

Peter Sekaer (1901–1950)
Gelatin silver print, 21.3 × 16.2 cm (8⅜ × 6⅜ in.), 1936
High Museum of Art, Atlanta, Georgia; gift of the Peter Sekaer Estate (2010.294)

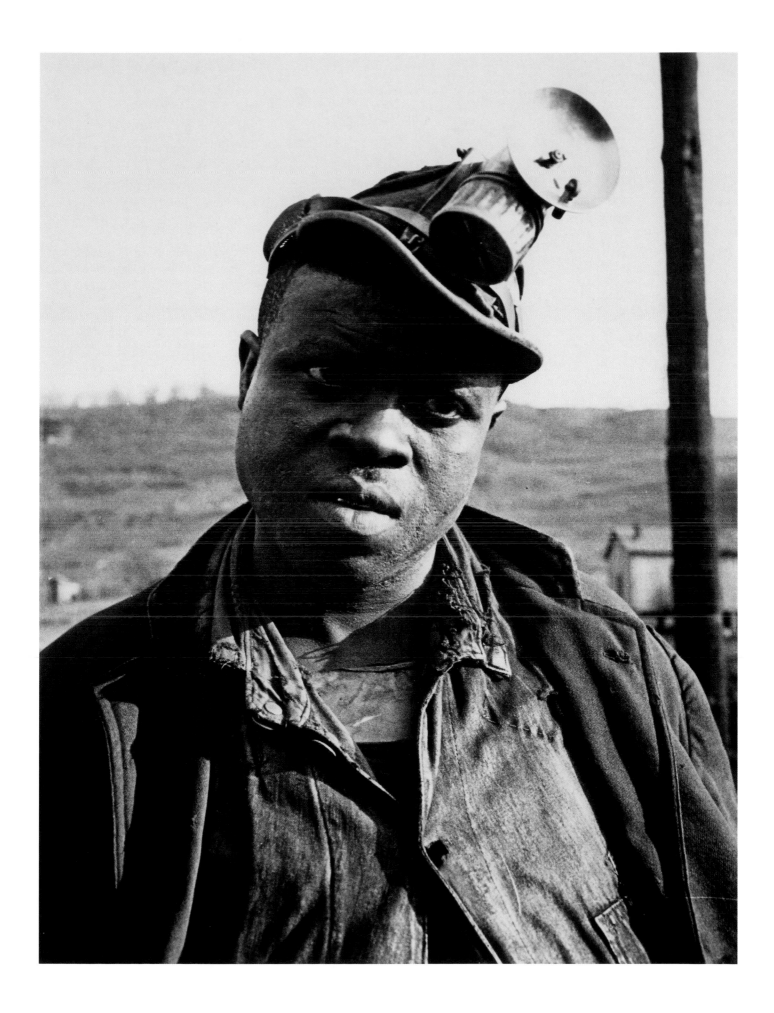

CEMENT WORKER'S GLOVE

Edward Weston said, "The camera should be used for a recording of life, for rendering the very substance and quintessence of the thing itself, whether it be polished steel or palpitating flesh." Weston was one of the founding members—along with Ansel Adams, Imogen Cunningham, Willard Van Dyke, and Sonya Noskowiak—of the circle of photographers known as Group f/62, who often set their camera lenses on their large-format cameras to the smallest aperture to ensure maximum sharpness in both the foreground and background of their pictures. In this photograph, an abandoned rubber glove with hardened cement plastered over its surface serves as a conceptual portrait of the worker who wore it, and it is a poignant reminder of the utilitarian aspects of a working life. The worker's absence in this photograph conjures a sense of anonymity that has often defined the American worker.

A decade before he took this photograph, Weston visited the ARMCO Steel Plant in Middletown, Ohio. The experience had a powerful effect on him and marked a turning point in his career in that he began to move away from his pictorialist style and started taking photographs that emphasized abstract forms. Weston believed an artist "clears the way for revolution" through visionary work that is out of sync with and ahead of its time. He wrote, "I am not trying to turn the artist into a propagandist, a social reformer, but I say that art must have a living quality which relates it to present needs, or future hopes, opens new roads for those ready to travel, those who were ripe but needed an awakening shock—impregnation."[36]

Edward Weston (1886–1958)
Gelatin silver print, 19.1 × 24.2 cm (7½ × 9½ in.), 1936
Edward Weston Archive, Center for Creative Photography,
University of Arizona, Tucson
© 1981 Center for Creative Photography, Arizona Board of Regents

SHARE CROPPER

Born in Paris, Texas, Jerry Bywaters was deeply connected to Texas culture. An artist, critic, and director of the Dallas Museum of Art, he was dedicated to art education and art that reached broad audiences. He was also a leader of the Dallas Nine, an influential group of Texas artists who focused on the land and the people, primarily laborers, of the Southwest. They often painted in a style evocative of German New Objectivity, an unsentimental approach to subject matter that developed in reaction to the romanticism of expressionism and impressionism. Bywaters was inspired by the Mexican muralists José Clemente Orozco and Diego Rivera; after spending time touring Mexico and studying their works, he created his own murals in Texas, including ten panels in Dallas's city hall that include scenes of laborers building the viaducts over the Trinity River.

Share Cropper reflects these influences, shown in the unromantic and frank depiction of a worker in a cornfield. The subdued colors, gray sky, and serious, unflinching expression on the sharecropper's face evidence the harsh realities of farm labor. Associated with the destruction of crops, the grasshoppers resting on the corn husks in the foreground further emphasize the challenges of agricultural work.

Jerry Bywaters (1906–1989)
Oil on Masonite, 76.5 × 61 cm (30⅛ × 24 in.), 1937
Dallas Museum of Art, Texas; Allied Arts Civic Prize, Eighth Annual Dallas Allied Arts Exhibition, 1937

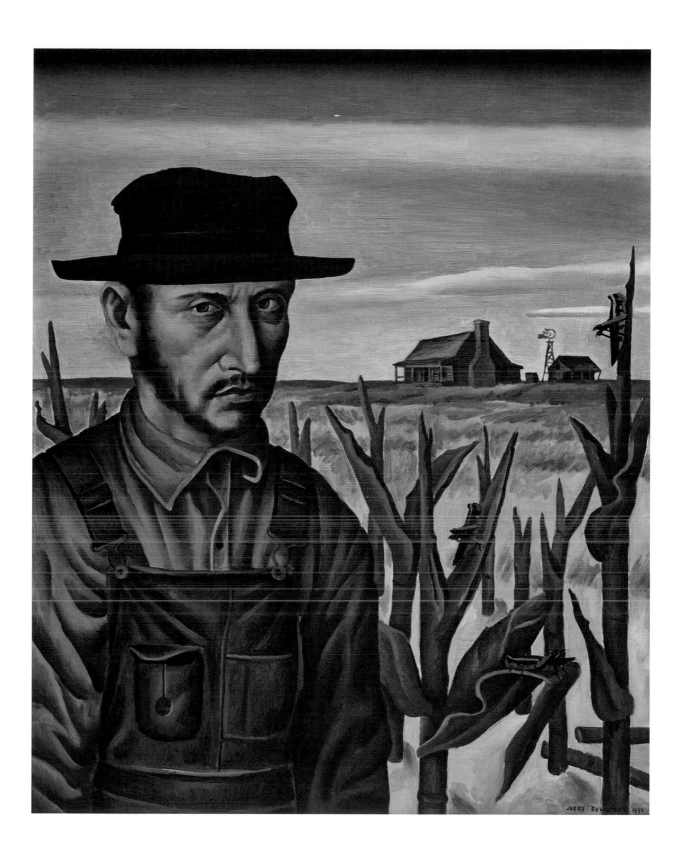

TORTILLA MAKER

French-born artist Jean Charlot was fascinated by the folk art he observed around the Mayan site of Chichén Itzá, where he lived from 1926 to 1928. He was also impressed by the humble lives and traditions of the Mexican peasants he observed. These sources are clear in this print, in which a woman, a baby strapped to her back, kneels on the floor and rolls out dough.

Charlot also was influenced by such Mexican muralists as José Clemente Orozco. Wanting his work to reach broad audiences, he appreciated art that communicated clearly and succinctly through simplified forms and direct, uncluttered compositions. In a 1971 interview, Charlot said, "You can make the portrait of a person or of a dog or of a tree. Each one is a mystery in the very real sense of the word. I don't think you have to go into theology for that, but simply the complexity of each one as a construction, and of course when it gets into motion, reasons, and so on, each one is a universe."[37] In this portrayal of a woman and her child, Charlot created an accessible image that ties the idea of work to the universal theme of family life.

Jean Charlot (1898–1979)
Lithograph, 40.6 × 30.5 cm (16 × 12 in.), 1937
Smithsonian American Art Museum, Washington, D.C.; gift of Jack Lord

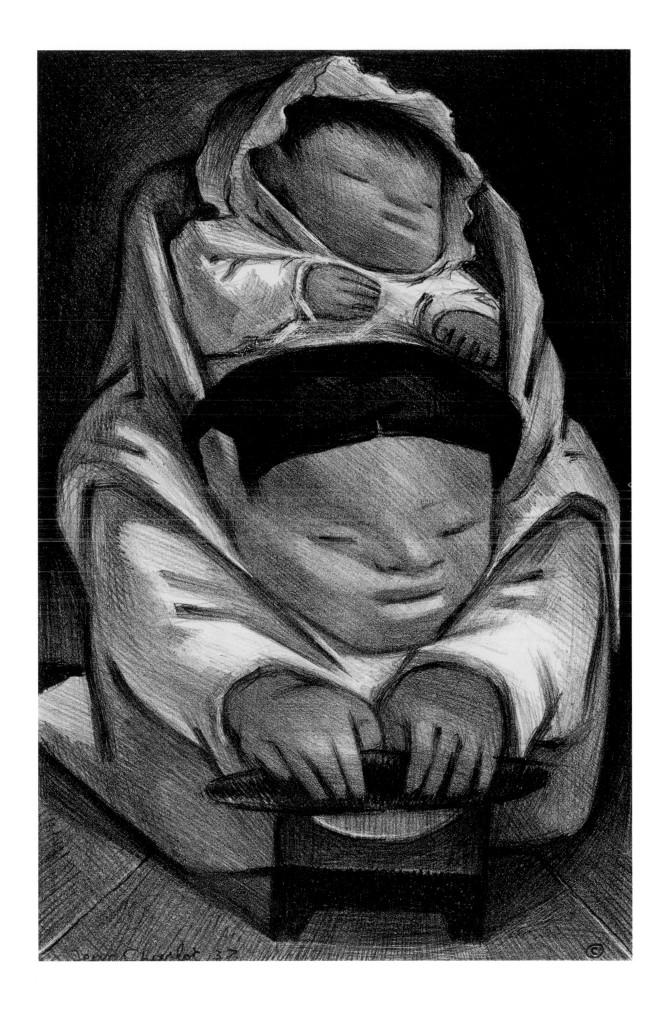

ARC WELDERS AT NIGHT

This etching, depicting an evening scene on East Thirty-fourth Street in the Murray Hill neighborhood of New York, is an example of Martin Lewis's ability to capture nighttime scenes. He focused on activity on the streets of New York, fellow night dwellers, and the lives of passersby in his many artworks. Although they are important aspects of any artist's work, Lewis particularly emphasized light and form, as is evidenced here by the bright rays emanating from the welders' torches on the dark Manhattan street.

Born in Australia, Lewis moved to the United States in his twenties, first landing in San Francisco and eventually settling in New York, where he spent most of his life. His travels also took him to Japan, where he lived briefly. Though constantly drawing and creating art from a young age, Lewis started out as a laborer, working on a cattle ranch, in logging and mining camps, and as a sailor before devoting himself exclusively to his art. Lewis received only a tenth-grade education, yet he was an avid reader and was known for his sharp intellect and humor.

Martin Lewis (1881–1962)
Drypoint and sandground, 36 × 27.5 cm (14³⁄₁₆ × 10¹³⁄₁₆ in.), 1937
Bank of America Collection

STUDY FOR MAN SEWING

Theodore Roszak is best known for his constructivist sculptures, which include rectangles, ellipses, and cubes of wood, plastic, and metal. Born in Poland, Roszak's parents immigrated to Chicago in 1907. His father had been a farmer, and his mother was a clothing designer, a fact that might have inspired this study for an oil portrait. Here, the sewer's intense focus and hunched back bring him eye to eye with the machine before him. Composed of simple geometric shapes, man and machine become one as the sewer reaches with an arm to manipulate the mechanism while the other rests on the table, fingers pinched around a piece of thread and forming a circle.

A year after he created this sketch and a series of related works, Roszak called his constructions a "unification of architecture and engineering, an idealized conception of man's creative potential."[38] His portraits, like his constructions, are at once whimsical and architectural, reflecting the inspiration of Bauhaus artists such as László Moholy-Nagy, who promoted the philosophy that artists are integral to advancing society technologically and thus enhancing the world.

Theodore Roszak (1907–1981)
Pencil on paper, 13.3 × 21.6 cm (5¼ × 8½ in.), 1937
Mr. and Mrs. Hunter S. Allen Jr.
Art © Estate of Theodore Roszak/Licensed by VAGA, New York, NY

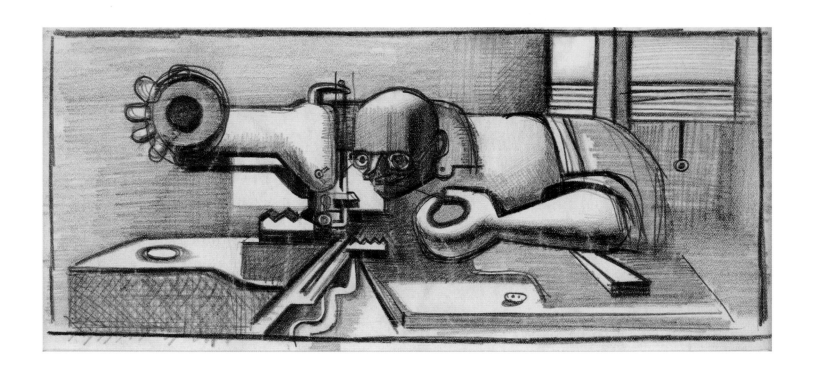

STOOP LABOR IN COTTON FIELD, SAN JOAQUIN VALLEY, CALIFORNIA

"Now the bag is heavy, boost it along. Set your hips and tow it along, like a work horse." John Steinbeck's description of California cotton pickers in *The Grapes of Wrath* fits this photograph perfectly. A man hunches over stalks of cotton plants, wearing a uniform of dark denim and draped by a cloth cross-body sack, the strap wearing thin as its bulging contents weigh him down. His hands and face hidden from view, the worker has lost his individual identity to the intensity and exhaustion of stoop labor. One consequence of the crouched position required in this type of backbreaking labor was an employer's inability to determine whether someone in the field was working or taking a break, an ambiguity that often led to undue punishments.

Dorothea Lange was known for documenting social and political events, such as the Dust Bowl migration, strikes in San Francisco, and the challenges faced by migrant workers. Traumatic childhood experiences—namely, contracting polio and being deserted by her father—shaped the way Lange came to view the world, especially her intense interest in family and community. In the 1930s, Paul Taylor, an economist for California's State Emergency Relief Administration, invited Lange to photograph an influx of people looking for agricultural work in the state. These photographs were sent to the relief agency and were ultimately used in reports that influenced the government's decision to establish camps for these migrant workers.

Dorothea Lange (1895–1965)
Gelatin silver print on Masonite mount, 23.5 × 30 cm (9¼ × 11¹³⁄₁₆ in.), 1938
The J. Paul Getty Museum, Los Angeles, California (2000.50.11)

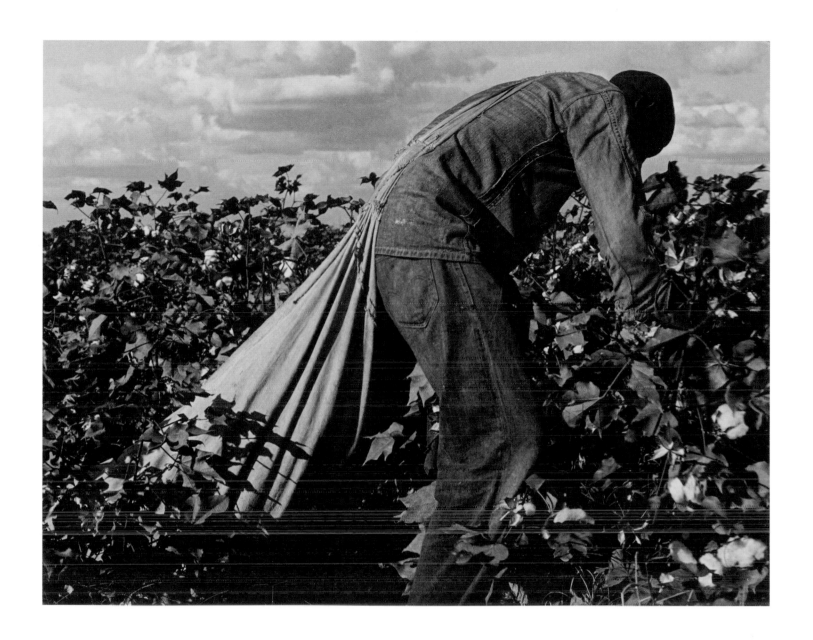

LABORER (STEVEDORE LONGSHOREMAN, NORFOLK, VIRGINIA)

Longshoremen, who engage in the physically demanding process of loading and unloading cargo ships at seaports, also face intermittent employment, as days may pass between the arrival and departure of boats. Pictured during one of these downtimes, the subject of Robert McNeill's photograph looks upward with a direct, inquisitive gaze. Born in Washington, D.C., McNeill attended Howard University as a premed student for two years before studying at the New York Institute of Photography. Designated a photographic consultant to the Federal Writers' Project, a government program supporting writers during the Great Depression, McNeill traveled across Virginia to document the lives of urban and rural working-class citizens. He contributed this picture to the publication *The Negro in Virginia* (1940), a detailed account of the history of African Americans from their arrival in the state in the early seventeenth century through the rise of Jim Crow laws. Admiring photographers such as Dorothea Lange (see cats. 34 and 41) and Gordon Parks (see cats. 48 and 53), McNeill aimed to expose the underside of American society apparent in its treatment of workers. Yet he did not describe his work in terms of activism, saying instead: "I never considered myself a protest photographer. Maybe I was always more interested in artistic depth than shaking things up."[39]

Robert McNeill (1917–2005)
Gelatin silver print, 24.1 × 19.4 cm (9½ × 7⅝ in.), 1938
Smithsonian American Art Museum, Washington, D.C.

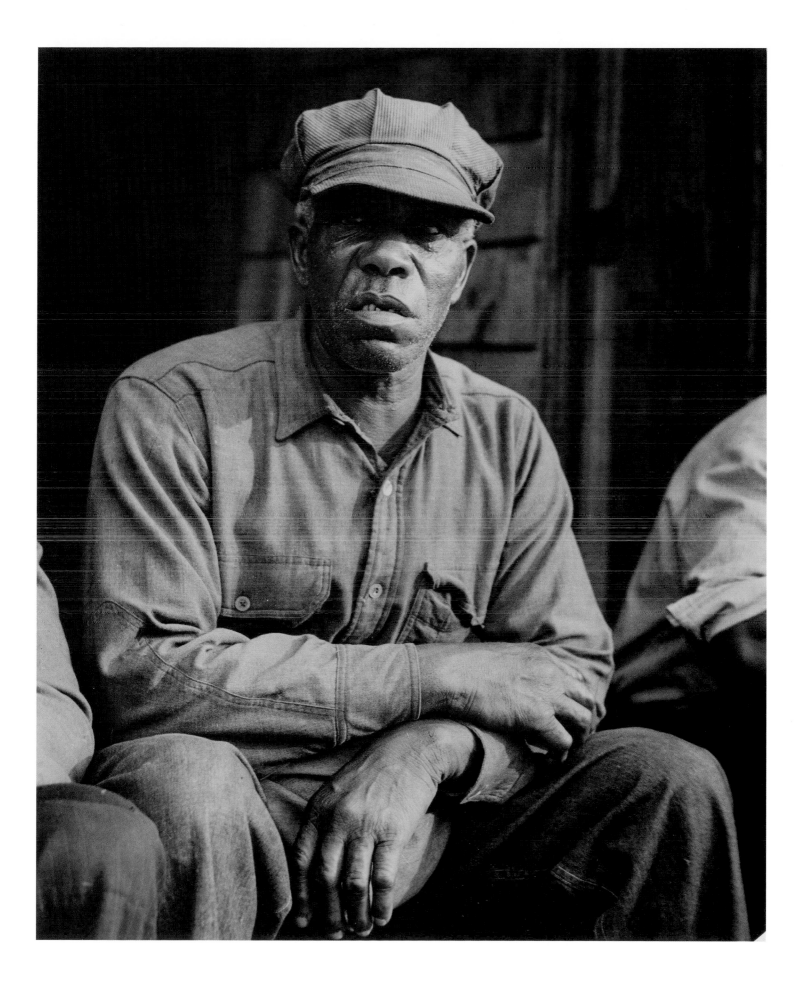

THE RIVETER (MURAL STUDY, BRONX CENTRAL POST OFFICE)

Best known as a painter and graphic artist, Ben Shahn worked from 1933 to 1938 as a photographer for the Farm Security Administration, the New Deal agency created to find solutions to rural American poverty, which commissioned artworks about the lives of laborers. Like many of his peers, he was interested in photography as a social and political tool, saying, "If we are to have values, a spiritual life, a culture, these things must find their imagery and their interpretation through the arts."[40] This belief is especially clear in the art Shahn produced later in his career, though his interest in workers and their value to American society began much earlier.

Early in 1938, the U.S. Treasury Section of Paintings and Sculpture hosted a competition to decorate the newly completed interior of the Bronx Central Post Office. Of the two hundred entrants, Shahn and his wife, Bernarda Bryson Shahn, were named winners and soon began sketches for the final design. Collectively titled *Resources of America*, the cycle of thirteen murals depicts the virtuosity of the American laborer through a series of portraits of working men and women. This study, later transferred onto the post office's walls, portrays a riveter who, with a determined gaze, maintains a steady arm and nimble fingers.

Ben Shahn (1898–1969)
Tempera on paperboard, 83.8 × 37.5 cm (33 × 14¾ in.), 1938
Smithsonian American Art Museum, Washington, D.C.

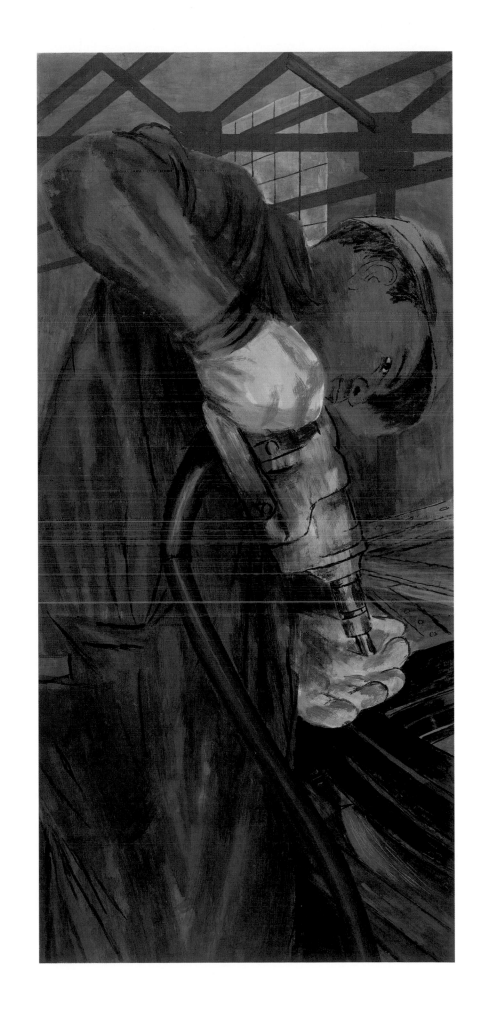

MIGRANT WORKER, VISALIA, CALIFORNIA

In an effort to counter objections from right-wing critics of California's Depression-era migratory labor camps, the Farm Security Administration (FSA), whose Information Division was led by Roy Stryker, sent staff photographer Arthur Rothstein to the city of Visalia to document the inhabitants of the camp there. The aim was to portray life within the camp in a positive light by picturing its members and facilities in an affirming and humanizing way. In addition to his photographs of tidy dwellings and quaint gardens, Rothstein systematically depicted members of the community in a series of close-up portraits that brought the individuality of the subjects into focus. As part of this series of images, this migrant worker, with his even gaze, clean-shaven face, and neat dress, displays a sense of sincerity and respectability, in effect offering proof of the dignity of the camp's residents.

In a 1964 interview, Rothstein reflected on his work with Stryker at the FSA, saying, "I think we had a great social responsibility. This is one thing that we all have in common. We were dedicated to the idea that [our] lives can be improved, that man is the master of his environment and that it's possible for us to live a better life, not only materially, but spiritually as well. We were all tremendously socially conscious. This had nothing to do with photography, but it was evident in everybody involved in this project, from Roy right on through—even to the secretaries."[41] Portraits such as this one reveal the honor and respect with which Rothstein approached his subjects.

Arthur Rothstein (1915–1985)
Gelatin silver print, 30.3 × 22.9 cm (11¹⁵⁄₁₆ × 9 in.), 1940
Davis Museum at Wellesley College, Wellesley, Massachusetts;
gift of Edith Davis Siegel (Class of 1938)

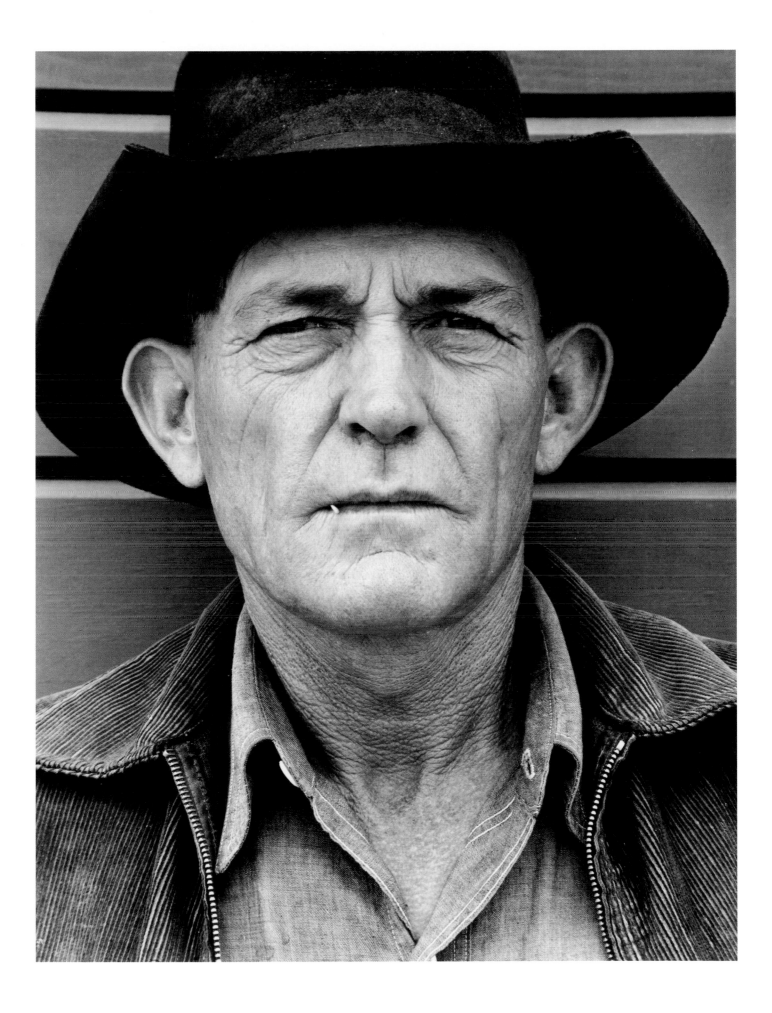

THE CARPENTER

Ben Shahn once said that he painted two things: "what I love and what I abhor."[42] Known for his left-wing politics, Shahn viewed his art as a means to expose social injustice. He developed his graphic, social realist approach as a young man while apprenticing for a commercial lithographer. This experience allowed him to support himself financially while working toward the goal of making a living as a painter. Shahn served in several different government programs, including the Farm Security Administration in the 1930s (see cat. 43) and the Graphic Arts Division of the Office of War Information during World War II.

Shahn was always proud that his father and grandfather in Lithuania had been woodworkers, and he identified strongly with laborers, a key theme of his art. His Depression-era images of urban poverty and laborers show his respect for working-class Americans and his concern for how they were treated. This unfinished portrait represents one such laborer, a carpenter who reaches above his head with large, forceful hands to steady a beam while hammering it into place. The image later served as a prototype for a cover of *Popular Homes* magazine.

Ben Shahn (1898–1969)
Watercolor and gouache on paper, 20.3 × 30.5 cm (8 × 12 in.), 1940–42
Mr. and Mrs. Hunter S. Allen Jr.
Art © Estate of Ben Shahn/Licensed by VAGA, New York, NY

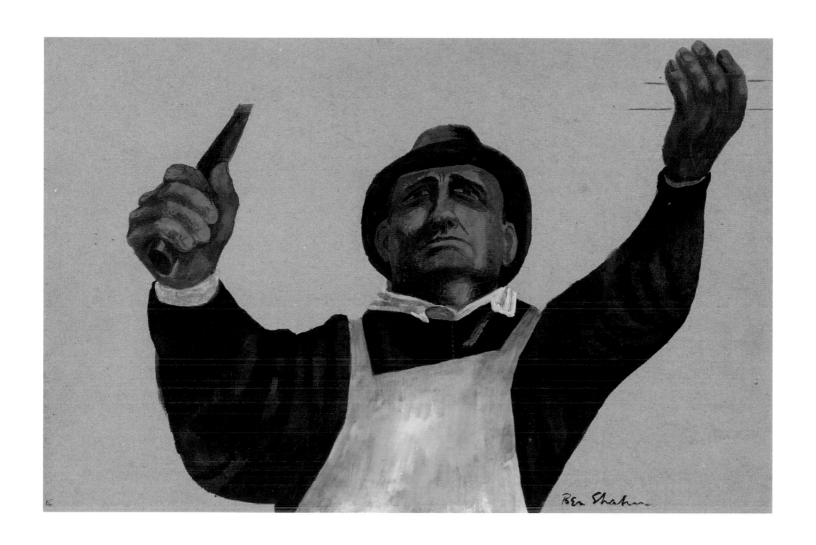

WORKERS AT THE ROUNDHOUSE OF THE C & NW RR PROVISO YARD, CHICAGO, ILL.

In his autobiography, Farm Security Agency staff photographer Jack Delano wrote, "I thought the camera could be a means of communicating how I felt about the problems facing the country and that therefore I could perhaps influence the course of events."[43] That impulse drove him to take pictures such as this one of two railroad men, whose toils are visible in their tired gazes and soiled overalls. The men worked for the Chicago and North Western Railway, which operated one of the longest railroad lines in the United States at the time; they are depicted in a roundhouse, a semi-circular structure typically built around a turntable that redirected steam trains and locomotives and used to store and repair the locomotives. This work represents one of Delano's earliest experiments with color photography, with hints of bright hues providing visual contrast within the dingy setting. The blue shirt and red bandana of the men call to mind the colors of the American flag, evoking a sense of patriotism and national pride during a period of war.

Jack Delano (1914–97)
Digital inkjet print from 4 × 5 color transparency, 1942
Prints and Photographs Division, Library of Congress, Washington, D.C.

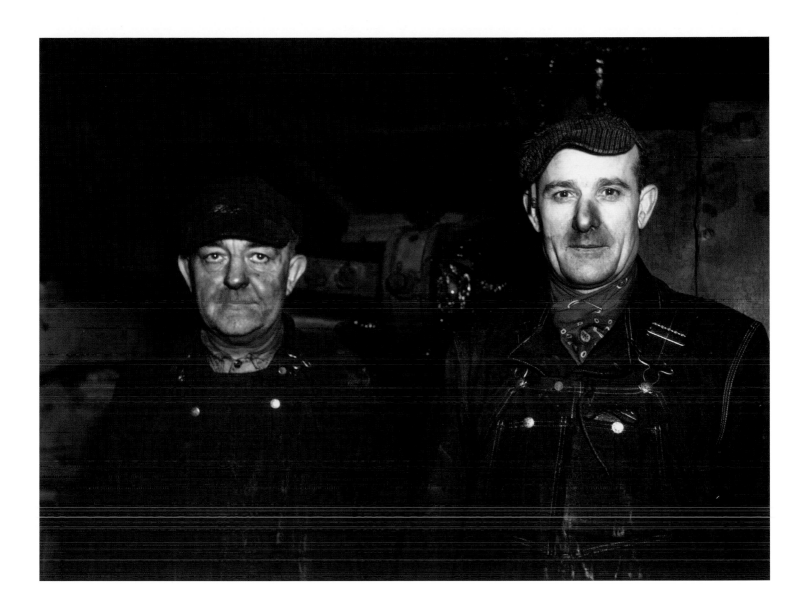

LATHE OPERATOR MACHINING PARTS FOR TRANSPORT PLANES AT THE CONSOLIDATED AIRCRAFT CORPORATION PLANT, FORT WORTH, TEXAS

Following the U.S. entrance into World War II, President Roosevelt created the Office of War Information, an agency that promoted patriotic activities while documenting and releasing news of the war. Among the renowned photographers employed by this agency were Ben Shahn (see cats. 43, 45, and 51), Dorothea Lange (cats. 34 and 41), Gordon Parks (cats. 48 and 53), and Lewis Hine (cats. 22, 24–27, 29, and 32). They captured the diversity of the American experience and often raised awareness about important topics. Staff photographer Howard R. Hollem contributed to this effort with his images of men and women involved in wartime industries, his photographs emphasizing their good work and capturing a sense of military preparedness and heroism.

The subject of this photograph is one of the many women who took jobs during World War II—the female labor force grew by 6.5 million during the war—as men left theirs and joined the military. With the end of the war, most women left their factory jobs and men returned to their former positions, but some women continued working in the booming postwar economy, often entering traditional female professions such as secretarial work and nursing.

Howard R. Hollem (died 1949)
Digital inkjet print from 4 × 5 color transparency, 1942
Prints and Photographs Division, Library of Congress, Washington, D.C.

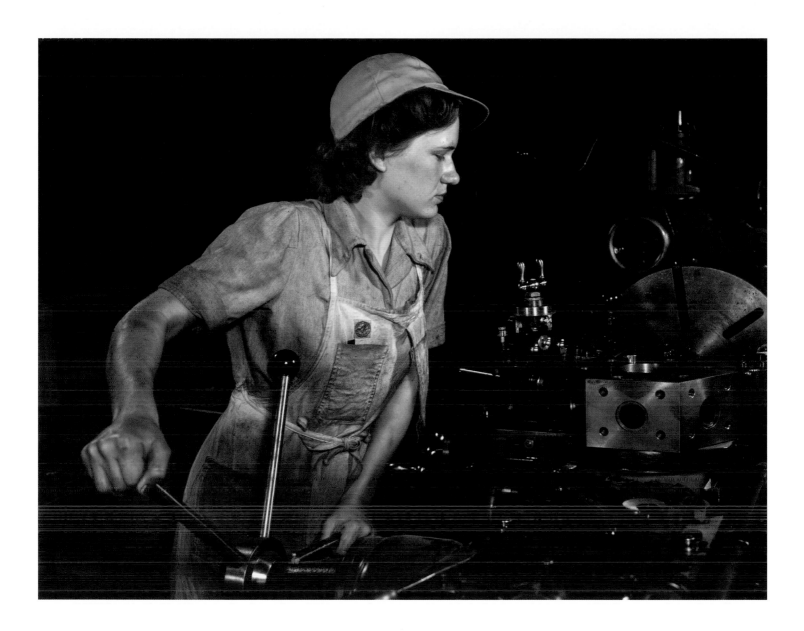

WASHINGTON, D.C., GOVERNMENT CHARWOMAN (AMERICAN GOTHIC)

The first African American staff photographer for *Life* magazine, Gordon Parks made this photograph when he was a part of the Farm Security Administration's photographic team in 1942 and 1943. This work, combined with his subsequent employment with the Office of War Information (1943–45), allowed him close access to workers, prompting him to capture his subjects from a perspective of identification and empathy: he was himself a government worker and had taken odd jobs throughout his life. In fact, many of his life experiences contributed to the urgency of the human- and civil-rights messages conveyed by his images.

The subject of this photograph, Ella Watson, was a worker he met at a government building. Holding a mop and broom and standing before an American flag, her pose calls to mind Grant Wood's iconic painting *American Gothic* (1930), and Parks saw this visual echo as an expression of the inequality experienced by African American workers. His own experience of discrimination in Washington, D.C., and his desire to expose the prejudice that pervaded the nation's capital motivated him to create a series of eighty-five portraits of Watson that charted her daily life. In contrast to his images of Watson cleaning offices at the U.S. Treasury, pictures of Watson going about her daily life with her daughter and grandchildren—at home and in places such as her church—provide a humane and tender portrait of a woman's life and offer viewers of all backgrounds a point of connection.

Gordon Parks (1912–2006)
Gelatin silver print, 110.6 × 81 cm (43⁹⁄₁₆ × 31⅞ in.), 1942
National Gallery of Art, Washington, D.C.;
Corcoran Collection (The Gordon Parks Collection), 2016.117.104

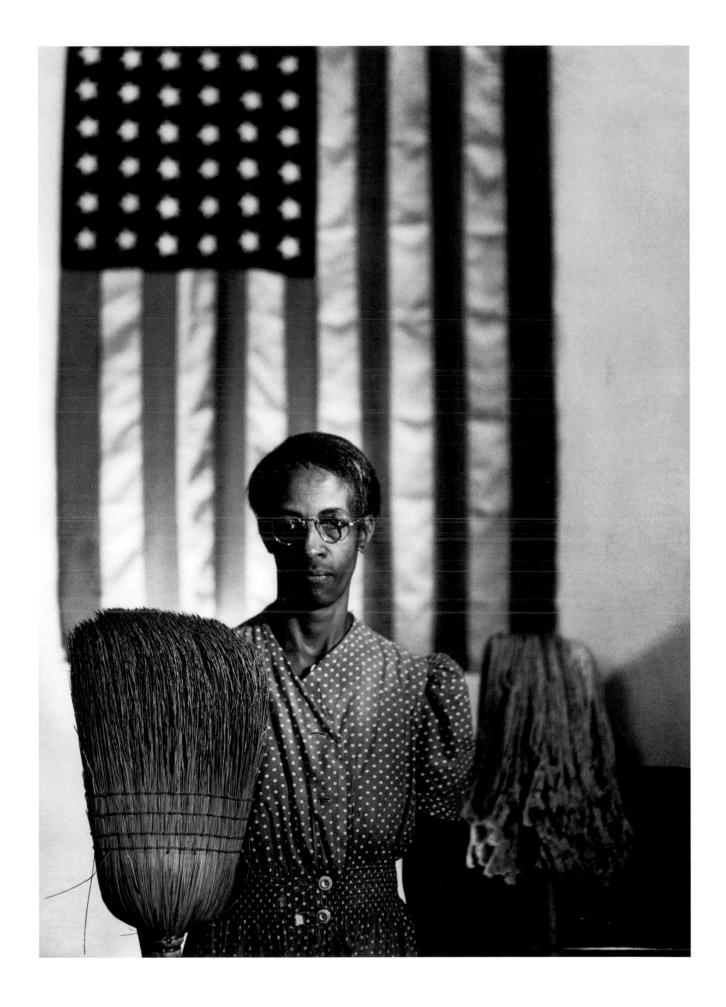

WE CAN DO IT!

In 1942, Westinghouse Electric and Manufacturing Company commissioned J. Howard Miller to create propaganda posters directed at women in the civilian labor force. Made with the intent of boosting the morale of Westinghouse employees, this image became an icon of its time, appealing to women throughout America. With booming production and a shortage of male workers due to the draft, women, retirees, and students filled many vacant factory jobs during World War II. This image portrays the lifestyle of those women as one of patriotism, confidence, and hard work. With an attractive and groomed appearance, the woman pictured here glamorizes the notion of female labor, suggesting that femininity need not be sacrificed in order to work. Flexing her arm muscles, she calls upon women to contribute to the war effort: "We can do it!" Images with similar themes were common during this period, as women workers were increasingly needed on the home front. Posters declared, "The more women at work the sooner we win!"[44] to encourage women to seek employment and acknowledge their value in the workforce.

J. Howard Miller (1918–2004)
Photolithograph, 55.9 × 43.2 cm (22 × 17 in.), ca. 1942
Division of Political History, Smithsonian National Museum of American History, Washington, D.C.

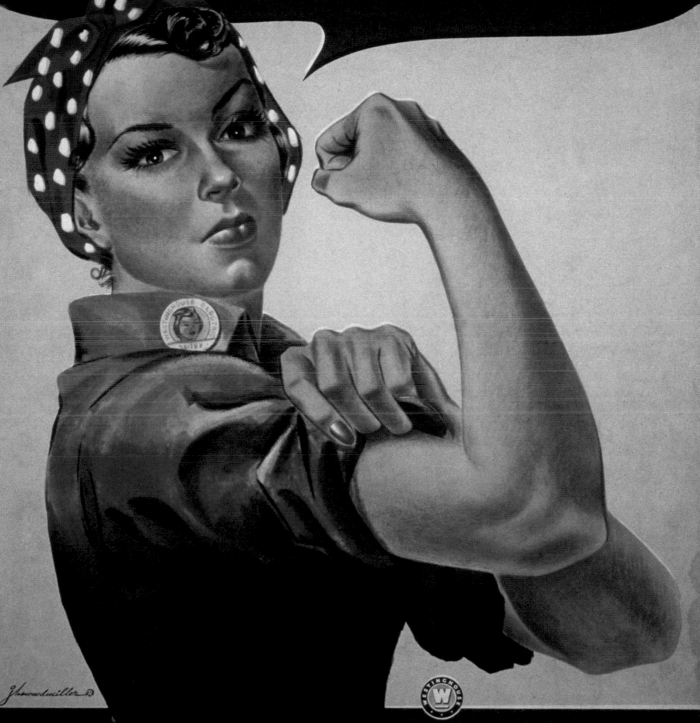

FARM COUPLE AT WORK

"I am no ordinary American Negro painter, or no ordinary American painter, I am recognized as a painter of value . . . so I must demand respect."[45] William H. Johnson's proclamation regarding his status as a black artist in the early twentieth century describes the spirit that informed his visualization of the African American experience. Johnson pursued a number of different styles during his creative development and entered his most prolific period in 1939. Seeking to capture what he called "modern primitivism," he used vibrant colors, solid forms, and stylized figures to portray contemporary black life. This graphic style was shaped in part by his experience copying the popular comic strip *Bringing Up Father* as a youth.

In *Farm Couple at Work*, Johnson imagines a folkloric scene of the pastoral South. Inspired by his upbringing in Florence, South Carolina, the artist conjured this subject during his stay in Harlem—a spot far removed from the painting's rural setting. The couple carry out daily tasks under a rising sun, suggesting the cyclical, ritualized nature of their labors. Their enlarged hands and feet imply lives of tough work, while the mule's wide hooves, crooked legs, and bound neck and girth indicate a burdensome, confined existence. Johnson was inspired by Pablo Picasso's highly decorative motifs and incorporated an ornamental quality in this painting through the stripped, banded landscape and blocks of color.

William H. Johnson (1901–1970)
Oil on paperboard, 61 × 72.7 cm (24 × 28⅝ in.), ca. 1942–44
Smithsonian American Art Museum, Washington, D.C.;
gift of the Harmon Foundation

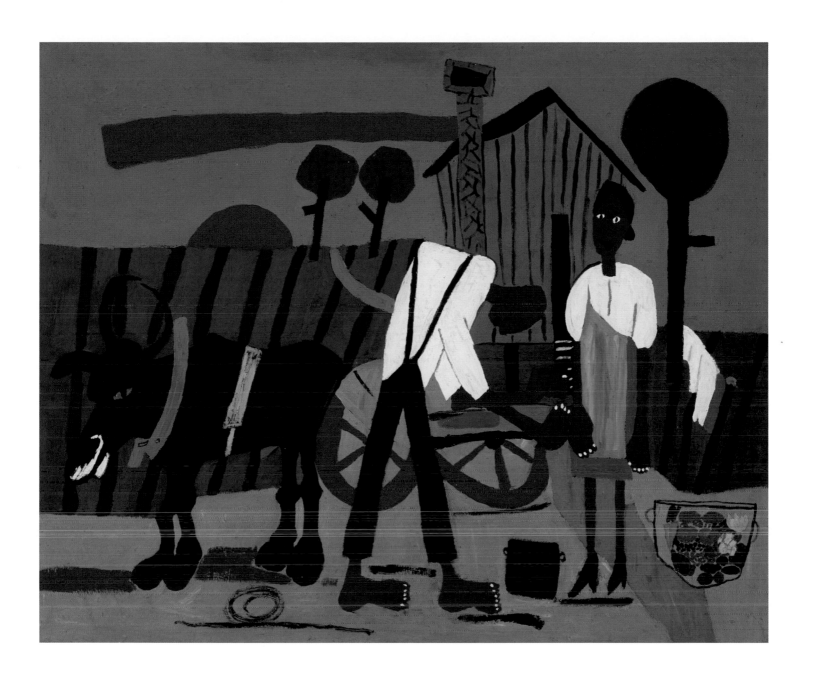

WELDERS

The stoic faces of these welders below their hinged masks dominate this dramatically cropped portrait. As the man on the right reaches his fingertips over the edge of the composition, his coworker creases his brow, perhaps studying their handiwork. The reflection of the looming red skeleton of a building in the welder's goggles—reminiscent of the one in the background of Shahn's *The Riveter* (cat. 43)—provides an optimistic glimpse of the future.

Shahn designed this sketch for the Office of War Information during World War II. Welders and other industrial laborers were regarded as an important part of the war effort, and this image was intended to encourage a sense of pride among Americans. And by presenting a black man and a white man together, it conveys that these two workers are equally valuable, despite race and ethnicity—a powerful message of unity during a time of unease. Though ultimately not used to promote antidiscrimination, the image did appear during the 1944 presidential election on a poster that read, "For full employment after the war, register to vote."

Ben Shahn (1898–1969)
Gouache on board, 55.9 × 100.9 cm (22 × 39¾ in.), 1943
Museum of Modern Art, New York City; purchase, 1944
Art © Estate of Ben Shahn/Licensed by VAGA, New York, NY

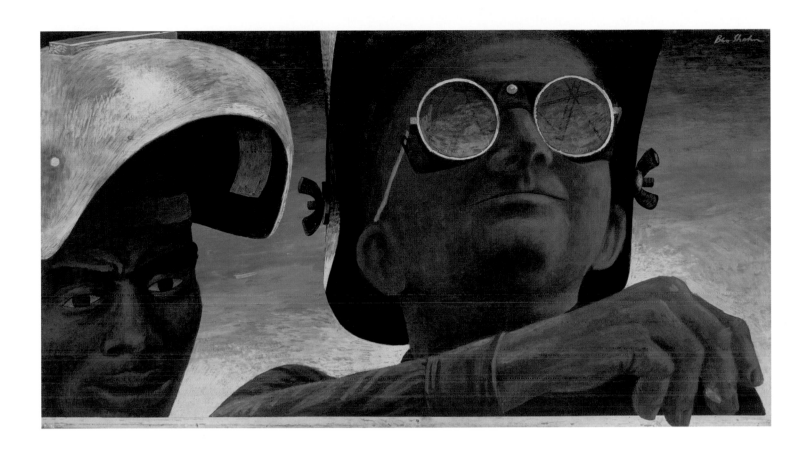

Norman Rockwell is celebrated for capturing the American experience, illustrating the lives of Americans of every age through several different eras, from life on the home front during World War II to the civil rights movement. Rockwell knew from an early age that he wanted to be an artist and began serious study as a teenager, ultimately leaving high school to attend the National Academy of Design. He often painted idealistic views of American life, and in his biography he professed, "I paint life as I would like it to be."[46]

Rockwell painted this smiling coal miner for a poster published by the War Manpower Commission, encouraging Americans to support the country and its energy needs through the commission's efforts. The text on the poster reads: "Mine America's Coal. We'll make it hot for the enemy! See your United States Employment Service." By representing a late-middle-aged man, Rockwell emphasized that workers of all ages could be American heroes. The red, white, and blue pin with two stars indicates that this man has two sons serving in the military. Conveying pride and confidence, the miner's smile suggests a bright future made possible through hard work and patriotism.

Norman Rockwell (1894–1978)
Oil on canvas, 53.3 x 35.6 cm (21 x 14 in.), 1944
Norman Rockwell Museum, Lenox, Massachusetts

CHARLIE MAH-GOW, FIRST RESTAURANT OWNER IN TOWN, YELLOWKNIFE, CANADA

In 1944, former Farm Security Administration (FSA) official Roy Stryker guided a documentary project for Standard Oil of New Jersey. Having worked successfully with Gordon Parks at the FSA, Stryker hired him to document the beneficial role of oil in the lives of North Americans. This assignment took Parks to Maine, where he photographed a man who had sold Standard Oil products in his shop for twenty years; to Pittsburgh, where he photographed grease plant workers; and finally to Canada, where this portrait was taken.

Charlie Mah-Gow proudly dominates the cluttered kitchen of his restaurant amid the utensils that have made him a success as a chef and an entrepreneur. Mah-Gow had been a pioneer in his community, opening the first restaurant in Yellowknife, Northwest Territories, a remote outpost that became accessible only after the advent of air travel. Parks's photographs—whether for the FSA, the Office of War Information, the Standard Oil project, or *Life* magazine, where he worked from 1948 to 1970—were informed by the odd jobs he took as a youth in Kansas and Minnesota, where he was sent to live with an older sister after his mother died. In photographing rural and urban laborers, he sought to honor his subjects with an empathetic view of their lives and struggles.

Gordon Parks (1912–2006)
Gelatin silver print, 25.4 × 25.1 cm (10 × 9⅞ in.), 1945
The Gordon Parks Foundation, Pleasantville, New York

LABOR DAY

German American artist J. C. Leyendecker was one of the most prominent illustrators in history, producing more than three hundred covers for the *Saturday Evening Post* and other magazines and numerous advertising illustrations (see cat. 28). As an employee of the Cluett, Peabody & Company ad agency, he invented the "Arrow Collar Man," an icon of male style in the early twentieth century. Art historian Roger Reed noted that "Leyendecker's main contribution is to have invented, along with other illustrators, the modern magazine cover as a miniature poster that would engage the viewer, impart an idea, and sell the issue, all within the few moments one browses at the newsstand."[47] Leyendecker's influence on magazine covers remains evident to this day.

In this illustration, Leyendecker departed from his usual middle-class subjects to depict a strong male worker sitting atop a globe. It depicts the pride American workers felt in their role in saving the United States from economic disaster after the Depression and defeating fascism in World War II. With a renewed sense of opportunity and potential after a time of such hardship and struggle, this worker is literally on top of the world.

J. C. Leyendecker (1874–1951)
Tear sheet from *The American Weekly*, 1946
Norman Rockwell Museum, Stockbridge, Massachusetts

THE AMERICAN WEEKLY

Greatest Circulation in the World

"The Nation's Reading Habit"
Magazine Section—Boston Advertiser
Copyright, 1946, by American Weekly, Inc.
All Rights Reserved.

Week of Sept. 1, 1946

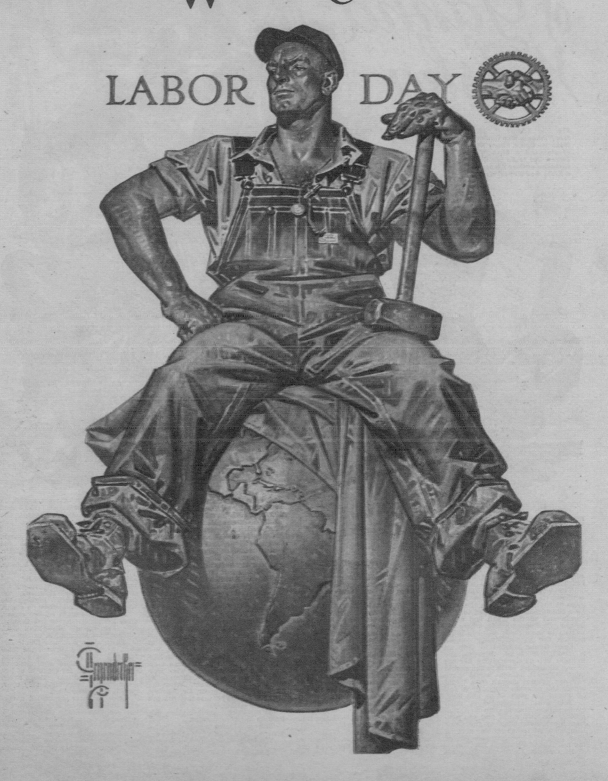

LABOR DAY

TWO STEEL WORKERS

Dramatic lighting and shadow were signature qualities of the photographs of Yousuf Karsh, who was born in Mardin, Turkey. At seventeen Karsh traveled alone by boat from Beirut to Canada, where he established himself as a photographer. His play with the effects of illumination began in early photographic experiments at Ottawa's Little Theatre, where he used light to focus attention on a subject's hands and facial expressions to achieve emotional impact. This use of directional lighting allowed Karsh to tell compelling stories through portraiture.

The steelworker in the foreground here is cast as a champion of modern life. Facing forward, he is presented as a man in command of his environment and projects a sense of authority and purpose. Although Karsh primarily photographed political and cultural figures, he employed the same techniques when depicting workers at steel plants in Ohio and Pennsylvania. Taking advantage of the industrial fireworks in the background, Karsh turned the bleak setting of factory life into a stage for heroic laborers, honoring them much as he would the celebrities he photographed. Of his steelworker photographs he wrote, "I have taken, as you know, the portraits of some of the most celebrated men and women of our time. I tell you these workers are the peers of those men and women who are better known. I say this, not in disparagement of the great ones, but in humble recognition of the same qualities of greatness in these industrial workers who are not so well known."[48]

Yousuf Karsh (1908–2002)
Gelatin silver print, 34.1 × 26.4 cm (13⁷⁄₁₆ × 10³⁄₈ in.), 1950
Estate of Yousuf Karsh

FORD OF CANADA (TERRY TRUSH AND MAURICE LEHOUX)

Yousuf Karsh portrayed these two workers at a spray booth at the Ford Motor Company Plant in Windsor, Ontario. By 1950, the Windsor works had more employees than any other Ford plant in Canada. Having been commissioned by Ford to make photographs of factory workers, Karsh took an intimate approach to his subjects, learning in conversation about their lives and interests, feeling that the individual narrative of each employee told the true story of the company. "It is the men who tell the company's story best," he wrote. "They give the machines life and movement. It is really their skill that gives [a car] strength and beauty."[49]

Karsh described Trush, left, as a hardworking immigrant whose "grandparents have a farm so he has no time for sports as he helps with the farm chores after work. Does some swimming and fishing in summer. Speaks Ukrainian at home."[50] Lehoux, Karsh explained, was a twenty-two-year-old whose father was a spot welder for Ford. The photographer commented that what drew him to this particular photograph was the men's interaction with each other: "The garb of the spray painters and their intense momentary involvement with each other reminded me of two surgeons consulting in the operating room."[51] Their closeness adds a sense of mystery to a shot of an ordinary assembly line. Applying his techniques of dramatic lighting, typically used on celebrity subjects, to the industrial setting, Karsh photographed workers as if they were actors on a stage.

Yousuf Karsh (1908–2002)
Gelatin silver print, 26.4 × 33.8 cm (10⅜ × 13⁵⁄₁₆ in.), 1951
Estate of Yousuf Karsh

SHARECROPPER

As the granddaughter of formerly enslaved people, Elizabeth Catlett was interested in depicting the lives of people affected by social injustice. She was the first African American woman to earn a master of fine arts degree from the University of Iowa, and in 1946, she moved to Mexico to work with a renowned collective of political print-makers at the Taller de Gráfica Popular (People's Graphic Arts Workshop). There she engaged in many forms of printmaking, honing her technical prowess and fostering her belief in the democratic power of this medium to reach diverse audiences. In her time abroad she grew more aware of the plight of *mestizaje*, Mexicans of indigenous, African, and Spanish ancestry. She also recognized the shared histories and intersect-ing struggles of the African American and Mexican peoples. As a result, her portrayal of marginalized subjects attracted a broad audience of people who recognized their own stories of struggle in her art.

Catlett created this empowering image of a woman sharecropper during her time in Mexico. The system of sharecropping confined many African American and white workers to their preexisting poverty. Catlett's portrait of this woman, with her bold, articulated facial features, evokes both a strength and honor that exemplify the artist's mission to "present black people in their beauty and dignity."[52] In framing the woman above the viewer, Catlett focused the viewer's gaze on her subject's integrity and resilience.

Elizabeth Catlett (1915–2012)
Linoleum cut on paper, 66 × 56.5 cm (26 × 22¼ in.), 1952
Smithsonian American Art Museum, Washington, D.C.; Museum purchase
Art © Catlett Mora Family Trust/Licensed by VAGA, New York, NY

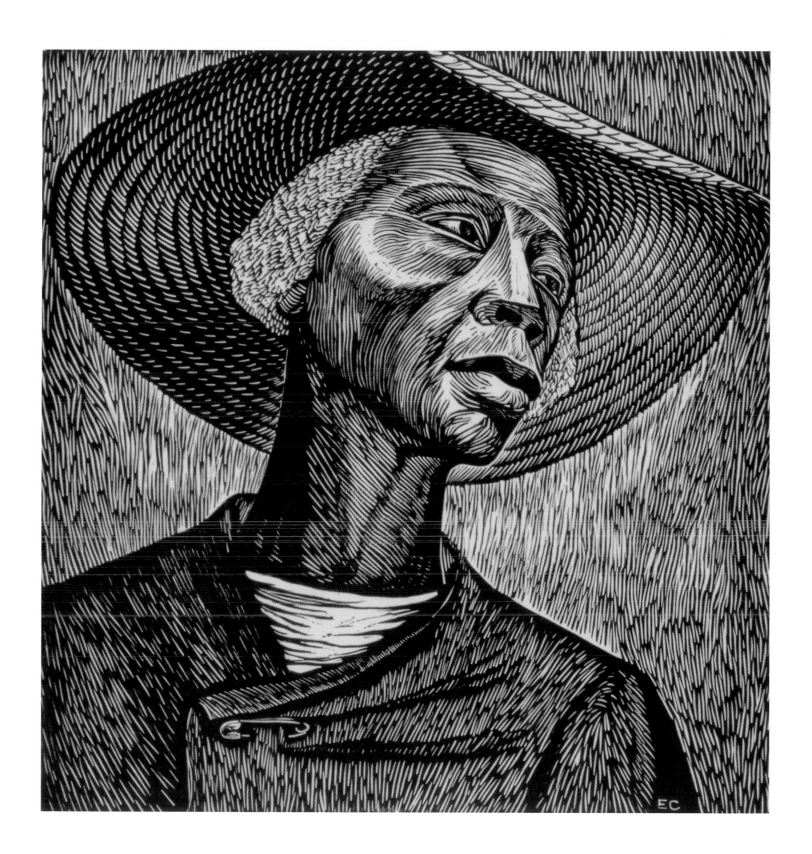

GRAPE PICKER, BERRYESSA VALLEY, CALIFORNIA, 1956

Pirkle Jones, a California photographer and student of the renowned Ansel Adams, was very much involved in social and political causes. For example, Jones and his wife, Ruth-Marion Baruch, a photographer, writer, and poet, intensively documented the Black Panther Party in 1968 with the goal of increasing the public's understanding of the group. Jones's responses to the people and places he encountered emerged in artworks of notable honesty and emotional resonance. As Adams said, "His pictures will live with you, and with the world, as long as there are people to observe and appreciate."[53]

In the mid-1950s, the need for water in California was so great that the U.S. government decided to vacate the Berryessa Valley, remove its inhabitants and uproot its farms, dam it, and make it into a reservoir providing water to surrounding communities. Known for collaborating with other artists, Jones worked with Dorothea Lange (see cats. 34 and 41) to document life in the valley before it was flooded. "It is important to document before change is made . . . to make a record of what no longer exists," said Jones.[54] The earnest expression of this grape picker offers insight into the final days in the valley. Jones described the Berryessa project as "one the most meaningful photographic experiences of my professional life."[55]

Pirkle Jones (1914–2009)
Gelatin silver print, 33.3 × 25.7 cm (13⅛ × 10⅛ in.), 1956
Bank of America Collection

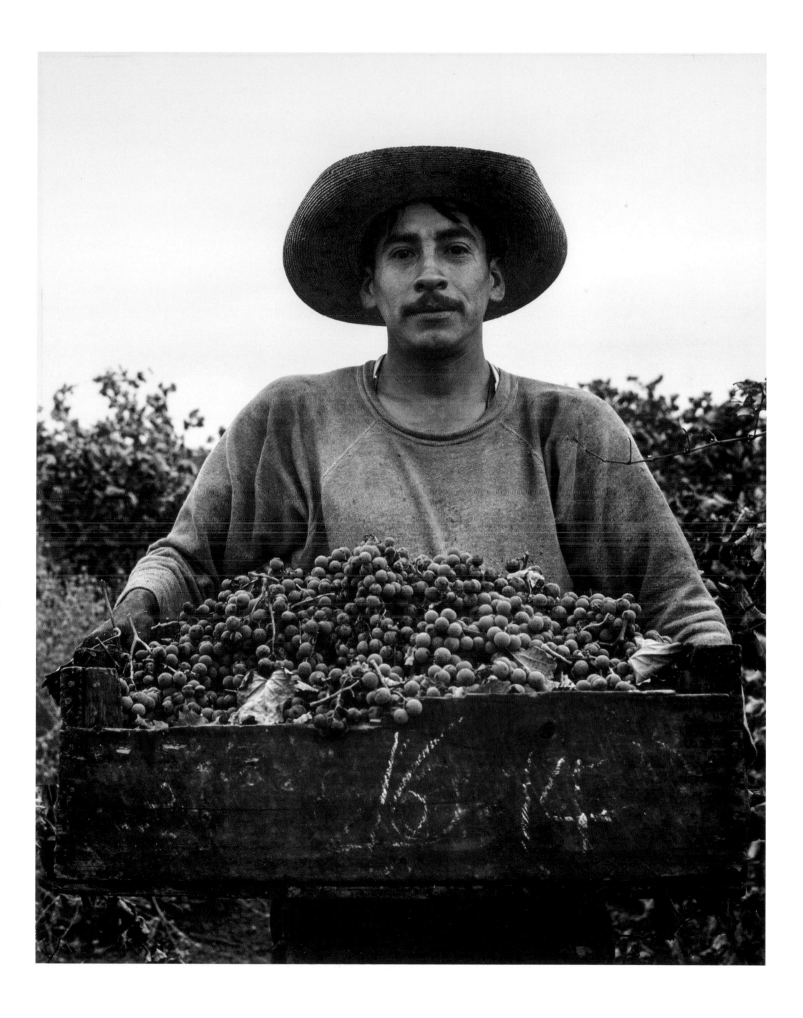

CABINET MAKER

Jacob Lawrence was one of the first African American artists to receive continued support and recognition from mainstream American art museums. When he joined New York's Downtown Gallery in 1941, he became the first artist of African descent to be represented by a major commercial gallery. His art was shown alongside that of such major American modernists as Ben Shahn (see cats. 43, 45, and 51), Charles Sheeler, John Marin, and Stuart Davis. Lawrence described his work as "abstract in the sense of having been designed and composed, but it is not abstract in the sense of having no human content."[56]

Lawrence firmly believed in the communicative power of art, and while he was keenly interested in the play of form and color, he did not want his art to be understood as pure abstraction. As art historian Lowery Stokes Sims has pointed out, this is especially applicable to Lawrence's builders paintings, which he created from the mid-1940s through the end of his life. In these compositions, both men and women are shown working with wood. Inspired by the Bates Brothers, Harlem cabinetmakers whom Lawrence knew and admired, the series celebrates the subject of work through abstract forms and saturated, mostly primary, colors. Of this theme Lawrence said, "I like the symbolism [of the builder]. . . . I think of it as man's aspiration, as a constructive tool—man building." He saw the paintings as representing "man's continuous aspiration to develop, to build."[57] It is significant that Lawrence began the series, which addresses the hard work of building a community of justice and equality, during a time that saw increasing economic opportunities for African Americans and the civil rights movement.

Jacob Lawrence (1917–2000)
Casein tempera on paper, 77.5 × 57.2 cm (30½ × 22½ in.), 1957
Hirshhorn Museum and Sculpture Garden, Smithsonian Institution,
Washington, D.C.; gift of Joseph H. Hirshhorn, 1966

LOWER MANHATTAN, NEW YORK CITY, 1967

In 1967, when most people were moving out of Lower Manhattan, Danny Lyon decided to move into the historic urban area. As a part of his series *The Destruction of Lower Manhattan*, Lyon captured both the leveling of some of the city's oldest streets and the people who worked there during that time, namely construction workers and demolition men. The two men pictured are Eddie Grant and Cleveland Sims, maintenance workers for the New York City Department of Urban Renewal.

The demolition of Lower Manhattan was carried out with the ultimate purpose of making room for the World Trade Center and Battery Park City. Of the soon-to-be-demolished buildings Lyon said, "For a hundred years they have stood in the darkness and the day. In the morning the sun has shined on their one side, and in the evening on another. Now, in the end, they are visited by demolition men. Slavs, Italians, Negroes from the South, American workers of 1967 drinking pop-top soda on their beams at lunch time, risking their lives for $5.50 an hour, pulling apart brick by brick and beam by beam, the work of other American workers who once stood on the same walls and held the same bricks, then new, so long ago."[58]

Danny Lyon (born 1942)
Gelatin silver print, 19.4 × 19.7 cm (7⅝ × 7¾ in.), 1967
Bank of America Collection

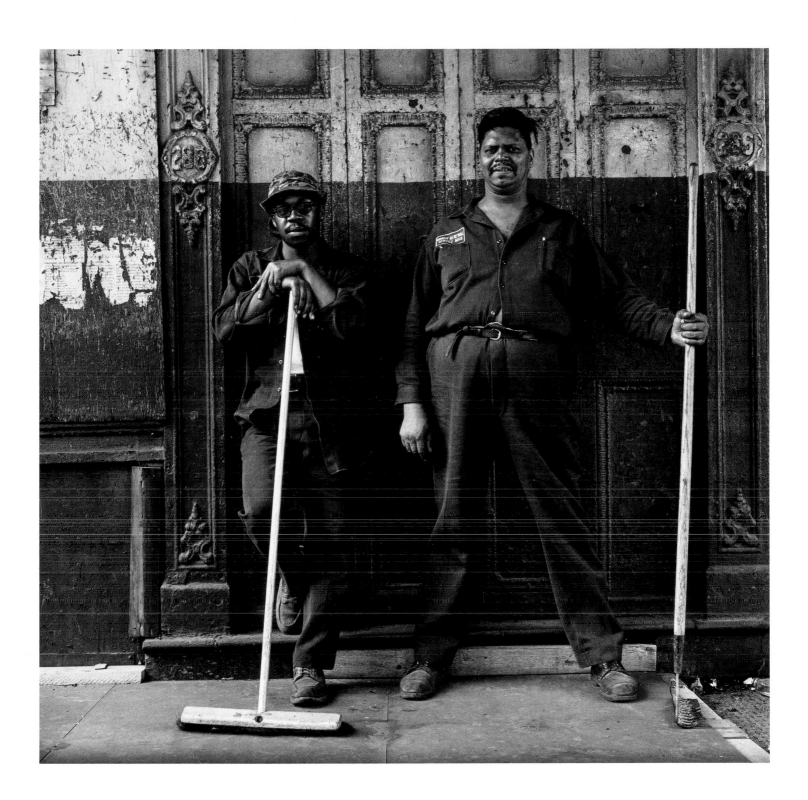

TWO YEARS, BURGLARY

Documentary filmmaker and photographer Danny Lyon graduated from the University of Chicago in 1963. That same year, he published his first photos while working for the Student Nonviolent Coordinating Committee, a civil rights organization. He was then inspired to create his own books that documented the lives of marginalized groups of people, including bikers and prison inmates. "As a child I had been afraid of so many things, but as soon as I held a camera in my hand, I began to expose myself to the very things that were foreign to me and that I had always feared," said Lyon.[59] He has published more than twenty books, including *Conversations with the Dead* (1971), which captures the lives of inmates in six Texas prisons over fourteen months. Lyon's immersive technique allowed him to engage with the prisoners in their environment—here a prison work gang—and establish an empathetic bond. As Lyon befriended many of the inmates, he often lost track of time during his photography sessions, spending hours talking and watching football in prisoners' cells late into the night. With a sensitive documentary practice that was informed by his personal connection to his subjects, Lyon bestowed a sense of humanity on his ostracized subjects.

Danny Lyon (born 1942)
Gelatin silver print, 27.9 × 35.6 cm (11 × 14 in.), 1967–68
Museum of Contemporary Photography, Chicago, Illinois

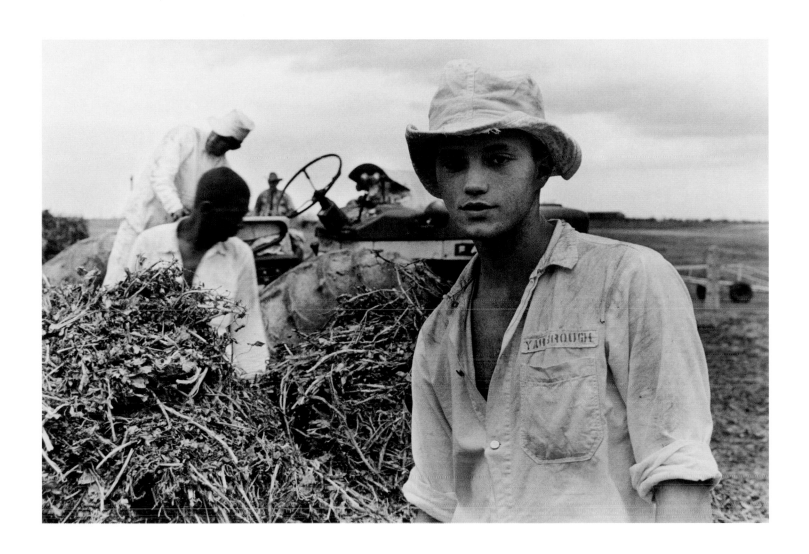

MR. MOORE'S BAR-B-QUE, 125TH STREET

As a young man, Dawoud Bey visited *Harlem on My Mind*, a much-discussed 1969 exhibition at the Metropolitan Museum of Art. His memory of that experience and his interest in his family's historical connections to Harlem led him to create his own view of the neighborhood in a series titled *Harlem, U.S.A.* (1976–79). He has said of the project:

> I began photographing in the streets of Harlem in 1975. At first these visits were just weekly excursions. On those occasions much of what I did was not photographing, but spending time walking the streets, reacquainting myself with the neighborhood that I wanted to again become a part of, seeing up close the people and the neighborhood I had glimpsed from the car window years before as a child. As I got to know the shopkeepers and others in the neighborhood, I became a permanent fixture at the public events taking place in the community, such as block parties, tent revival meetings, and anyplace else where people gathered.[60]

This portrait captures an ordinary interaction at a lunch counter on 125th Street, the "Main Street" of Harlem. At the time this picture was taken, the locality was in deep decline, marred by poverty and still reeling from the race riots of the previous decade. The 1970s would see the flight of thousands of residents from the neighborhood, leaving behind those who were unable to follow. In this photograph there are no obvious indications of the hardships of life in 1970s Harlem. Revisiting the location recently, Bey commented, "Typical of the changes that have transformed this community is the McDonald's where Mr. Moore's Bar-B-Que luncheonette used to stand on 125th Street and Lenox Avenue. As I pass the location by I still recall his beaming face and the pictures I made there."[61]

Dawoud Bey (born 1953)
Gelatin silver print, 20 × 30.2 cm (7⅞ × 11⅞ in.), 1976
Courtesy of the artist and Stephen Daiter Gallery, Chicago, Illinois

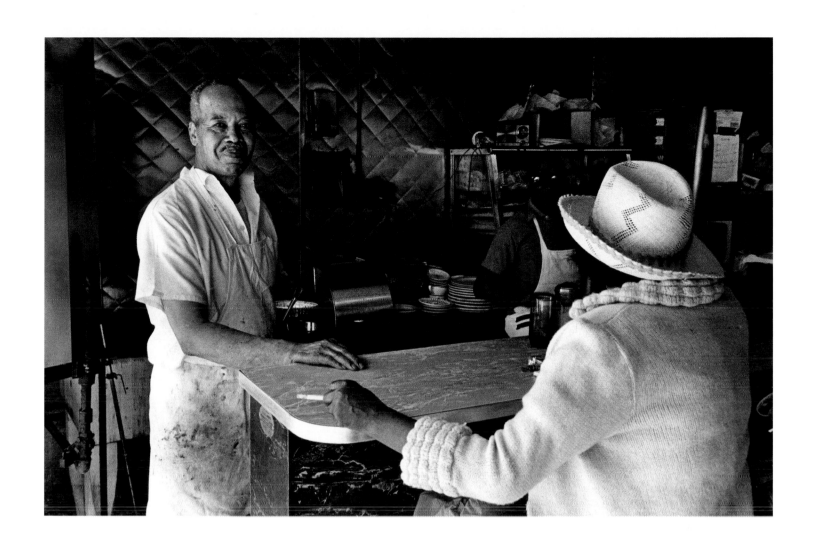

DEAS McNEILL, THE BARBER

Resting his hands on the ledge of his work space and an empty barber chair, barber Deas McNeill plants his right leg on the chair's footrest, asserting control over his work environment, the barbershop. Surrounded by a cacophony of hair products, wires, and walls buzzing with blurred dots that appear to have been spray painted, Deas McNeill is undeniably the master of his domain. This photograph by Dawoud Bey is a part of his acclaimed *Harlem, U.S.A.* series, for which the artist traveled the streets of Harlem documenting his "family's history . . . the people and the neighborhood." In reflecting on this photograph and the changes to the Harlem he had observed, Bey wrote, "Barbershops used to be ubiquitous in the community. . . . I knew of at least three on Adam Clayton Powell Jr. Boulevard between 135th and 139th Streets: Garden Barbershop, Deas McNeill, and the nameless shop below street level between 138th and 139th by Striver's Row. I photographed in all of them, and none—of course—are there now."[62] While Harlem has changed dramatically since the 1970s, the sense of place and timelessness of Bey's portraits derive in part from the moment when they were taken, which Bey described as a time when "Harlem . . . was still a place where the present intermingled more visibly with Harlem's original heyday."[63]

Dawoud Bey (born 1953)
Gelatin silver print, 20.6 × 30.2 cm (8⅛ × 11⅞ in.), 1976
Courtesy of the artist and Stephen Daiter Gallery, Chicago, Illinois

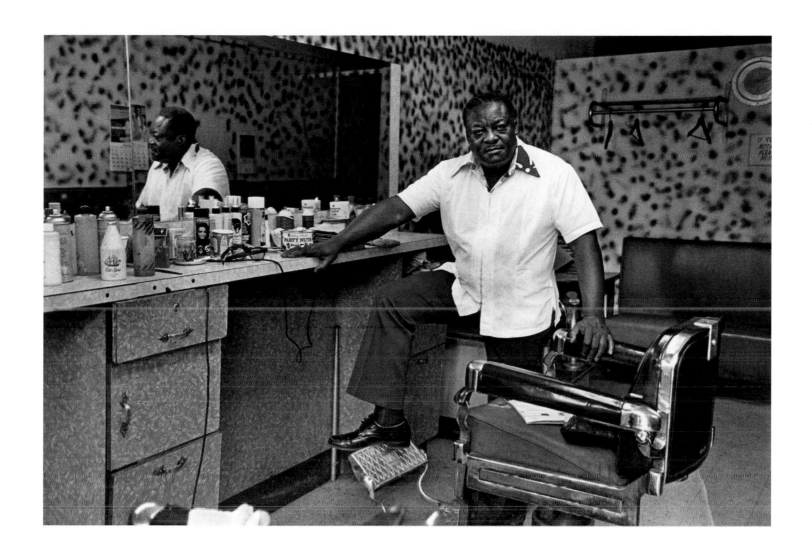

UNIDENTIFIED MIGRANT WORKER, EAGLE PASS, TEXAS

I am close enough to touch the subject and there is nothing between us except what happens as we observe one another during the making of the portrait. This exchange involves manipulations, submissions. Assumptions are reached and acted upon that could seldom be made with impunity in ordinary life.

—Richard Avedon, foreword, *In the American West: 1979–1984*
 (New York: Abrams, 1985)

Primarily known for his portraits of celebrities and fashion icons, Richard Avedon would later regard his project *In the American West* as his greatest accomplishment. In this compendium of photographs, Avedon sought to create a modern mythology for the frontier by cataloguing the lives of its inhabitants, some of whom lived in difficult economic circumstances. Avedon's take on the contemporary frontier is in many ways a dark one; the people he photographed lived on the margins of society and frequently seem to display an air of listlessness and discontent. This portrait of a Mexican day laborer positions him in a typical Avedon format: standing in front of a stark white background. Water drips from his long, stringy hair and down his bare torso as he stares with an exhausted though determined expression into the camera. His soaking-wet body and clothing suggest that he has possibly just finished swimming across the Rio Grande in search of work.

Avedon's primary concerns in his portrait work included the performance of the individual and a drawing out of commonalities between seemingly disparate groups of people. He said of his practice, "I am interested in connections between people of remote experience, in similarities that are unexpected, unexplained."[64] In bringing unnamed workers of the American West into focus against the stark white backgrounds that also frame his celebrity portraits, he reminds us of the power of portraiture to reveal the universalities of the human condition.

Richard Avedon (1923–2004)
Gelatin silver print, 142.6 × 114.3 cm (56⅛ × 45 in.), 1979
The Richard Avedon Foundation, New York City

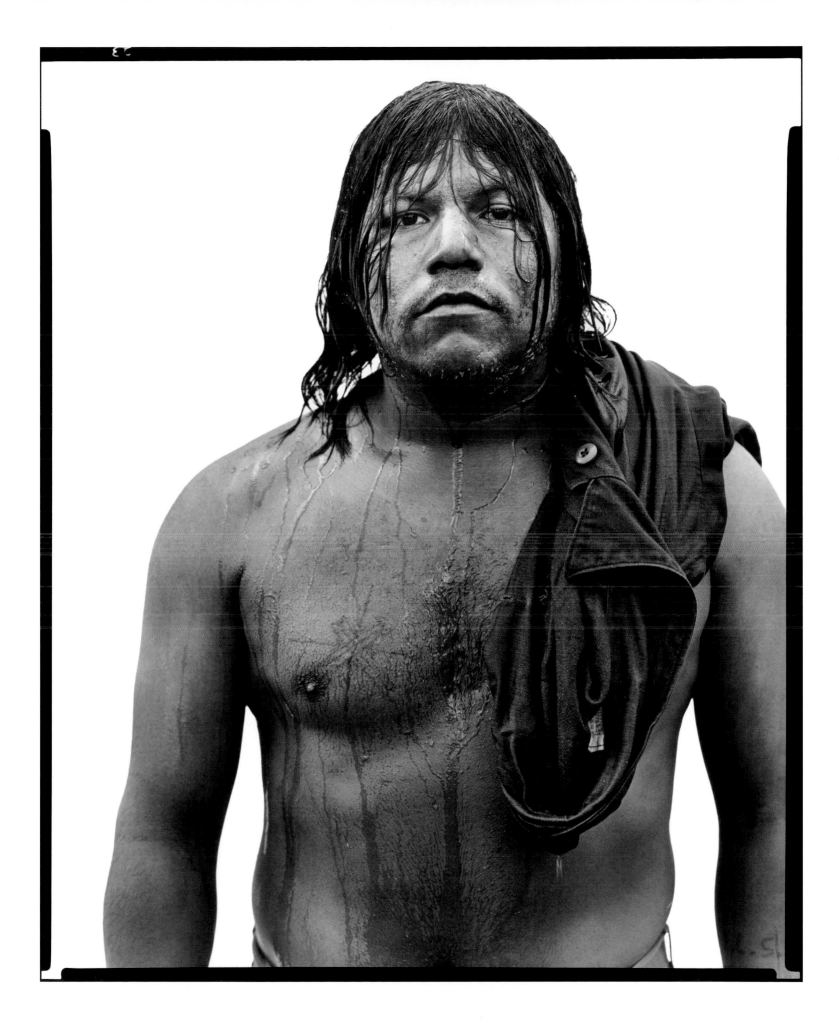

THE GARDENER (MELISSA WITH BOB MARLEY SHIRT)

New York–based artist John Ahearn and sculptor Rigoberto Torres made an impact in the art world in 1979 with their *South Bronx Hall of Fame* public art project at the experimental art space Fashion Moda, where they publicly made life casts of faces of people from the neighborhood as a collaborative social activity. Ahearn continues to create painted casts of his neighbors, works that are in many ways extensions of the earlier project. His subjects are far from glamorous: they are ordinary human beings, oftentimes living in difficult economic circumstances, and some of them have been imprisoned at some point. Regardless of their struggles, Ahearn strives to portray them compassionately and with a quiet dignity.

Ahearn has said, "I grew up with the crowded iconography of Catholic churches and was especially drawn to painted plaster saints. The early itinerant portrait painters were role models for me." Citing itinerant portraiture links Ahearn to a tradition of artists who represented communities of people. His portrait work is activist and community-based in that it is meant to acknowledge those who are often overlooked or neglected, especially in the art world. Melissa, a gardener, is one of the many workers who have inspired Ahearn to create their likeness. The sculpture represents Melissa enjoying a brief pause in her manual labor, a moment to which anyone can relate; at the same time, she is shown as an individual, and the sculpture honors her as a worker, a woman, and a friend of the artist.

John Ahearn (born 1951)
Pigmented fiberglass resin with cement base, 170 cm (67 in.) height, 1997/2007
Courtesy of the artist and Alexander and Bonin, New York City

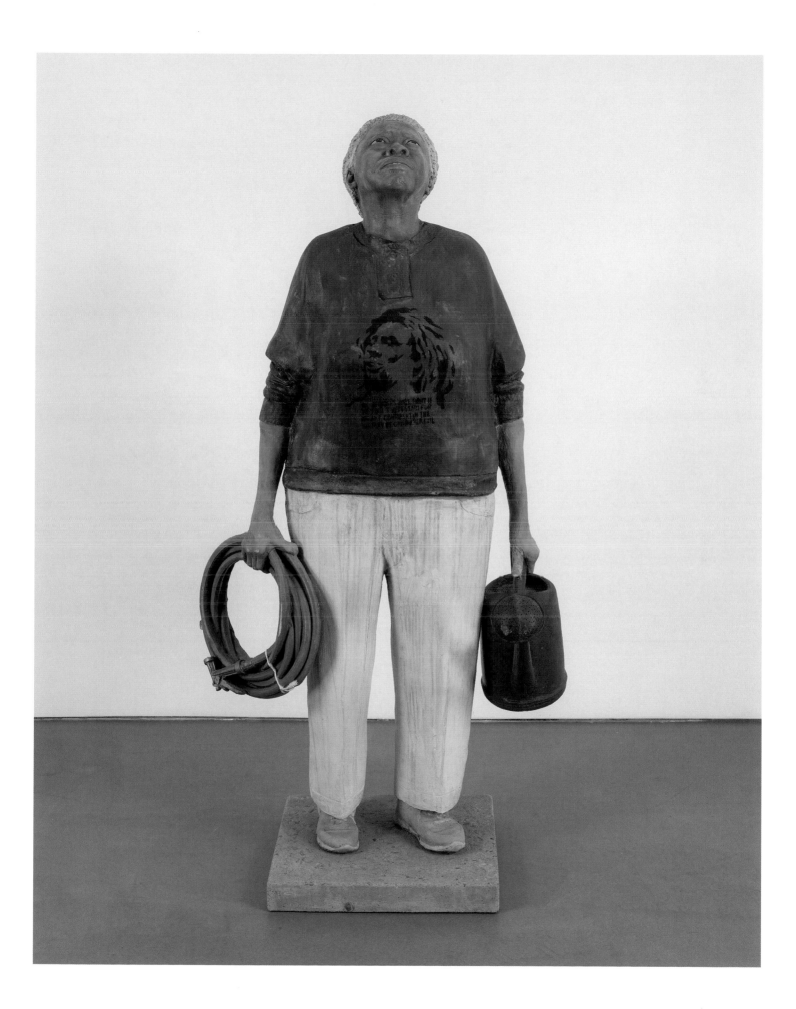

ALMOND POLING CREW DURING HARVEST NEAR LOST HILLS, CA. SEPTEMBER 16, 2009

Los Angeles–based photographer Sam Comen is inspired by the Farm Security Administration (FSA) photographers of the Great Depression, including Dorothea Lange (see cats. 34 and 41), Walker Evans, and Arthur Rothstein (see cat. 44), who were commissioned to document the hardships of Dust Bowl refugees seeking work in California's fields in the 1930s. Comen said, "Those photographers were able to capture a sense of being. [Their] photographs . . . fed me as a photographer, and I wanted to find a new way to explore the great American narrative."[65] This inspiration led him to Lost Hills, a town of 3,500 people in the southern corner of California's Central Valley. Here Comen saw an opportunity to document a contemporary iteration of the iconic American story that the FSA photographers found seventy-five years earlier. To Comen, the people of Lost Hills "embody the bootstrapping grit and cooperative frontier spirit of the American West—and are living a new iteration of the 'Okie' experience so prominent in our national psyche. But because some of Lost Hills' residents are undocumented immigrants, all are assumed to be, and so may be cut out of their own American dream, and denied their place in the American historical record."[66]

During harvest time in the almond groves of California's Central Valley, specialized tractors grab and shake each tree so vigorously that a storm of nuts rains down to the ground. This crew of farmworkers, photographed near Lost Hills, was sent into select groves as an experiment to glean any last nuts that remained in the trees after shaking. This task requires alertness and precision so that no almonds are left on the branches when the job is done. In this group portrait, the workers stand at attention like a platoon of soldiers before battle, their poles raised high in the sun. As Comen explained, "Lost Hills is about more than illuminating life in the town itself. It's a metaphor for today's American experience."[67]

Sam Comen (born 1980)
Archival pigment print, 61 × 91.4 cm (24 × 36 in.), 2009
Courtesy of the artist

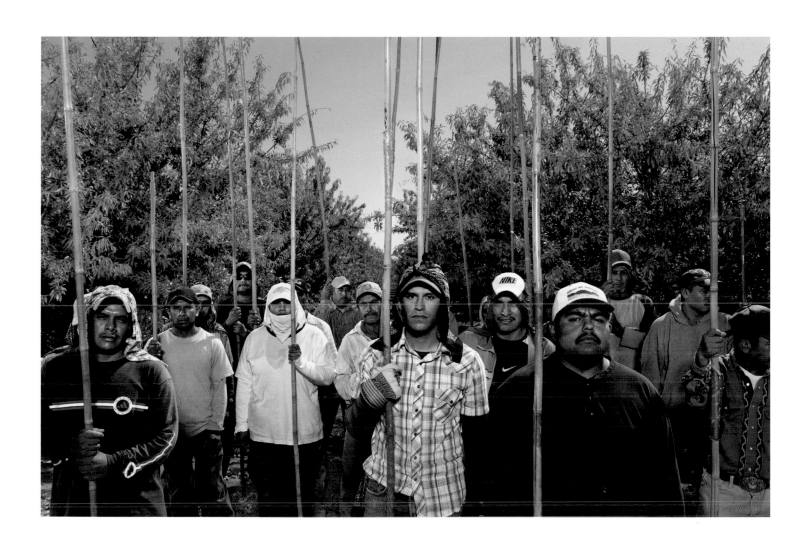

CUTTING SQUASH (LEAH CHASE)

Leah Chase (born 1923) is reverentially referred to as the "Queen of Creole Cuisine." In 1945, she married jazz musician Edgar "Dooky" Chase Jr. and joined the family restaurant business in New Orleans. By the 1960s, Dooky Chase's Restaurant was famous for Leah's recipes and also served as a gathering spot for prominent civil rights activists, including Martin Luther King Jr., who would join local leaders for strategy sessions over meals upstairs. Native New Orleans artist Gustave Blache III made a series of small portraits documenting Leah Chase in the kitchen. Blache began work on the series in October 2009, photographing and sketching Chase in New Orleans. The artist created the portraits at his New York studio from this source material, and periodically held sittings with the chef back in New Orleans to refine his likenesses. Blache's work has been influenced by photojournalism as well as nineteenth-century French artists Gustave Courbet and Edgar Degas and early-twentieth-century American artists John Sloan and Robert Henri (see cat. 21). His intimate genre scenes convey an immediacy that captures Chase's tireless work ethic from a variety of perspectives and angles.

As passionate about the arts as she is about cooking, Leah Chase became a supporter and advocate for the arts in New Orleans after exposure to a Jacob Lawrence (see cat. 59) retrospective in 1975. She took this support to a national level in May 1994 when she spoke before a congressional subcommittee of the Appropriations Committee, arguing in her testimony that her working-class background played an important role in her appreciation of the importance of funding for the arts: "My life experience provides evidence that refutes the allegation that federal money for the arts benefits only higher-income people. For me, support for the arts is an investment in the artistic excellence of my people."[68]

Gustave Blache III (born 1977)
Oil on panel, 21.6 x 25.4 cm (8½ x 10 in.), 2010
National Portrait Gallery, Smithsonian Institution;
gift of the artist in honor of Mr. Richard C. Colton Jr.

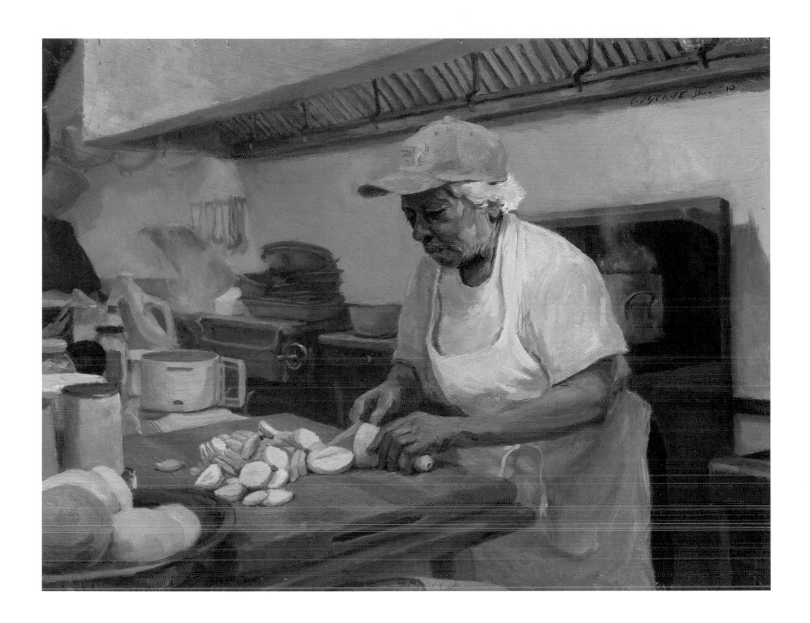

BRIGHTNESS ALL AROUND

Brightness All Around is part of feminist artist Janet Biggs's *Arctic Trilogy*, a series of videos filmed in the Arctic between Norway and the North Pole. Biggs describes her larger body of work as exploring identity with a focus on how we navigate the limits imposed by society while "trying to push past those limits."[69] In this video she tracks Linda Norberg, a coal miner and machine operator who dons protective gear as she plummets into the earth in one of the coldest parts of the world. The intense physical and psychological strain of this work presents a perfect subject for Biggs, whose videos often chronicle extreme activities.

"I kind of ride the line of documentary filmmaking very closely . . . because I define myself as an artist, not as a documentary filmmaker," said Biggs. "There comes a point when I need to purposefully push myself sideways off of that path. And for me often that comes by bringing in other images that make sense . . . and hopefully that kind of lead will be compelling to someone else."[70] In juxtaposing Norberg's dangerous, even life-threatening job with the glamorous, seductive performance of underground singer Bill Coleman, whose lyrics address near-death situations, Biggs accentuated Norberg's determination, fearlessness, and inner strength. Biggs said, "I very much want to make work that can exist on many different levels and invite an audience member to enter on one level and hopefully . . . encourage them to have their own exploration or search."[71]

Janet Biggs (born 1959)
Single-channel, high-definition video with audio, 16:9 format, 8 min. 36 sec., 2011
Courtesy Connersmith, Washington, D.C.

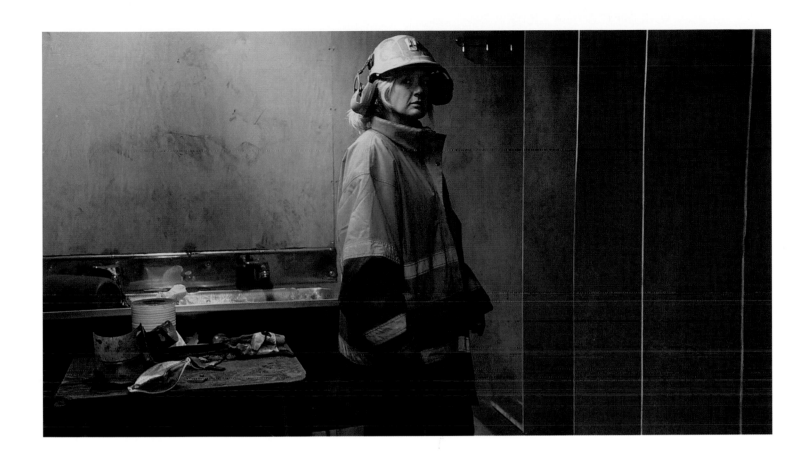

ROGER

New York–born artist John Sonsini lives and works in Los Angeles. Known for his large gestural paintings of Latino workers, whom he pays to sit for portraits at their normal hourly wages, Sonsini recognizes people whose stories are largely untold and who are underappreciated. Although they make up approximately 15 percent of the U.S. labor force, Latino workers are essentially absent in the dominant narratives of American history told through portraiture. Sonsini seeks to address this with paintings that bring these workers, who are named in the portrait's titles, into the spaces of museums, thereby highlighting their importance and dignity. Without staging or props, Sonsini focuses on his subjects' individuality through pose and often a direct gaze that captures the attention of the viewer and lends the paintings a sense of not only presence but also quiet monumentality.

Sonsini has explained that showing these paintings in the spaces of museums and art galleries is essential to their meaning. He allows that "there are artists who don't view exhibiting (which is a public experience) as all that important. But, in my case, I had always intended that exhibiting my work was an important continuum in the process of making art."[72] Sonsini's art is done in a spirit of activism to help institutions, such as the National Portrait Gallery, begin to bring into view the many people who have been left out of history but whose stories are essential in providing a multifaceted view of the American experience.

John Sonsini (born 1950)
Oil on canvas, 114.6 × 91.4 cm (45⅛ × 36 in.), 2011
Smithsonian American Art Museum, Washington, D.C.

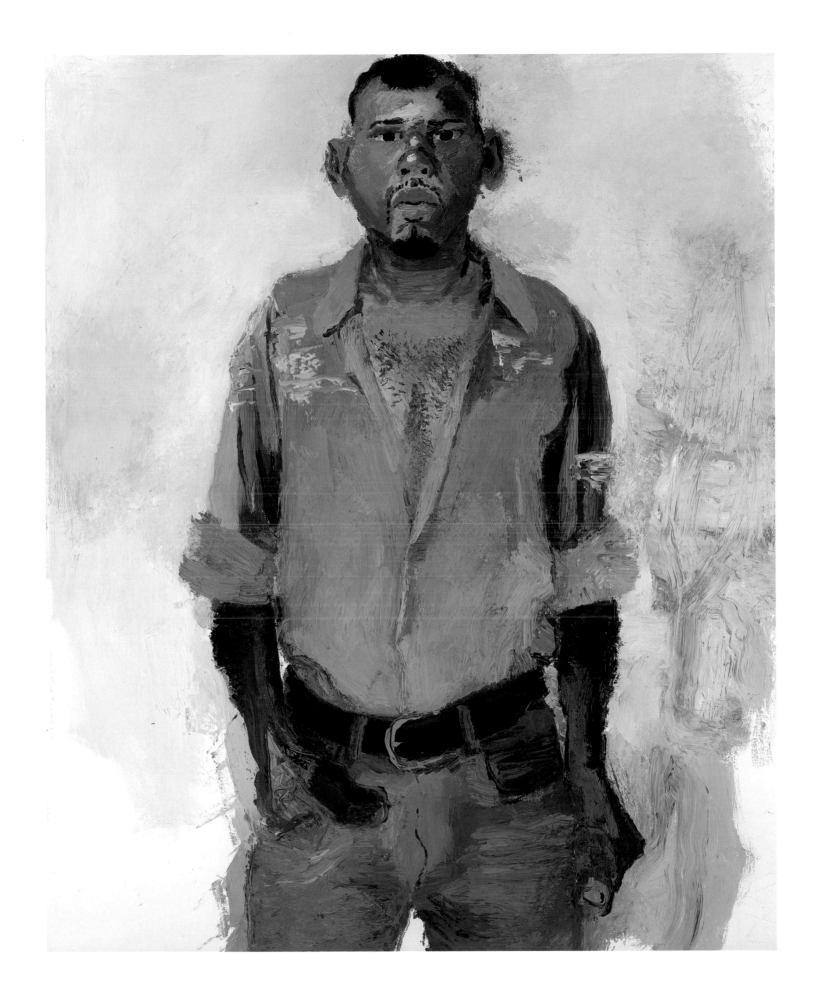

WOMAN CLEANING SHOWER IN BEVERLY HILLS (AFTER DAVID HOCKNEY'S MAN TAKING SHOWER IN BEVERLY HILLS, 1964)

Ramiro Gomez frequently obscures the faces of his subjects as a way of communicating his view that the working-class Latinos from his community in Los Angeles are often marginalized and ignored in society, sometimes to the point that they blend into the landscape. At the same time, the obscuring of facial features lends his subjects an everyman or everywoman quality. These meanings are evident here in this scene of a Los Angeles housekeeper scrubbing the tiled walls of her wealthy employer's shower, a composition based on a painting by David Hockney (see fig. 3.7). Her head is turned away from the audience, with her back bent and her head slightly bowed, stripping her of her individuality. Her pose conjures the act of praying or even weeping. Recent data compiled by the Bureau of Labor Statistics estimates that the average house cleaner earns only around $20,000 annually, less than half of the national average for individuals.

Gomez, who has worked as a nanny to support his art practice, has said, "As an artist, I want to represent truth without stereotyping and reinforcing. . . . I'm just putting something in a context that allows for contemplation of the issue. I'm painting my own mother. I'm painting about my dad. I'm painting about myself."[73] As autobiographical work, Gomez's appropriations carry an urgent, activist message, a call to make the invisible visible and in the process highlight the stories of millions of immigrant workers whose voices have been excluded from dominant narratives of history or who feel their lives are ignored by current politicians.

Ramiro Gomez (born 1986)
Acrylic on canvas, 91.4 × 91.4 cm (36 × 36 in.), 2013
Private collection

KEAN, SUBWAY SANDWICH ARTIST

The stylized pose, dark backdrop, and emphasis on the individual in this portrait all contribute toward Shauna Frischkorn's goal of appropriating conventions of Renaissance portraiture to point to the overbearing and economically stifling practices of corporate fast-food chains. She says of her series *McWorkers*, of which this is a part, "I am purposefully creating an ironic yet historical dialogue between my young subjects and Renaissance portraiture. Historically, the portrait's role was to immortalize the wealthy and important, and to celebrate the individual. Conversely, my subjects have a difficult time earning a living wage. Transplanted from their work environment, they look vulnerable yet dignified as they peer from behind their visors and into my camera. Although they are dressed like thousands of other workers, if you look close, you can see their nobility."[74]

By inserting employees from workplaces such as Subway into an elite art historical context, Frischkorn emphasizes the low social and economic status given to fast-food employees. Their "unattractive and ill-fitting" uniforms might be designed to make them anonymous, yet Frischkorn pushes against this strategy and brings out each worker's uniqueness, offering at once a critique of corporate culture and traditional portraiture. Many of her subjects are her own students, while others are strangers she meets on the streets and invites into her studio.

Shauna Frischkorn (born 1962)
Digital C-print, 101.6 × 76.2 cm (40 × 30 in.), 2014
Courtesy of the artist

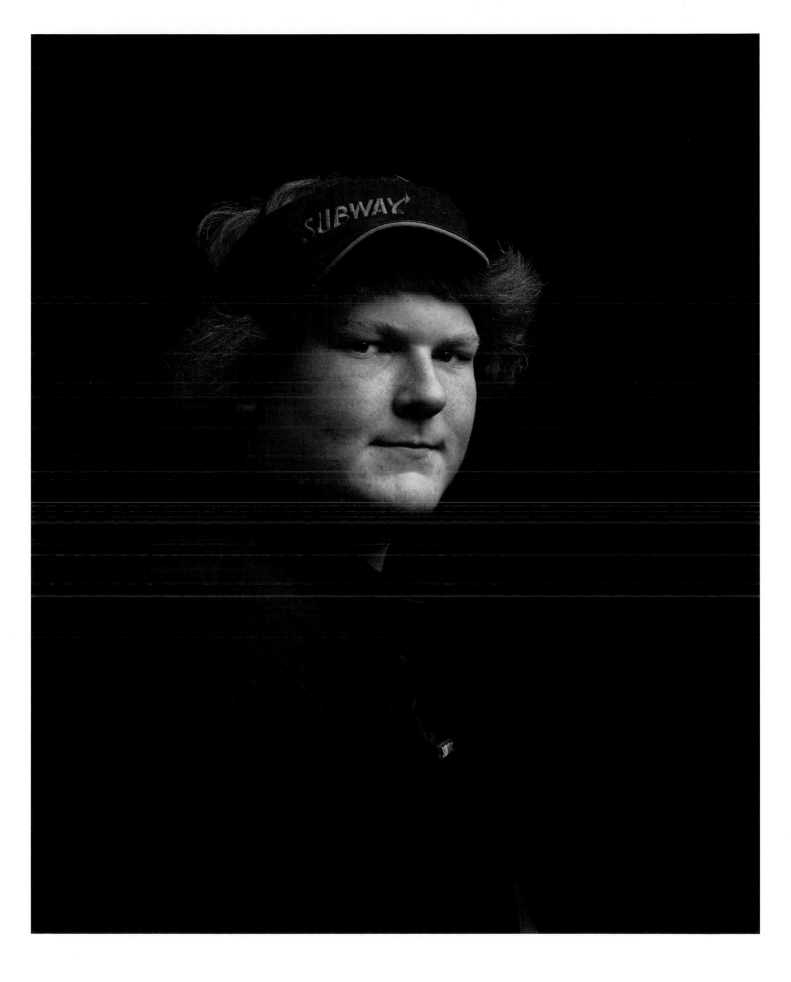

NINE TO FIVE

Josh Kline is an artist and curator who lives and works in New York City. Interested in posthumanism, a concept based on the increasingly complex relationships between humans and technology, Kline uses a wide range of media to highlight the implications of technological advancement and innovation, often finding inspiration in current events. He employs innovations such as 3D printing in the creation of art that addresses labor and the human condition. Additionally, he creates these pieces with accessibility in mind. "I'm interested in the kind of expanded field that includes audiences without expensive degrees in art or art history," said Kline.[75]

For a series of untraditional portraits, Kline interviewed janitors and other workers about their jobs and tools. After taking full-body scans of these people, Kline used 3D technology to print selected body parts. He then placed the body parts and cleaning supplies on janitor's carts. Kline's "posthuman" beliefs are evident as he blurs the line between tools, tasks, and body parts. Current 3D-printing technology cannot achieve the resolution of Kline's scans, so the artist treats these sculptures as copies of future originals. The originals will be created once 3D printing is able to reproduce these scans in full detail.

Josh Kline (born 1979)
3D-printed sculptures in plaster, ink-jet ink, and cyanoacrylate; janitor cart,
LED lights, 101.6 cm (40 in.) height with base, 2015
Courtesy of the artist; 47 Canal, New York City; Galerie Max Hetzler, Berlin, Paris

Notes

1 Quoted in Laura Rigal, *The American Manufactory: Art, Labor, and the World of Things in the Early Republic* (Princeton, NJ: Princeton University Press, 2001), 181.

2 [Walt Whitman], "Visit to Plumbe's Gallery," *Brooklyn Daily Eagle*, July 2, 1846, http://bklyn .newspapers.com/image/50242631/.

3 T. Allston Brown, *A History of the New York Stage: From the First Performance in 1732 to 1901* (New York: Dodd, Mead, 1903), 284.

4 "Exhibition of the National Academy," *Crayon* 3 (May 1856): 146.

5 Richard J. Powell and Jock Reynolds, *To Conserve a Legacy: American Art from Historically Black Colleges and Universities* (Cambridge, MA: MIT Press, 1999), 237.

6 Ibid.

7 Charles Dickens, "An American Railroad: Lowell and Its Factory System" (1842), quoted in "New England Factory Life," *Harper's Weekly* 12, no. 694 (July 25, 1868): 471.

8 Marianne Doezema, *American Realism and the Industrial Age* (Cleveland: Cleveland Museum of Art in cooperation with Indiana University Press, 1980), 35–36.

9 Quoted in Rick Dingus, *The Photographic Artifacts of Timothy O'Sullivan* (Albuquerque: University of New Mexico Press, 1982), 4.

10 Quoted in Barry Combs and Andrew J. Russell, *Westward to Promontory: Building the Union Pacific across the Plains and Mountains; A Pictorial Documentary* (Palo Alto, CA: American West, 1969), 8.

11 William Cullen Bryant, *The Poetical Works of William Cullen Bryant*, ed. Parke Godwin (New York: D. Appleton and Company, 1883), 2: 71.

12 Harriet H. Robinson, *Loom and Spindle: Or Life among the Early Mill Girls* (New York: Thomas Y. Crowell, 1898), 61.

13 Anthony Lee, *Picturing Chinatown: Art and Orientalism in San Francisco* (Berkeley: University of California Press, 2001), 9.

14 Jacob Riis, *How the Other Half Lives: Studies among the Tenements of New York*, ed. David Leviatin, 2nd ed. (Boston: Bedford/St. Martin's, 2011), 186.

15 Jacob Riis, *Neighbors: Life Stories of the Other Half* (New York: Macmillan, 1919), v–vi.

16 Quoted in Kenneth T. Jackson and David S. Dunbar, ed., *Empire City: New York through the Centuries* (New York: Columbia University Press, 2002), 338.

17 Quoted in Emily Dana Shapiro, "J. D. Chalfant's Clock Maker: The Image of the Artisan in a Mechanized Age," *American Art* 19, no. 3 (2005): 43.

18 "'Out of Home's Narrow Confines Is Full Growth Possible for Children' Says Robert Henri," *New York Tribune*, January 25, 1915.

19 Walt Whitman, "Enfans d'Adam 10," *Leaves of Grass*, in *Walt Whitman: Selected Poems, 1855–1892*, ed. Gary Schmidgall (New York: St. Martin's, 1999), 220.

20 Quoted in Kate Sampsell-Willmann, *Lewis Hine as Social Critic* (Jackson: University of Mississippi Press, 2009), 33.

21 Lewis Hine to Frank Manny, 1906 or 1907, quoted in ibid.

22 Robert W. Snyder and Rebecca Zurier, "Picturing the City," in Rebecca Zurier et al., *Metropolitan Lives: The Ashcan Artists and Their New York* (New York: W. W. Norton for the National Museum of American Art, 1995), 125.

23 Quoted in G. Dimock, "Children of the Mills: Re-Reading Lewis Hine's Child-Labour Photographs," *Oxford Art Journal* 16, no. 2 (1993): 39, doi:10.1093/oxartj/16.2.37.

24 Lewis Hine, *Sadie Pfeifer, 48 Inches High, Has Worked Half a Year. One of the Many Small Children at Work in Lancaster Cotton Mills. Nov. 30, 1908. Location: Lancaster, South Carolina*. National Child Labor Committee Collection, Library of Congress, Washington, DC.

25 Quoted in Sampsell-Willmann, *Lewis Hine as Social Critic*, 68–69.

26 Quoted in Terri Weissman, *The Realisms of Berenice Abbott: Documentary Photography and Political Action* (Berkeley: University of California Press, 2011), 22.

27 Quoted in Janet Zandy, *Hands: Physical Labor, Class, and Cultural Work* (New Brunswick, NJ: Rutgers University Press, 2004), 38.

28 Quoted in Alex Nemerov, *Soulmaker: The Times of Lewis Hine* (Princeton, NJ: Princeton University Press, 2016), 1.

29 Correspondence between Lewis W. Hine and Paul Kellogg, Editor of *The Survey*, Letters from the Social History of Archives, University of Minnesota Libraries, http://notesonphotographs .org/index.php?title=Power_Makers_Timeline.

30 Sampsell-Willmann, *Lewis Hine as Social Critic*, 182.

31 Caption, *Survey Graphic* 23, no. 5 (May 1934): 212.

32 Max Kalish and Emily Genauer, *Labor Sculpture* (New York: Comet Press, 1938), excerpted from http://americanart.si.edu/collections/search/ artwork/?id=12905.

33 Quoted in Terry Smith, *Making the Modern: Industry, Art, and Design in America* (Chicago: University of Chicago Press, 1993), 288.

34 Quoted in Jim Rasenberger, "The 'Sky Boys,'" *New York Times*, April 23, 2006, www.nytimes .com/2006/04/23/nyregion/thecity/the-sky-boys.html.

35 Quoted in Gail Stavitsky, *Restructured Reality: The 1930s Paintings of Francis Criss* (Washington, DC: Corcoran Gallery of Art, 2001), 23.

36 Quoted in John Raeburn, "Seeing California with Edward Weston," *A Staggering Revolution: A Cultural History of Thirties Photography* (Champaign: University of Illinois Press, 2006), 248–49.

37 Jean Charlot, interview with Jean Pierre Charlot, August 7, 1971, www.jeancharlot.org/writings/ interviews/JohnCharlot/interview26.html.

38 Quoted in Amy Oliver Beaupre, "Theodore Rozak [*sic*] (1907–1981), Rectilinear Study, ca. 1937," in *American Dreams: American Art to 1950 in the Williams College Museum of Art*, ed. Nancy Mowll Mathews (New York: Hudson Hills, 2001), cat. 45, 156.

39 Quoted in Nicholas Natanson, *The Black Image in the New Deal: The Politics of FSA Photography* (Knoxville: University of Tennessee Press, 1992), 266.

40 "Ben Shahn," Smithsonian American Art Museum website, accessed November 29, 2016, http://americanart.si.edu/collections/search/artist/?id=4384.

41 Arthur Rothstein, interview by Richard Doud, New York, May 25, 1964, Archives of American Art, Smithsonian Institution, www.aaa.si.edu/collections/interviews/oral-history-interview-arthur-rothstein-13317.

42 Quoted in Virginia M. Mecklenburg, *Modern American Realism: The Sara Roby Foundation Collection* (Washington, DC: Smithsonian Institution Press for the National Museum of American Art, 1987), excerpted from americanart.si.edu/collections/search/artist/?id=4384.

43 Quoted in David Gonzalez, "Jack Delano's American Sonata," *Lens: Photography, Video, and Visual Journalism*, October 13, 2011, http://lens.blogs.nytimes.com/2011/10/13/jack-delanos-american-sonata/?_r=0.

44 Alfred T. Palmer, *The More Women at Work the Sooner We Win! Women Are Needed Also as [. . .] See Your Local U.S. Employment Service, 1943.* Miscellaneous Items in High Demand, Library of Congress, Prints and Photographs Division, Washington, DC.

45 William H. Johnson, Bob Thompson, and Lizzetta LeFalle-Collins, *Novae: William H. Johnson and Bob Thompson* (Los Angeles: California Afro-American Museum Foundation, 1990), 8.

46 Norman Rockwell, *My Adventures as an Illustrator* (New York: Abrams, 1988), 24.

47 "Norman Rockwell Museum Presents 'J. C. Leyendecker and the *Saturday Evening Post*,'" Norman Rockwell Museum, March 4, 2015, www.nrm.org/2015/03/norman-rockwell-museum-presents-j-c-leyendecker-and-the-saturday-evening-post/.

48 Yousuf Karsh, quoted in press release for "Men Who Make Atlas Steels," October 22, 1950, reprinted in Sandra Getty, "The Industrial Portraits of Yousuf Karsh," in *Yousuf Karsh: Industrial Images* (Windsor, ON: Art Gallery of Windsor, 2007), 19.

49 Ibid., 21.

50 Ibid., 27.

51 Ibid.

52 Deborah Wye, *Artists and Prints: Masterworks from the Museum of Modern Art* (New York: Museum of Modern Art, 2004), 218, www.moma.org/collection/works/88189?locale=en.

53 Quoted in Pirkle Jones, *Pirkle Jones: California Photographs* (New York: Aperture, 2001), 103.

54 Ibid., 105.

55 Ibid., 36.

56 Quoted in Lowery Stokes Sims, "The Structure of Narrative: Form and Content in Jacob Lawrence's Builders Paintings, 1946–1998," in *Over the Line: The Art and Life of Jacob Lawrence*, ed. Peter T. Nesbett and Michelle DuBois (Seattle: University of Washington Press, 2000), 203.

57 Ibid., 210.

58 Danny Lyon, *The Destruction of Lower Manhattan* (New York: PowerHouse Books, 2005), 1.

59 Danny Lyon, *Knave of Hearts* (Santa Fe, NM: Twin Palms Publishers, 1999), 53.

60 Dawoud Bey, artist statement, 1979, quoted on Studio Museum of Harlem website, www.studiomuseum.org/exhibition/dawoud-beys-harlem-usa.

61 Dawoud Bey, "Harlem USA 35 Years Later," Artists' Blogs, Studio Museum of Harlem website, November 9, 2010, www.studiomuseum.org/studio-blog/artists/artists-blogs/harlem-usa-35-years-later-guest-blog-post-dawoud-bey.

62 Ibid.

63 Ibid.

64 Quoted in Larry Gagosian, *Avedon/Warhol* (London: Gagosian Gallery, 2016), 95.

65 Sam Comen, project statement, 2015, www.samcomen.com/index.php?/projects/lost-hills-new/.

66 Ibid.

67 Quoted in Adam McCauley, "Bridging Eras: Sam Comen's Travels through Lost Hills," *Time*, July 15, 2013, http://time.com/3800956/bridging-eras-photographer-sam-comens-travels-through-lost-hills.

68 E. John Bullard, "Leah Chase and the Arts," in *Leah Chase: Paintings by Gustav Blache III* (Manchester and New York: Hudson Hills Press, 2012), 23.

69 Janet Biggs, interview with Cathy Byrd, Fresh Talk, Fresh Art International, Tampa Museum of Art, 2012, published October 4, 2016, www.youtube.com/watch?v=HEOibgG_ggo/.

70 "Janet Biggs: Echo of the Unknown," Houston Public Media, interview at the Blaffer Museum, University of Texas at Austin, February 19, 2015, www.youtube.com/watch?v=LtLmdQKyrz8.

71 Ibid.

72 Quoted in Britney Keller, "An Interview with Artist John Sonsini," February 27, 2013, *S [R] Blog*, https://blog.superstitionreview.asu.edu/2013/02/27/an-interview-with-john-sonsini.

73 Quoted in Carolina A. Miranda, "From Nanny to International Art Star: Ramiro Gomez on How His Paintings Reveal the Labor That Makes California Cool Possible," *Los Angeles Times*, May 4, 2016.

74 Shauna Frischkorn, www.shaunafrischkorn.com.

75 Maurizio Cattelan, "Josh Kline: When the Boundaries between Art and Life Dissolve," *Purple* 25 (2016), http://purple.fr/magazine/ss-2016-issue-25/josh-kline/.

SELECTED BIBLIOGRAPHY

Bernstein, Irving. *A Caring Society: The New Deal, the Worker, and the Great Depression—A History of the American Worker, 1933-1941*. Boston: Houghton Mifflin, 1985.

———. *The Lean Years: A History of the American Worker, 1920-1933*. Boston: Houghton Mifflin, 1960.

———. *The Turbulent Years: A History of the American Worker, 1933-1940*. Boston: Houghton Mifflin, 1970.

Brody, David. *In Labor's Cause: Main Themes on the History of the American Worker*. New York: Oxford University Press, 1993.

———. *Labor Embattled: History, Power, Rights: The Working Class in American History*. Urbana: University of Illinois Press, 2005.

———. *Workers in Industrial America: Essays on the Twentieth Century Struggle*. New York: Oxford University Press, 1993.

Bryan-Wilson, Julia. *Art Workers: Radical Practice in the Vietnam War Era*. Berkeley: University of California Press, 2009.

Cikovsky, Nicolai, Jr., Franklin Kelly, and Winslow Homer. *Winslow Homer*. Washington, DC: National Gallery of Art; New Haven, CT: Yale University Press, 1995.

Commons, John R., et al. *History of Labor in the United States*. 4 vols. New York: Macmillan, 1918-35.

Dabakis, Melissa. *Visualizing Labor in American Sculpture: Monuments, Manliness, and the Work Ethic, 1880-1935*. Cambridge: Cambridge University Press, 1999.

Fleischhauer, Carl, Beverly W. Brannan, Lawrence W. Levine, and Alan Trachtenberg. *Documenting America, 1935-1943*. Berkeley: University of California Press, 1988.

Foner, Philip Sheldon, and Reinhard Schultz. *The Other America: Art and the Labour Movement in the United States*. London: Journeyman Press, 1985.

Forbath, William E. "The Shaping of the American Labor Movement." *Harvard Law Review* 102, no. 6 (1989): 1109-1256.

Gutman, Herbert G. "Work, Culture, and Society in Industrializing America, 1815-1919." *American Historical Review* 78, no. 3 (1973): 531-88.

Hapke, Laura, *Labor's Canvas: American Working-Class History and the WPA Art of the 1930s*. Newcastle: Cambridge Scholars Publishing, 2008.

Hemingway, Andrew. *Artists on the Left: American Artists and the Communist Movement, 1926-1956*. New Haven, CT: Yale University Press, 2002.

———. *Landscape Imagery and Urban Culture in Early Nineteenth-Century Britain*. Cambridge: Cambridge University Press, 1992.

Hurt, Douglas R. "The Historiography of American Agriculture." *Organization of American Historians Magazine of History* 5, no. 3 (1991): 13-17.

Johns, Elizabeth. *American Genre Painting: The Politics of Everyday Life*. New Haven, CT: Yale University Press, 1991.

Jones, Caroline A. *Machine in the Studio: Constructing the Postwar American Artist*. Chicago: University of Chicago Press, 1996.

Kasson, John F. *Civilizing the Machine: Technology and Republican Values in America, 1776-1900*. New York: Hill and Wang, 1999.

Krueger, Thomas A. "American Labor Historiography, Old and New: A Review Essay." *Journal of Social History* 4, no. 3 (1971): 277-85.

Larkin, Susan G. *American Impressionism: The Beauty of American Work*. London: Frances Lincoln, 2005.

Lasser, Ethan W. "Selling Silver: The Business of Copley's Paul Revere." *American Art* 26, no. 3 (Fall 2012): 26–43.

Lembcke, Jerry Lee. "Labor History's 'Synthesis Debate': Sociological Interventions." *Science and Society* 59, no. 2 (1995): 137–73.

Marx, Leo. *The Machine in the Garden: Technology and the Pastoral Ideal in America*. New York: Oxford University Press, 1964.

Miranda, Carolina A. "From Nanny to International Art Star: Ramiro Gomez on How His Paintings Reveal the Labor That Makes California Cool Possible." *Los Angeles Times*, May 4, 2016.

Mitchell, Don. *The Lie of the Land: Migrant Workers and the California Landscape*. Minneapolis: University of Minnesota Press, 1996.

Molesworth, Helen, ed. *Work Ethic*. Baltimore: Baltimore Museum of Art; University Park: Penn State University Press, 2003.

Nardo, Don. *Migrant Mother: How a Photograph Defined the Great Depression*. Mankato, MN: Compass Point Books, 2011.

Natanson, Nicholas. *The Black Image in the New Deal: The Politics of FSA Photography*. Knoxville: University of Tennessee Press, 1992.

Nemerov, Alexander. *Soulmaker: The Times of Lewis Hine*. Princeton, NJ: Princeton University Press, 2016.

O'Leary, Elizabeth. *At Beck and Call: The Representation of Domestic Servants in 19th-Century American Painting*. Washington, DC: Smithsonian Institution Press, 1993.

Ott, John. "Labored Stereotypes: Palmer Hayden's 'The Janitor Who Paints.'" *American Art* 22, no. 1 (2008): 102.

Peiss, Kathy. *Cheap Amusements: Working Women and Leisure in New York City, 1880–1920*. Philadelphia: Temple University Press, 1985.

Perkinson, Robert. *Texas Tough: The Rise of America's Prison Empire*. New York: Metropolitan Books, 2010.

Rather, Susan. "Carpenter, Tailor, Shoemaker, Artist: Copley and Portrait Painting around 1770." *Art Bulletin* 79, no. 2 (1997): 269–90.

Rigal, Laura. *The American Manufactory: Art, Labor, and the World of Things in the Early Republic*. Princeton, NJ: Princeton University Press, 2001.

Ross, Steven. "Struggles for the Screen: Workers, Radicals, and the Political Uses of Silent Film." *American Historical Review* 96, no. 2 (1991): 333–67.

Sante, Luc. *Low Life: Lures and Snares of Old New York*. New York: Farrar, Straus and Giroux, 1991.

Stampp, Kenneth M. *The Peculiar Institution: Slavery in the Ante-Bellum South*. New York: Vintage, 1956.

Stange, Maren. *Symbols of Ideal Life: Social Documentary Photography in America, 1890–1950*. Cambridge: Cambridge University Press, 1989.

Taylor, George Rogers. *The Transportation Revolution, 1815–1860*. New York: Rinehart, 1951.

Trachtenberg, Alan, ed. *Classic Essays on Photography*. New Haven, CT: Leete's Island Books, 1980.

Weschler, Lawrence, and Ramiro Gomez. *Domestic Scenes: The Art of Ramiro Gomez*. New York: Harry N. Abrams, 2016.

Wilentz, Sean. *Chants Democratic: New York City and the Rise of the American Working Class, 1788–1850*. New York: Oxford University Press, 1984.

Wyckoff, Walter. *The Workers: An Experiment in Reality*. New York: Charles Scribner's Sons, 1897.

ACKNOWLEDGMENTS

The Sweat of Their Face: Portraying American Workers has been a collaborative project among colleagues across the country and within the Smithsonian. We wish to thank the artists, private collectors, and institutions who agreed to lend their treasures to the exhibition and who made their works available for study as we prepared the exhibition script and catalogue essays. We are indebted to those who financially supported this exhibition and are truly grateful for their support in our endeavor to recognize American workers in celebration of the Portrait Gallery's fiftieth anniversary. Our deepest thanks go to John Fagg for his collaboration and his contribution of an insightful catalogue essay.

Every Portrait Gallery exhibition is a group effort that involves virtually every member of our staff. We extend our thanks to colleagues, notably director Kim Sajet and the museum's commissioners for their support of the project from its inception. For their work in coordinating the loans and securing image rights, we are grateful to the Portrait Gallery's Exhibitions Department, notably Claire Kelly, Marlene Harrison, and Devra Wexler. We also wish to thank the registrars, John McMahon, Molly Grimsley, and Jennifer Wodzianski. The exhibition could not have happened without the dedication of the museum's design team, including Tibor Waldner, Michael Baltzer, Alex Cooper, Peter Crellin, Raymond Cunningham, Rachel Huszar, Grant Lazer, and Caroline Wooden, whose expertise resulted in a cohesive and beautiful installation.

Thanks also to Deborah Sisum and Benjamin Bloom for their expert work in new media, which will allow the exhibition to reach audiences globally. We also extend thanks to Amy Parker and the Portrait Gallery's Advancement team for their efforts in fundraising and coordinating the events associated with the opening of the exhibition.

Thanks also to the museum's Education Department, headed by Rebecca Kasemeyer, for creating dynamic programming and educational outreach opportunities in association with the exhibition. We are especially grateful to Dru Dowdy, the Portrait Gallery's head of publications, and Smithsonian Books' staff, designer, and editors, Laura Harger, Christina Wiginton, Carolyn Gleason, Bob Aufuldish, and Tom Fredrickson, for their work in producing a beautiful publication.

Finally, we wish to extend our gratitude for the skillful work of Portrait Gallery Curatorial and History Department research and administrative assistants Laura Manaker and Jacqueline Petito, and the excellent behind-the-scenes research and writing undertaken with enthusiasm and diligence by interns Ray Cwiklinski, Courtney Walls, Katie Mikulka, Samantha Page, Frances Gurzenda, and Anna Jacobs.

Alma Sewing by Francis Hyman Criss
(detail of cat. 33, p. 129)

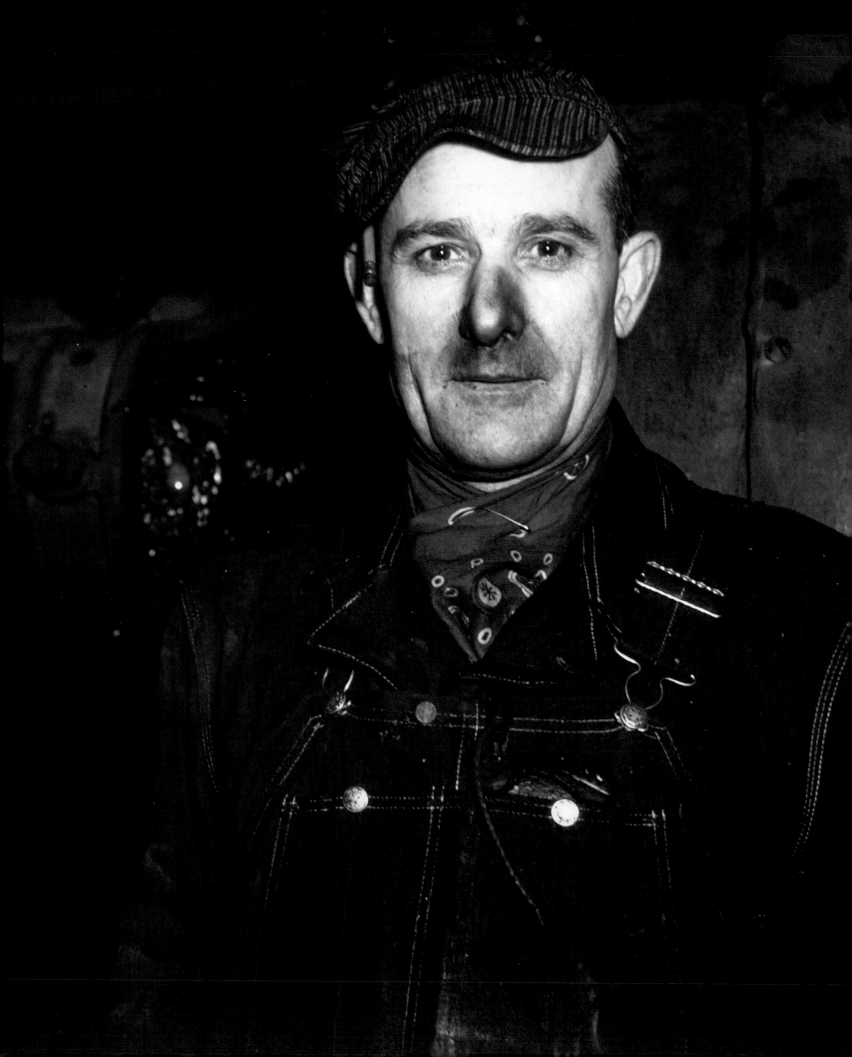

INDEX

Workers at the Roundhouse of the C & NW RR Proviso Yard, Chicago, Ill. by Jack Delano (detail of cat. 46, p. 155)

IMAGE CREDITS

Published to accompany an exhibition at the National Portrait Gallery, Smithsonian Institution, Washington, DC.

This book may be purchased for educational, business, or sales promotional use. For information, please write: Special Markets Department, Smithsonian Books, P.O. Box 37012, MRC 513, Washington, DC 20013

Published by Smithsonian Books
Director: Carolyn Gleason
Managing Editor: Christina Wiginton
Project Editor: Laura Harger
Project Manager, National Portrait Gallery: Dru Dowdy
Edited by Tom Fredrickson
Designed and typeset by Bob Aufuldish, Aufuldish & Warinner

Library of Congress Cataloging-in-Publication Data
Names: Ward, David C., 1952– Face of labor. | Moss, Dorothy. Worker in the art museum. | Fagg, John, 1977– Unit and gross.
Title: The sweat of their face : portraying American workers / David C. Ward and Dorothy Moss ; with an essay by John Fagg.
Description: Washington, DC : Smithsonian Books, 2017. | Includes bibliographical references and index.
Identifiers: LCCN 2017004906 | ISBN 9781588346056 (hardback)
Subjects: LCSH: Working class in art—Exhibitions. | Working class—United States—Portraits—Exhibitions. | Art, American—Themes, motives—Exhibitions. | BISAC: ART / Collections, Catalogs, Exhibitions / General. | ART / Subjects & Themes / Portraits. | POLITICAL SCIENCE / Labor & Industrial Relations.
Classification: LCC N8219.L2 S94 2017 | DDC 704.9/49331—dc23
LC record available at https://lccn.loc.gov/2017004906

Manufactured in China, not at government expense
21 20 19 18 17 5 4 3 2 1

For permission to reproduce illustrations appearing in this book, please correspond directly with the owners of the works, as seen in their captions and on p. 223. Smithsonian Books does not retain reproduction rights for these images individually or maintain a file of addresses for sources.

Frontispieces:

P. 2: *Lathe Operator Machining Parts for Transport Planes at the Consolidated Aircraft Corporation Plant, Fort Worth, Texas* by Howard R. Hollem (detail of cat. 47, p. 157)

P. 6: *Willie Gee* by Robert Henri (detail of cat. 21, p. 105)